THE PERCIVAL DAVID FOUNDATION COLLOQUIES

In addition to the gift of his incomparable collection of
Chinese porcelain, Sir Percival David provided monies which
have been constituted an Academic Fund destined to advance
the objects of his Foundation. One thing desirable was
deemed to be the institution of a regular meeting of scholars
engaged in the field of Asian art and archaeology, for debate
on a pre-determined subject, and the prompt publication, in
modest form, of their contributions. It is intended that
the Colloquies be held annually on themes in which China is
central, or implicated in a wider exchange of ideas. The
participants invited to the Colloquy will be limited to a
number easily allowing general discussion. The texts of
the papers will be printed in an edition of some hundreds.

Colloquy Number 1 - *Pottery and metalwork in T'ang China:
their chronology and external relations*

Colloquy Number 2 - *Mahayanist art after A.D. 900*

Colloquy Number 3 - *The westward influence of the Chinese
arts from the 14th to the 18th century*

Colloquy Number 4 - *The Art of Iran and Anatolia from the
11th to the 13th century*

Colloquy Number 5 - *Chinese painting and the decorative style*

Colloquy Number 6 - *Artistic Personality and Decorative Style
in Japanese art.*

PREFACE

In the seventh colloquy we looked at artifacts made by the
nomadic peoples of the Eurasian steppelands and at others
produced under their inspiration. Various classes of works
of art, many of them well-known under the general heading of
'the animal style' were examined in detail. To complement
these papers we added studies of crafts basic at certain
epochs to the nomadic way of life: chariotry, archery and
tentage. It became clearer than ever that the material and
artistic culture of the steppe peoples, fascinating in itself,
must play a major part in the piecing together of their largely
unwritten history.

 I must record my thanks to Miss Angela Moore for the
practical organisation of the colloquy; to Miss Pauline
Fortune for her considerable typing and layout work; to Mr.
Glenn Ratcliff for re-printing and mounting the illustrations;
to Professor Watson and Miss Margaret Medley for much advice
and assistance; and to the lecturers for presenting to us the
results of their researches.

Philip Denwood
Bloomsbury 1978

CONTENTS

Introductory Note

Preface

The Chinese Chariot: An Insider's View	W. Watson	1
Chinese Chariotry: An Outsider's View	S. Piggott	32
The Transformation and Abstraction of Animal Motifs on Bronzes from Inner Mongolia and Northern China	J. Rawson	52
The Tiger Motif: Cultural Transference in the Steppes	R. Kerr	74
Some Georgian Belt-Clasps	J. E. Curtis	88
The Anecdotal Plaques of the Eastern Steppe Regions	E. C. Bunker	121
The Tents of Timur An Examination of Reports on the Quriltay at Samarqand, 1404	P. A. Andrews	143
Nomadic Archery: Some observations on Composite Bow Design and Construction	E. Mc Ewen	188
Recently found relics of Turkic Stone Sculpture from the territory of the Mongolian People's Republic	I. Erdélyi	203
Nomad Arts and Tibet	P. Denwood	218

When the chariot is found on the Chinese Central Plain, in the sacrificial pits of the Shang capital near Anyang in Honan, it appears to be already rather fully integrated into the native context. Of the weapons which armed the two-man chariot team, *ko* halberds and bronze-tipped arrows are of the standard Shang type, and the ornament of much of their accoutrement conforms wholly to the hieratic style prevailing in Shang art. But both in equipment and in the decorative motifs chosen for the chariot fittings there are items which do not so easily blend into the repertory of the Shang state, and the question whether these items are to be referred to another part of China, or reflect even more distant connexions of the Chinese Bronze Age, holds the greatest interest for the theme of this colloquy.

If the thesis of a west-east transmission of chariot design is accepted, and the evidence for it seems very strong, the communication cannot have been an isolated contact, any more than it can have taken place in the course of a single far-ranging ethnic movement or through a massive transfer of culture. Neither of these phenomena is compatible with what we know of the Chinese Central Plain and of the 'Northern Zone' of Shensi-Shansi-Inner Mongolia which adjoins it to north and northwest. When ideas of chariot building passed through Asia they can only have travelled over routes kept open, or intermittently reopened, by the passage of less spectacular goods. We have only to look at a few things associated with the Chinese chariots and their ill-starred drivers, and the distant retreats of grassed and wooded steppe appear to the imagination like glimpses caught through the rides of a vast forest, and we are transported to the Inner-Asian realm of primordial animal art. Meanwhile China may be shown to have contributed important initial elements to the Animal Style of the steppes in the stricter sense in which this style is understood of the art which flourished throughout Inner Asia during the last seven pre-Christian centuries.

THE BOW-GUARD (Pls. 1,2)

Among the first objects in the Shang chariot burials which attract attention is the bow-quard (*pi*, Jap. *yumidame*[a]). Two of these are regularly found within the perimeter of the platform of each buried chariot, as it is recorded in

1

the soil, or lying only slightly across the edge of it, and so appear to belong one each to the two occupants of the vehicle (Pl. 1, Pl. 2a-c). The lower ends of the strongly curved arms generally lie on the curve formed by the main body of the instrument, in some specimens they even project slightly below this line, and they end, with few exceptions, in a pierced spherical jingle, a horse-head. In the West the *pi* have at first sight often been thought to have to do with the reins. Ch'ing dynasty antiquarians described them as 'horse bells' or 'harness bells' (*ho ling*[b]), which suggested that they were part of the chariot structure; and the excavators were content to call them *kung hsing shih*[c] 'bow-shaped ornaments'. There is however an ancient literary tradition to the effect that the *pi* (to use one of the several names preserved in the older texts[d]) was closely connected with the bow, and the idea was once current that the excavated objects were (merely omitting *hsing* 'shape') *kung shih* 'bow ornaments', something which remained on the bow even while it discharged arrows.

In the total absence of material remains of the bow itself, the fact that the Shang archer shot from a *compound* bow may be inferred with some certainty from the triple-curved shape depicted, with arrow nocked, in some emblematic ideographs cast on bronze sacrificial vessels. By this bow he was heir to the Siberian hunters of the Serovski neolithic stage, where the shape of compound bows is preserved by the disposition in burials of numerous bone plaques originally mounted on them. No other form of bow is known to the compilers of the *K'ao-kung-chi* (Record of Works) chapter of the *Chou li* in which a complex and apparently carefully regulated compound structure is described. Unfortunately the pre-Han tradition synthesized in the 3rd century B.C. by the codifiers of this and other ritual texts included a number of technical terms which evidently had become obscure in Han times, perhaps through the obsolescence of the technical device intended, or, more probably, through the linguistic uncertainties resulting from the Western Han reform and the unification of the script. Consequently the purpose of the *pi* bow-guard came to be misunderstood by commentators. Its true function is explained, in the light of excavated and textual evidence, by T'ang Lan in an article published in 1973.[1] He abandons Shih Chang-ju's earlier theory that the *pi* was attached to the strung bow.

Since in burials the *pi* lie nearly always on their side, and not in notable proximity to the clutch of bronze arrow-heads representing a quivered stock of arrows, Kuo Pao-chün had suggested that the bronzes may have been fitted to shields, the main inner portion equalling the breadth of

the shield. I at first accepted this interpretation; but the
shield thus imagined was singularly narrow, and it seemed
unlikely that both archer and driver would be furnished with
one. The studs which appear on the upper, decorated, surface
of some surviving *pi* cannot have served to attach them in any
permanent fashion to another object. Neither these studs,
nor the perforations which occasionally appear near to the
arms, are regular features, and the majority of the *pi* lack
both. The under surface of most *pi* (a point difficult
however to verify in illustrations) appear to be smooth,
without rabbeting or projections.[2] Apart from the question
of attachment and the difficulty of curvature when the arms
descend beyond the line of the centre, the great width of
some *pi* (up to 3½") disposes of the possibility that this
bronze instrument may have been a permanent fixture of the
bow as ornament or strengthener. A moment's reflexion on
the action of the strung bow showed how ludicrous were the
last two interpretations, and yet the close association of
the *pi* with the chariot archers is undeniable.

After arguing that the *pi* cannot be a component of the
bow (for example its 'handle', as the *fu*[e] of the *K'ao kung
chi* had been understood, whereas it refers only to the middle
part of the bow - the grip, but nothing separate) T'ang Lan
establishes that the Han commentator Cheng Hsüan (A.D. 127 -
200) provides both a source of confusion and a clue to correct
identification. One character written for the bow-guard *pi*[f]
is taken by Cheng to be a bamboo mat, a cover for the chariot,
while of another script variant he gives a definition which
settles our problem: '*pi* is a bow-straitener. When (the bow)
is unstrung it is bound inside the bow, to prevent damage'
(commentary on the *Chi hsi chi* chapter of the *Yi Li*[g]).

Both in China and in collections in Japan and the West
the majority of bow-guards are without recorded provenance,
although in many cases, their typical late-Shang relief-cast
and inlaid ornament goes far to vouch for manufacture at
Anyang itself. It is from the sacrificial chariot pits in
Sector C at Anyang and from the great shaft tombs at Wu-kuan-
ts'un and Ta-ssu-k'ung-ts'un that the best documented
specimens come.[3] (Pl. 2c). According to T'ang Lan these
pi 'at the time of excavation still had decayed wood on
their inner side; on the back where the body joins the
projecting arms, on both sides of the inner angle, equally
on all three surfaces, were traces of leather thongs
remaining from the use of leather straps bound around (the
bow guards)![4] This does not however dispose of the question
whether the *pi* as we see them were laid directly against the
unstrung bow on its inner face, or were part of a larger
device of which the rest was made of wood, a question not

3

raised by T'ang Lan. It is clear that the argument from
curvature tells equally against the bronze having lain
snugly against the bow whether strung or not, a point
reinforced by the straightness of the central part of
the Siberian *pi* to be instanced presently. It is possible
that the bronze part of the bow-guard was embedded in a
wooden armature in some way that obviated the use of pegs
or edging on the bronze itself. T'ang Lan's traces of
decayed wood would then derive from this armature and not
from the bow itself.

 Whenever two *pi* are present in a tomb they lie some
distance apart, which may suggest that they were bulkier
objects than the bronzes themselves indicate. In the
earliest references the character *pi* is preceded by *tien*[h],
which, in keeping with the misconception regarding a
chariot *cover*, is defined in the *Shuo wen chieh tz'u*
(A.D. 100) as a bamboo mat, the same meaning being given
to the binome *tien pi*. But the character *tien*[i], deprived
of the bamboo radical at the top, becomes *t'án*, which in
the *Erh ya* (of older tradition than the *Shuo wen*) is given
as 'long', 'to lengthen'. This meaning fits well with the
function of the *pi* as bow guard and straitener, while the
writing with bamboo radical perhaps hints at bamboo as a
component together with bronze, in keeping with what was
proposed above about a wooden armature.

 If the bow-guard or bow-straitener was for binding on
the unstrung bow to preserve its shape and prevent damage,
it is still mysterious that the instrument should appear to
be an indispensable part of the archer's equipment when he
was presented in full panoply for slaughter at a royal
consecration or a noble's funeral. An explanation is
probably given by the mention of *pi* among the gifts made by
the Chou king to deserving officers as recorded in two
inscriptions cast on presentation ritual vessels, the Fan
Shen *kuei* and the Mao Kung *ting*[j].[5] In each case the gift
is described as a 'bronze bow-guard (*tien pi*) and a fish
quiver (*yü fu*[k])'. Strange as it appears in this context,
the 'fish' of the quiver may refer to fish or alligator
skin or such, and reminds one of the shark's skin used on
the sheaths of ancient and recent Japanese swords. *Chin*
is either gold or bronze, and while the archaeological
record gives no grounds for supposing that *pi* were ever
made of gold, they are accompanied in the gift lists by
ornamental *chin* objects which may well have been cast in
the precious metal. But in either metal it is clear that
the *pi* was conferred on the recipient as a mark of rank
and honour. It is not surprising therefore that they
should have been included in the ritual burial of Shang

chariots. These charioteers were apparently no common soldiers.

How far may the bow-guards be taken as evidence of a cultural sphere extending beyond the Shang metropolitan area in Honan? They are found, in less decorated versions, in the Minusinsk region of South Siberia in a context of Karasuk culture (Pl. 2d), and an outlier is recorded from Tomsk.[6] Of the South Siberian specimens those from Kurgan 3 at Askyz and from the kurgans at Abakan-Most and Tukai, and the specimen from Tomsk, are attributed to the 8th or 7th century B.C. The bow-guard from Beiskaya Shakhta is put between the late 11th and the early 8th century, but the upper date depends upon a dating of bronze knives in parallel with China (see below) which is not strict enough to make certain that the *pi* was already in use in Siberia when it was manufactured for the Shang burials. A curious difference between the Siberian and the Shang *pi* is that the central segment of the former is straight. The tips, splayed a little and turned out, lie approximately on the line of the centre. Two specimens apparently also of Karasuk date, but unlocated, have studs along the convex side of the arms and pegs at the join of the arms which would serve to secure a binding, whether this attached the bronze to a bow directly or, as seems more likely, to a wooden armature forming part of the instrument. The gentler curve of the arms as compared with Chinese specimens indicates a difference of the armature, or possibly of the bow itself. In the Siberian tombs the *pi* is placed at the hip, across the pelvis or on the breast of the dead man, and for this reason it was interpreted by some Soviet archaeologists as part of a shaman's equipment. There is no sign of the chariot in South Siberia in the Karasuk period, and chariots are even less probable at Tomsk, far to the northwest and beyond the wooded steppe.[7]

Of the *pi* found in China those recovered in controlled excavations are far outnumbered by undocumented pieces, the majority of which appears from the decoration to belong also to the Shang period. The mention in two early Western Chou inscriptions shows that *pi* continued in use after Shang, and specimens are known from Western Chou tombs at Ch'i-shan in Shensi and Pai-fu in Ch'ang-p'ing-hsien near Peking[8], but it seems certain that early in the Western Chou period, probably in the 10th century B.C., the bronze *pi* ceased to be made in metropolitan China, even if a wooden version continued in use, as is indicated by the later survival of a variety of names for the device.[9] The chariot burials at Hsin-ts'un[10] (10th-8th centuries B.C.) and Chang-chia-p'o[11] (9th century B.C.) were without bow-guards; and while one might explain

this absence by a distaste now arisen for burying the drivers
with their vehicles, it is improbable that bronze *pi*, were
they still in use, should be missing from the bronze grave-
goods of the Western Chou period in general, especially
when (as at Shang-ts'un-ling) [12] arrows, indicated by their
bronze points, were placed in quiver groups. Since the
literary tradition of the *pi* continues later, it may be
that the instrument was now made entirely of perishable
materials.

It follows from the comparison of dating of the bow-
guard in China and in Siberia that the Shang charioteer
belonged by an important item of his equipment to a sphere
of common practice extending far to the northwest through
the Mongolian steppes, and that he was the innovator, his
weapon drill being copied at a somewhat later date by
archers living as far away as Minusinsk and Tomsk. Soviet
archaeologists believe that the Karasuk bronze culture of
South Siberia assumed its characteristic form under direct
influence from China, where, as a source of this influence,
they make no distinction between the tradition of the
Shang centre in Honan and that of the Chinese Northern
Zone. [13] Resemblances of knives and battle-axes,
particularly the former, are taken to warrant a parallel
dating of the earliest stage of Karasuk with the Anyang
period of Shang, both beginning from the 14th or 13th
century B.C. But the only absolute dates, by radiocarbon,
which exist on the Karasuk side - burial site No. 4 at
Karasuk - take the record no further back than 980 ± 60
and 760 ± 75 B.C. [14] Any theory which envisages some delay
between the Chinese phenomenon and its Siberian counterpart
will necessarily shake the argument for the early inception
of Karasuk. We have seen, in the case of the bow-guard, and
on evidence of dating derived from the existing Soviet
scheme, that one may not rule out the possibility of
considerable retardation between China and Minusinsk.

THE SCULPTURED KNIFE (Pl.3)

Another informative item of the charioteer's equipment is his
knife, which is slightly curved, single-edged and ends at the
handle in a ring or a horse head. Knives of this general
class have been found in fair numbers in Shang tombs, and
are not confined to chariot burials. [15] A special interest
attaches to those terminating in an animal head, for the
approach to natural form which these represent falls
outside the norms of Shang hieratic art as it is preserved
on ritual vessels and on other ceremonial and utilitarian

objects. Similar knives have been found widely distributed
in South Siberia, the Zabaikalye, and in rare specimens
occur westwards to the Ural mountains. For comparison with
China two groups are specially important, having different
historical and artistic implications.

The most picturesque group consists of three knives,
from Seima, Turbino II and Rostovka in western Siberia,
whose handle ends are decorated with in-the-round figures
respectively of two horses, three rams and a man standing
by a horse which he controls by a rein to its mouth.[16] (Pl. 3c).
In Shang China nothing is found to compare with these pieces,
either in the representation of whole animals on knives or in
the quality of the realism, although a pale reflection of
this ornament is seen in some single-ram terminals in the
Minusinsk region and the Ordos[17], and in the profile of a
'grazing animal' found on daggers from Inner Mongolia and
Shansi which have been dated to the 8th-6th century B.C. [18]
The West Siberian sculptured knives are set apart by their
superior quality. The shapes (apart from the handle-end
widened to take the little animals) correspond approximately
to Chlenova's classes 2 and 3, and so on her dating would
belong to the late 13th - 11th century B.C. Bader argues
typologically for a slightly earlier date, and suggests that
the knives were made in some unidentified centre on the
steppes or wooded steppe, not far from the Gorny Altai and
in the Ob'·Irtysh bronze province, and therefore represent a
distinct tradition from that of Minusinsk[19] (though in that
case we should have to accept that the South Siberian
centre took over the tradition and continued it, less the
animal sculpture, after the central Siberian production had
ceased).

An hypothesis of exchange between the Shang state in
central China and the Siberian bronze centre or centres in
which the sculptured knives were made can be built on
analogies of spearheads and socketed axes, but the idea of
including the decorated knives in the scope of the exchange
is most attractive. The horse-head knives of the charioteers
and the deer-head knives attributed to Shang are decorated
in the same quasi-naturalistic manner, which lacks any hint
of the schematising characteristic of the Animal Style
proper. Moreover (Pl. 3a,b) the knives imply a procedure
different from that followed in the usual Shang casting,
with its multiple ceramic moulds. Whether the knives,
Chinese and Siberian, were cast by the wax process, or in
open bivalve moulds, is not yet determined. Some *single*
open moulds of stone found dispersed through Siberia, and at
a Northern Zone site in the T'ang-shan district of China,
are not necessarily incompatible with a theory of *cire*

perdue.[20] The implausibility of a theory of multi-part moulds
for casting the comparatively complicated knife terminals,
tells in favour of wax.

There can be little doubt that the Chinese knives were
produced in local foundries - their numbers alone seem to
vouch for that - and perhaps Chinese practical sense is seen
in the substitution of a head for the complete animals of the
Siberian design (sometimes a bovine or monster head replaces
the horse), and in the guarding of the deer-head by loops
above and below, of which the former vaguely suggests
antlers. The animal has been called an ibex or ram. The
long muzzle and heavy features may indicate the elk, the cer-
vid best known and represented in the Siberian regions with
which the sculptured knives connect. If the last identity
is correct the deer-head knife links the Shang city-state
with the woodland steppe and the taiga, through the Northern
Zone of China, and betokens a contact with an Inner Asian
style of animal art that preceded the advent of schematic
design, or at least is distinct from that tradition.

The second group of South Siberian knives which relate
to China is a small one, in which the deer-head terminals
look like degenerating versions of the Chinese examples.
One of them, with multiple antler tines and no loops, comes
from the kurgan at the village of Maryasova, which through
the correspondence of another, ring-handled, bronze knife to
the E-16 burial at Hsiao-t'un, is dated to the very end of
the Shang period, in the late 11th century B.C. A horse-
head fragment is dated to the 10th-9th century, a poorly
shaped ram-head is of the 7th century and a further
degenerated deer-head of the 8th. Meanwhile in Inner
Mongolia, which constitutes the greatest extent of the
Northern Zone, authentic versions of the deer-head knife
were made. One of these, from Ch'ao-tao-kou, may go back
to the 11th century, but the indications are that the type
survived much later in the Northern Zone.[21] The deer-head
knife is common in collections made in the vicinity of the
Great Wall, associated with others of later kinds, so that
its disappearance from central China at the end of Shang
by no means guarantees that its appearance in South Siberia
was equally early. Indeed the inferiority of the Siberian
specimens suggests a later date. A reasonable inference is
that in the first instance the knife with animal sculpture
was invented in some Siberian centre more northerly than
the Minusinsk basin, whence the idea was communicated to
Shang China and there adapted in some degree to Chinese
taste. How early the sculptured knives began to be made
at Anyang cannot be ascertained: those found in the
chariot tombs are late in the Shang period, but those

from other tombs may reach back nearer the foundation of the
capital at Hsiao-t'un in the 14th century B.C. Subsequently
the deer-head knife found its way through Mongolia to South
Siberia, arriving there at the very end of Shang, or more
probably in the 10th or 9th century B.C. It took part in
the wider flow of ideas from metropolitan China and from
the Northern Zone, which carried with it the bow-guard and
certain artistic motifs now to be examined.[22]

THE HUMPED K'UEI (Pls. 4,5a)

A glance at the decorative motifs used on the bronze working
parts and ornaments of the Shang chariots is enough to show
that they fall outside the range of motifs customarily used
for the bronze sacrificial vessels on which our view of Shang
art is chiefly based. Characteristic of the chariot bronzes
is a gaping-jawed monster with a serpentine body, the back
usually rising to form a hump, below which is a projection
like a single claw, or in some versions an elaborately clawed
foot. This general description fits the so-called *k'uei* of
the hieratic ornament of the bronze vessels, but the nature
of this *humped k'uei* of the chariots is different. It does
not enter into the graphic permutations of the *k'uei* defined
in Shang ornament of the Anyang period, and it is distinct
from the type of *k'uei* in the Shang repertory which can be
identified with the half segment of a t'ao-t'ieh monster
mask. The humped *k'uei* (hereafter HK') appears in relief
or in line on bronze parts designed to strengthen joints in
the chariot structure, and on pieces composing or decorating
the head-harness. There are two varieties: one disposed
more or less horizontally and resembling a slinking wolf
(Pl. 4a), and the other with the head turned to the ground
and a more strongly curved body (Pl. 4c). In the latter
the HK' generally wears the 'bottle horn' familiar from
other sections of Shang ornament.

On the whole it is the former type, HK'1, which is
favoured on the chariot bronzes. It is single on many
tubular components, as on some from the Elephant Tomb at Anyang,
and on a similar piece recently found in the chariot
burial at Ch'i-shan in Shensi. The tail spirals in the
opposite direction from the claw; the nose curls up and the
lower jaw bends down, and there is a small curving and
projecting process at the articulation of the jaw. The HK'
has a leaf-shaped ear when it lacks the bottle-horn, and the
claw is more often elaborated. Both types like however to
appear as confronted pairs, and a place for pairs is found
also on the chariot bronzes, as on bridle frontals at the

9

Elephant Tomb, where one pair lacks the claw altogether. On
a shaft mount from the same tomb there is a version of HK'
characteristically abbreviated to fit the small field of a
shaft mount, while on a similar bronze two HK' II
uncharacteristically pose tail to tail (Pl. 5a).

For the thesis presented in this paper it is important
to determine rather precisely the contexts in which HK'
figure when they are employed on bronzes other than those
belonging to chariots and harness. It is not surprising
to find them decorating parade weapons, as symbols of the
martial spirit, notably on the magnificent inlaid shafted
ko in the Freer Gallery and the shaft-hole axe in the Swedish
Royal Collection (Pl. 7c). Their association with bronze
vessels generally is shown in the table:

VESSELS *	HK' I	HK' II	TIGER	TIGER/HK'	BODY-TT	ELEPHANT	LATE TRAITS ***
Round Ting	3				2		3
Rect. Ting	3	1		(2)	1		4(2)
Yü	4		1		2(1)		
Kuei	4	6		(3)		1	4
Kuang	3	1	2(4)	(1)		2(2)	
Yu	4	5			1	1	4
Fang Yi		2	(2)				
Misc **	4	2					1

 * 40 vessels with HK'
 (12) with tiger without HK'

 ** Ho, lei, chih, p'ou, p'an

 *** Nipples, rhomboids, masks on legs,
 heavy flanges.

In a survey of nearly all the published catalogues of vessels
in western and eastern collections, under fifty were found to
display the HK', and only some dozen more vessels with HK'
seem to have been excavated in China since 1949. In the
Anyang excavations HK'-decorated pieces were a bird-shaped
tsun and an otherwise plain *hsien,* both types falling late
in the Anyang sequence. The 'late traits' included in the
table are none of them characteristic of the Anyang style,
and as far as they can be associated with Shang-style
ornament at all appear on vessels which share prominent
features belonging typically to bronzes dated by inscription
to the early Chou reigns. At the earliest they may be
classed as final-Shang, probably dating towards the middle
of the 11th century B.C. Thus the HK' I around the mouth of
a round *ting* are matched with a *t'ao-t'ieh* joined
continuously to 'bodies' on either side, the type of
'bodied' mask which Karlgren recognized as a version of the
motif quite distinct from other more frequent treatments.
The flanges of the piece in the Wessén collection are
heavier than those of typical Honan Shang pieces, as are
those of a handle-less *kuei,* also with 'bodied' *t'ao-t'ieh,*
on which the HK' I are paired about a ram mask, (this detail
suggestive of the Shensi and Shansi uplands more than the
Chinese central plain) (Pl. 6a). The representation of HK'
on *kuei* of the late grotesque kind, on elaborately decorated
kuang, on *yu* and *fang yi,* speaks for itself: these vessels
are inventions which correspond to the last decades of Shang,
or, if they are any earlier, belong (especially in grotesque
versions) to the northwestern Chou territory whose artistic
traditions were distinct. The *only* t'ao-t'ieh with which
HK' associate is the bodied variety; their connexion with
nipples, leg masks and rhomboid pattern is no less constant
than with heavy and hooked flanges, and no less indicates
their late date in the Shang-early Western Chou sequence.
On one *yü* of unknown provenance included in the table the
HK' I are rendered in a shallow line. This piece is devoid
of other ornament, and in this respect resembles a *hsien*
with similar HK' I which was excavated at Anyang[23], a lone
representative of its class in bearing the humped *k'uei.*
The casting of both these pieces is uncharacteristic of the
Anyang foundries. While the *yü* has an older history at the
Shang capital, the *hsien* is decorated typically with heavy
bovine masks on the lobes of the body in a style which
borders the Western Chou period and may have northwestern
affinity.[24] The northwestern connexion of the grotesque
style (absent from Honan) is ensured by the finds made in
Pao-chi hsien in Shensi[25] (Pl. 6b).

 HK' II sometimes appear on the same vessel as HK' I,

but generally they are separate, and, as the table shows, they favour the elaborate vessels of the late Shang and early Western Chou kind, particularly richly ornamented *kuei* and *kuang,* elaborate *yu* of the type which stand at the beginning of a series leading into the 10th century B.C., and certain anomalous vessels which have the same final-Shang and initial-Chou position in the stylistic evolution. The last include a number of bird-shaped *tsun* and the celebrated man-eating (or man-protecting) monsters of the Guimet and Sumitomo collections.[26] Occasionally a HK' is modelled in the round, its lowered head allies it to the second variety, although it does not much resemble it. These *k'uei* are seen to advantage on *kuei* in the Brundage Collection which belongs clearly to the Western Chou period, in the late 11th and the 10th century B.C. and in the Nelson-Atkins Gallery.[27] These belong to the late 11th or the 10th century B.C. In *kuei* of 9th-8th centuries B.C. large slug-like HK' form the handles of the vessels.[28] (Pl. 4d).

THE TIGER (Pls. 5b-d, 7a-b)

In one form or another the tiger supplied a martial emblem and an apotropaeic invocation in much of Shang art. The interest of this motif lies on the one hand in its association with the humped *k'uei,* and on the other in the evidence it affords of a vein of naturalism coexisting with the schematizing motifs of the hieratic style. The naturalistic tiger coincides however with only a limited and characteristic group of these. It is seen occasionally on *yü* and *tsun,* and on elaborately decorated *fang-yi* and *kuang* they are an expected addition. On the Honolulu *yü* - a piece that would not be out of place at Anyang, though it is unlocated - two fully drawn tiger bodies extend either side of a mask, and the latter serves to identify as tiger heads a varied series of small masks which are used in other less explicit contexts.[29] (Pls. 5b, 8a). The design already has the features which were to be perennial in later versions both in China and the steppes: the paws are spiralled, and one can see how readily they might become mere crescents; the tail naturally forms another spiral, and spirals appear again on either side of the nose. A similar double-bodied animal on a notably exotic *tsun* from Funan in Anhui is modelled in sinuous relief, with a more real head.[30]

It is only on *kuang* that the HK' (of both types, but oftener it is HK' II) are brought together with the realistic tiger, and on a number of these vessels they accompany an elephant no less realistic. All three animals are placed

close together on the Brundage *kuang* (Pls. 7a,b), and on the Fujita *kuang* a very thin tiger accompanies a HK' I viewed from above, the *k'uei* head also being assimilated to the felid. The mask which forms the front of a *kuang* lid sometimes suggests a tiger head conventionalized in much the same manner as the heads of the double-bodied tigers mentioned above[31], and on the *kuang* of the Hakuzuru collection it is an elephant (Pl. 5c)[32] mask, the naturalistic tigers being consigned to the foot-rim of the vessel. On the Minneapolis *fang yi*[33] the elephants near the foot are real enough, but in drawing the tigers intended for the frieze at the mouth of the vessel the artist seems to have hesitated between the proboscidean and a felid. The idea of the real tiger is represented by the two *tsun* in the Freer Gallery, in which the whole vessel takes on the animal's shape.[34]

The tiger undergoes certain transformations, and its shape may approach that of the humped *k'uei*. This occurs when it is conflated with a snake. A *kuei* in the Singer collection has around the foot a double snake joining a single head which is none other than the formalised tiger mask (Pl. 6c). In the band below the rim of the vessel the animal is equally serpentine, but here front and back paws, elaborately clawed, are added in reference to the tiger, and the head is horned. Precisely the same motif appears in the upper zone of a *kuei* in the Ashmolean Museum, in this instance accompanied by normal confronted HK' II in the lower zone.[35] The tiger-headed snake is frequent on the heavily ornamented vessels produced in the last quarter of the 11th century B.C., on *fang yi* such as the famous piece in the Freer Gallery, on a number of rectangular *ting*, on *kuang* and some bird-shaped *tsun*. The survival of this idea into the late 9th century is demonstrated by a great *hu* in the Art Institute of Chicago, and here it is still accompanied by reminiscences of the HK'.[36]

A more elusive avatar of the tiger is that in which it tends to identify with the halves of a *t'ao-t'ieh* mask. On the Cull *fang-yi* (Pl. 5d) this device is explicit enough: the two tiger bodies are quasi-naturalistic. The single mask in which they join is still quite tiger-like according to the convention, while it lacks the lower jaw in the regular *t'ao-t'ieh* manner. But the tiger is adapted to a fundamentally different principle of design when the head is seen in side view and confronted either side of a flange on the vessel side, for then the two heads may resemble a single frontal *t'ao-t'ieh* to the point of identity (Pl. 6a). If any real reference is present in the *t'ao-t'ieh* of Shang tradition of central China, from the early phase at

13

Cheng-chou onwards, it can hardly be anything but the tiger. In the early versions of the design there seems to be no intention of suggesting that the halves of the mask should be seen elusively as the heads in side view of two animals represented by the lateral extentions of the mask. At some point in the evolution however it is plain that this ambiguity becomes intentional, both in the decoratively disintegrated schemes of the late Shang in Honan and in the consolidated 'bodied' *t'ao-t'ieh* which we have seen to coincide with the introduction of the humped *k'uei* (Pls. 6a, 7d). The quasi-naturalistic tiger was adopted into the hieratic ornament at about the same time, and it seems probable that this innovation was connected with the new graphic ambiguity of *t'ao-t'ieh*, although this cannot be proven until closer dating and, more particularly, a fuller account of the regional allegiance of northwestern styles is available. While the pervasive similarities of the hieratic motifs spring from the common roots of Chinese myth and iconography, small differences in the treatment of individual elements and in the rhythm of larger schemes still serve to distinguish local traditions.

The function of an animal motif, both independently and in the part it plays in multiple ornament, goes beyond the identity of a real or mythical creature. This is classically demonstrated by the destinies of the HK' and the tiger. The shape and ductus of the HK' I are precisely those of the long-tailed bird which becomes so prominent in the bronze iconography from the beginning of the Chou period, and whose cultivation in the late 11th and the 10th centuries B.C. can be located in the northwestern province of Shensi. The HK' II became the basis for a large version of confronted gaping heads which on some *kuei* take over the rôle of the bodied *t'ao-t'ieh* as the ornament of the main field. In the Honan Shang style, apart from the approximation of tiger heads and the mask which was discussed above, one may see the whole tiger executed in profile in the skeletal angular style of relief ribbons which is characteristic of the late Shang art of Honan.[37]

CONCLUSIONS

What has been said above arises more or less directly from an examination of the immediate context in which the war chariot first appears in East Asia. What may be gleaned on the rôle of China in the formation of an initial tradition of animal art of the Inner-Asian steppes? Some points to be considered are the following.

1. In armament the use of the bow-guard, *pi*, is

attested in China from the 11th century B.C,
while its appearance in Siberia seems to be
later, possibly by some centuries. If this
priority is not an accident of survival, it
underlines a parallel Chinese priority in the
development of bronze arrowheads towards a
type which became established in the steppes
from the late 7th century B.C. and further
illustrates the importance for Inner Asian
tradition of the cultural zone which included
South Siberia with the Chinese north and
northwest.

2. Certain animal-head bronze knives found in
 South Siberia closely resemble the like found
 in Shang chariot graves, but this does not
 prove that the two groups are of equal
 antiquity, since the knives continued to be
 made to the same pattern in the Chinese Northern
 Zone until the 8th century B.C., and possibly
 still later.

3. The main principles of design found in the
 steppe art are anticipated in China. The
 polymorphism of animal designs, the equivalence
 of different animal motifs adapted to the same
 contour and ductus, the ambiguity of design in
 which a part has a double function, the
 coexistence of schematic and naturalistic
 styles[38]: all features of the Animal Style
 are shown to be present in central and northwest
 China before 1000 B.C., and to be rooted in a
 tradition which goes back at least another
 three centuries. In the case of an art
 suddenly transferred to bronze on the advent
 of metallurgy it is vain to speculate closely
 on priorities of invention. China either
 bequeathed these principles of design to the
 inhabitants of the Siberian-Mongolian steppes,
 or participated in the initial stages of a
 common tradition which was spread rapidly
 through the whole East Asian steppe, adding
 such features which can be looked for in a
 centre of high technology and evolved city-
 state civilization.

4. Regarding particular motifs the Chinese
 connexion may be better defined. The tiger
 profile, prolonged in the steppe as a somewhat
 anonymous 'standing animal', and the *animal*

enroulé anticipated in China as a coiled *k'uei*, a serpent dragon, are also current in China at the beginning of the Western Chou period, in the late 11th century B.C. The coiled dragon is frequent on chariot bronzes of the 9th century B.C. at Hsin-ts'un in Honan, and the earliest dated versions of the head of a bird of prey designed in a spiral are seen on harness ornaments from the same site (Pl. 8b). Already in a version of the *k'uei* which substitutes a raptorial bill for the normal jaws (this making it remote from the HK') the steppe preoccupation with hawks, eagles and griffins is foreshadowed.

There remains the problem of the singular humped *k'uei* of the type we have designated HK' I. The hint it gives of a stalking wolf should perhaps be taken seriously. A gaping monster which looks like a descendant of this HK' is a regular theme in the 6th century phase of the Sarmatian art of the south Ural region (Pl. 8d). It is known also from the north Caucasus, where it is associated with the 'standing animal'.[39] (Pl. 8c). The rapid far travel and long survival of artistic motifs in the steppes, as of weapon forms, should not surprise us.

William Watson

NOTES

1. T'ang Lan, 'kung-hsing-ch'i (t'ung kung pi) yung-t'u
k'ao (弓形器（銅弓柲）用途考)',
K'ao-ku 1973, No. 3 pp. 178-184, 161.

2. E.C. Bunker et al. *"Animal Style" from East to West*,
Asia Society Inc., New York 1970, p. 100 item 56,
mentions examples of *pi* in which there are
'attachment holes under the arched terminals'.
See Footnote 8 below.

3. M. von Dewall, *Pferd und Wagen im Frühen China*,
Bonn 1964, gives a list of the contents of chariot
burials and of chariot parts and associated objects
from other tombs known to her.

4. T'ang Lan *loc. cit.* p. 184.

5. The point is made by T'ang Lan. For the texts of the
inscriptions see Kuo Mo-jo, *Liang Chou* pp. 130
and 135.

6. See the review in N.L. Chlenova, *Khronologia Pamyatnikov
Karaksukskou Epokhi*, Moscow 1972, to which I owe much;
also W.Watson, *Cultural Frontiers in Ancient East
Asia*, p.126, fig. 57.

7. Chlenova (*op. cit.* p. 122 and pl. 58) instances marks
on tambourines recently used among the Tubalar
inhabitants of the northern Altai, which resemble
the shape of the bow-guard.

8. *K'ao-ku* 1976 No. 1. p. 31 ff and No. 4 p. 246 ff.
Cf. Bunker *op. cit.* where a succession is proposed,
the *pi* with plain ends being taken as earliest and
those with jingles as latest. There is no
excavated evidence for chronological separation
of these different designs. The Ch'i-shan specimen
has jingles.

9. One reads in Hsün Tzu, Ch'en Tao chapter, 'The *pi*
(柲) is the means of assisting and correcting the
bow and the cross-bow'. This may mean that a form
of bow-guard was indeed employed in the 3rd century
B.C., but it is possible that the philosopher is
quoting from old literature. The character used
here for *pi* was then and still is current with the
meaning 'help'.

10. Kuo Pao-chün, *Chün-hsien Hsin-ts'un*, Peking, 1964.

11. *Feng-hsi fa-chüeh pao-kao*, Institute of Archaeology,
 Peking 1962.

12. *Shang-ts'un-ling Kuo-kuo mu-ti*, Institute of
 Archaeology, Peking 1959.

13. For the theory of the Northern Zone see M. Loehr,
 Chinese Bronze Weapons, Ann Arbor 1956; W. Watson,
 Cultural Frontiers in Ancient East Asia,
 Edinburgh 1971.

14. In dating from parallels with China, Chlenova
 follows S.V. Kiselev, who based his views on
 Tung Tso-pin's periodization of the oracle
 inscriptions and on his own observations made
 during a journey in China in the late 1950's,
 but adjusts the lower dating to end Shang at
 1027 B.C. in accordance with the chronology now
 generally received, and followed in the present
 paper.

15. The knives found at Hou-chia-chuang in the great
 tombs 1008, 1311, 1537, 1736 were not seen to be
 connected with chariots or archers, although
 equipment of this kind may have originally been
 included in the grave-goods. Horse-head knives
 found in miscellaneous burials at Hsiao-t'un are
 like those from the chariot tomb M 20 at this
 site and the horse-pit 1137 at Hsi-pei-kang.
 Chlenova's group No. 10 comprises knives with
 ring terminals having three low projections.
 This long-lived type also proves the China-
 South Siberia commerce. In the Ordos and
 Zabaikalye knives of this kind date between the
 10th and 8th centuries B.C., and Chlenova accepts
 them in South Siberia from the 10th century.

16. Cf. O. N. Bader, 'Bronzovy nozh iz Seymy c loshad'mi
 na navershii', *Kratkie Soobshcheniya Akademii
 Nauk SSSR* 127 (1971) p. 98 ff, where the Seima
 knive with two horses is discussed. The author
 observes that the bridle on the stallion (there
 is no bridle on the mare) may reflect the
 difficulty of controlling Przewalski's horse in
 domestication; but he gives some support also
 to the view of V.F. Rumyanstev and V.I. Gromova
 that the domesticated steppe horse in this early
 period was not Przewalski's horse but a cross

between this and some varieties of the Tarpan.
As far as is known the skeletal remains in the
Chinese horse burials would be compatible
with either theory.

17. See Chlenova, *op. cit.* pl. 24.

18. *Nei-meng-ku ch'u-t'u wen-wu hsien-chi,* Peking 1963,
 pl. 26 No. 39, and the discussion in Watson
 Cultural Frontiers p. 61 ff.

19. Bader, *loc. cit.* p. 103 in conclusion.

20. See *K'ao-ku hsüeh-pao* No. 7 (1954) p. 77 ff.

21. *K'ao-ku* 1962 No. 12.

22. Chlenova, *op. cit.* pl. 9. The deer-head knives are
 poorly documented, and one may question whether
 they were current in central China in the Shang
 period. Many are included however in collections
 in the company of Honan Shang bronzes, whose
 characteristic patina they share. One recently
 excavated at Yen-t'ou-ts'un, Sui-te-hsien, Shensi
 was buried with Shang-type weapons and ritual
 vessels datable to the 12th-11th century B.C.
 See *Wen-wu* 1975 No. 2, p. 83, ff pl. 3b.

23. Li Chi and Wan Chia-pao, *Yin-hsü ch'u-t'u 53 nien
 ch'ing-t'ung-ch'i chih yen-chiu,* pl. XLVI.

24. A plain *hsien* of unknown provenance in the British
 Museum proved on analysis to be made of virtually
 pure copper, a feature of metallurgy in the
 Northern Zone rather than central China.

25. Notably the altar set in the Metropolitan Museum, and
 the altar, also from Pao-chi-hsien in Shensi,
 published in *Wen-wu* 1975, No. 3 p. 47 ff. There
 is also a bronze altar decorated with HK' I in
 the Sumitomo collection, *Senoku seisho (teisancho)*
 No. 165 pl. XLI.

26. W. Watson, *Ancient Chinese Bronzes,* pl. 36a.

27. R -Y. L. d'Argencé, *Ancient Bronzes in the Avery
 Brundage Collection,* pl. XXIX; S. Mizuno, *In-shu
 seidoki to gyoku,* pl. 92.

28. In the Brundage collection, R-Y. L. d'Argence *op. cit.* pls. XXXVB, XXXVIC; formerly in the Mayer collection: see the sale catalogue of Messrs. Christie, London, for 24-25 June 1974, item 219.

29. M. Loehr, *Ritual Vessels of Bronze Age China*, No. 27, p. 70.

30. *Wen-wu* 1972 No. 11, p. 64 ff.

31. e.g. the *kuang* in the Fogg Museum of Art. See S. Mizuno, *op. cit.* pl. 54.

32. *Ibid.* pl. 55.

33. *Ibid.* pl. 60.

34. Freer Gallery of Art, *Descriptive and Illustrative Catalogue* 1946, p. 53, pl. 27.

35. W. Watson, *Ancient Chinese Bronzes*, pl. 43b.

36. *Ibid.* pl. 53.

37. Li Chi and Wan Chia-pao, *op. cit.* pl. XV.

38. For naturalism *cf.* hares on a 10th century bronze ritual *chih* from Loyang (*K'ao-ku* 1972 No. 2 pl. 2); on a shaft mount hares appear placed on either side of a *t'ao-t'ieh* mask.

39. K.F. Smirnov, *Savromaty*, pl. 81, Nos. 2,4,6.

a 弜 on 弱

b 和鈴

c 弓形飾

d 棐,柲

e 弣

f 帗

g 柲弓檠弛, 則縛于弓裡備損傷 (儀禮:既夕記)

h 簟笰

i 覂

j 番生簋, 毛公鼎

k 魚葡

l 岐山

PLATES

1a. Chariot burial at Ta-ssŭ-k'ung, Anyang.

1b. Dto detail.

2a. Bronze *pi* in the Swedish Royal Collection, Shang.

2b. Bronze *pi* excavated at Ho-chia-ts'un, Ch'i-shan, Shensi,
 Western Chou.

2c. Bronze *pi* from the chariot burial at Ta-ssŭ-k'ung.

2d. Bronze *pi* found in Siberia.

3a. Bronze knives with sculptured terminals: 15-19 from
 Hsiao-t'un, Anyang; 11 from Hou-chia-chuang, Anyang;
 13 from the Ordos.

3b. Bronze knife with elk-head terminal excavated at Yen-
 t'ou-ts'un, Sui-tê-hsien, Shensi, Late Shang.

3c. Bronze knives with sculptured terminals found in the
 region of the central Urals. Left to right, from
 Seima, Turbino, Rostovka.

4a. Bronze chariot fitting with humped *k'uei*. Excavated
 at Ho-chia-ts'un, Ch'i-shan, Shensi. Western Chou.

4b. Detail of a bronze *kuang* showing a variety of humped
 k'uei. Late Shang. Fujita Museum, Japan.

4c. Bronze chariot fitting with humped *k'uei*, found at
 Chang-te-fu, Honan. Late Shang.

4d. Detail of the handle of a bronze *kuei* showing a late
 variety of humped *k'uei*. 9th century B.C.

5a. Bronze chariot fitting showing pairs of humped *k'uei*
 and tigers. Late Shang or early Chou. Atkins-Nelson
 Gallery. Kansas City.

5b. Detail of a bronze *kuei* showing two tiger bodies joined
 to a single head. Shang. Honolulu Academy of Arts.

5c. Detail of the foot of a bronze *kuei*, with a pair of
 tigers. Shang. Kakuzuru Museum, Japan.

5d. Decoration of one face of a bronze *fang-yi*, showing a
 'solid' *t'ao-t'ieh* mask associated with tigers.
 Shang. Cull collection.

6a. Bronze *yü* showing a 'solid' *t'ao-t'ieh* mask combined
 with a humped *k'uei*. Wessén collection. Museum of
 Far Eastern Antiquities, Stockholm.

6b. Bronze *kuang* from Pao-chi-hsien, Shensi. 12th or 13th
 century B.C. Formerly in the possession of Messrs.
 Yamanaka.

6c. Bronze *kuei* displaying tigers assimilated to snakes.
 11th century B.C. Collection of Dr. Paul Singer.

6d. Detail of a bronze *ho*, with humped *k'uei*. 11th century
 B.C. Avery Brundage collection, San Francisco.

7a. Bronze *kuang*. 11th century B.C. Avery Brundage
 collection, San Francisco.

7b. Dto, detail showing association of tiger and humped *k'uei*.

7c. Bronze shafthole axe decorated with a humped *k'uei*.
 12th-11th century B.C. The Swedish Royal Collection.

7d. Bronze *ting* showing humped *k'uei* associated with a
 'solid' *t'ao-t'ieh* mask. Shang. Somerville
 collection.

8a. Bronze tiger mask. 9th or 8th century B.C. Formerly
 in the Frederick Mayer collection.

8b. Rubbings of bronze harness ornaments excavated at Hsin-
 ts'un in Shensi. 9th century B.C.

8c. Ornament carved in elk antler, showing at bottom right
 the 'standing animal' of ancient East Asian tradition.
 5th century B.C. Found in the Pyatimary I kurgan in
 the Ural mountains.

8d. Bone ornaments carved to resemble a gaping wolfine
 monster somewhat resembling one form of the
 ancient Chinese *k'uei*. 6th century B.C. Found in
 the Chornaya Gora kurgan at Abramovka, Yuzhnoye
 Priuralye.

Plate 1

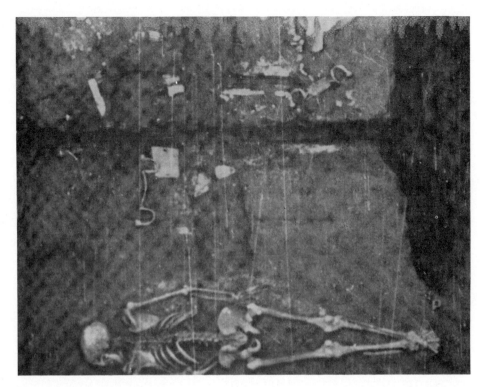

a

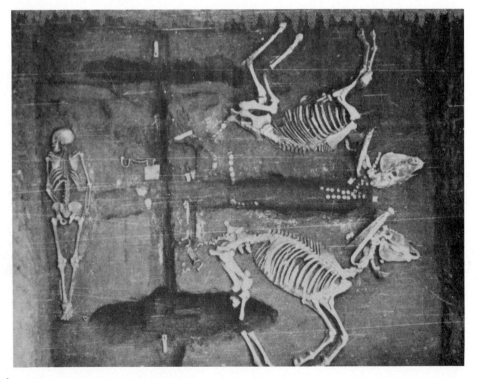

b

24

Plate 2

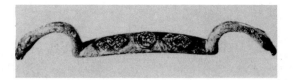

a

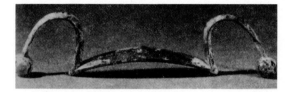

b

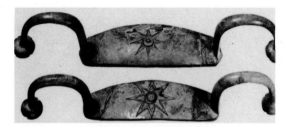

c

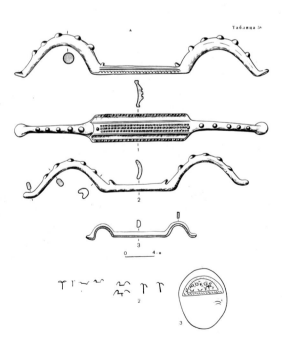

d

25

Plate 3

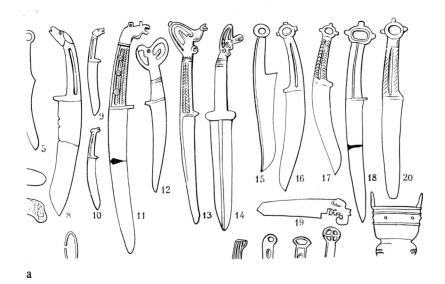

a

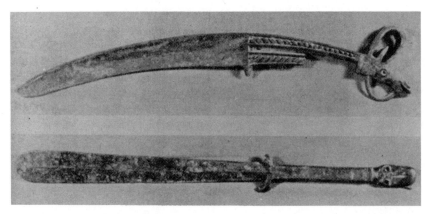

b

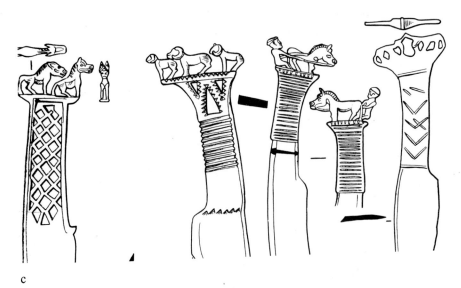

c

Plate 4

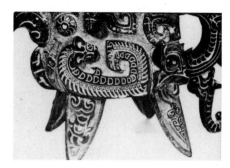

b

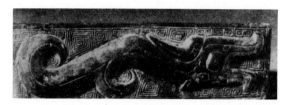

a

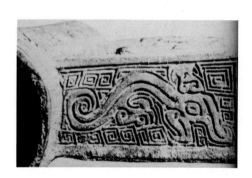

c

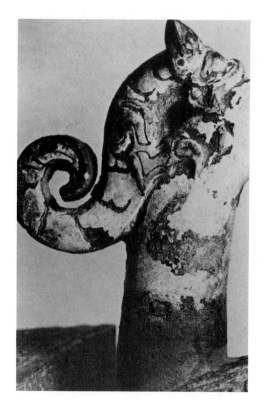

d

Plate 5

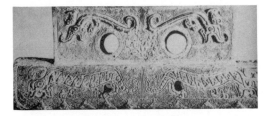

a

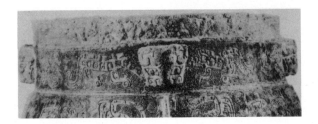

b

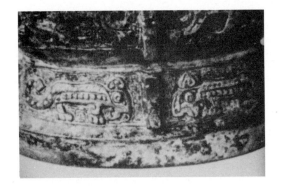

c

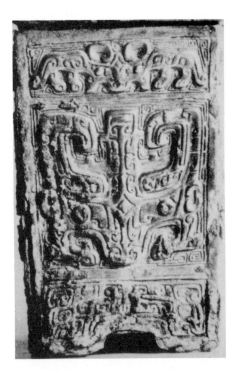

d

28

Plate 6

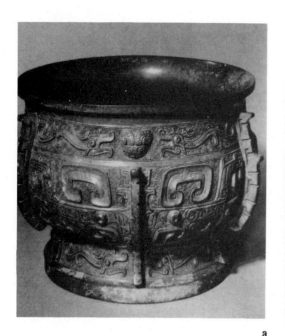

a

b

c

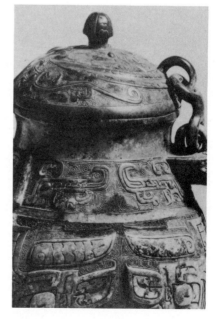

d

29

Plate 7

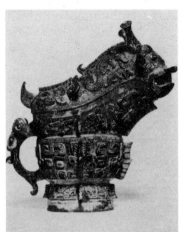

a

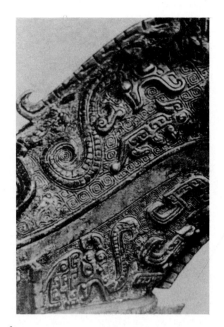

b

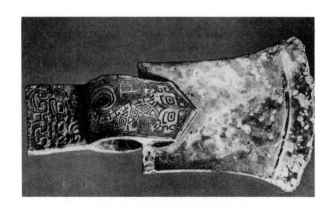

c

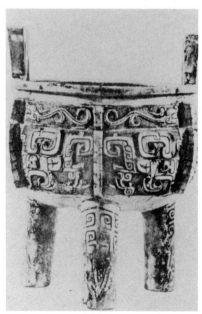

d

30

Plate 8

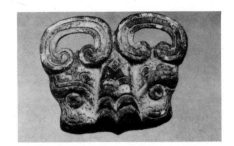

a

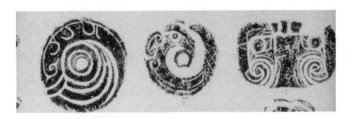

b

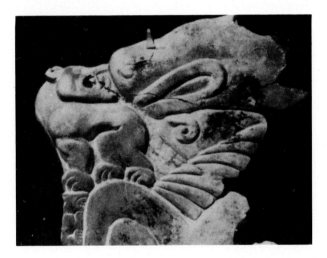

c

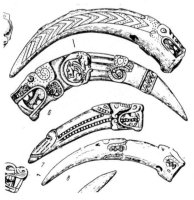

d

CHINESE CHARIOTRY: AN OUTSIDER'S VIEW

In order to excuse my presence at this Colloquy I would like to open with a quotation from Professor William Watson. A few years ago he wrote 'Of all the Shang themes which lead to a discussion of ancient Chinese relations with inner and western Asia the war chariot is the most intriguing in its suggestion of a specific contact which cannot be fully substantiated by archaeological evidence'.[1] For some time I have been concerned with questions bearing on the earliest use of wheeled vehicles in Europe and Asia, and of their relationship to the domestication of draught animals - initially cattle and later the horse - so perhaps I can usefully offer a view of the Chinese problem from the outside, and from a standpoint which might contribute to our understanding of this critical instance of a general theme in the debate between the place of indigenous development and of outside stimulus in understanding culture - change. It is obviously of cardinal importance in any discussion of the relations between ancient China and the Eurasiatic steppe, and of this area to the urban civilizations of Western Asia no less than to the prehistoric communities of eastern Europe.

To start with definitions, I shall use two terms, 'chariot' and 'chariotry'. The first is descriptive of a piece of rather complex technology, in the form of a light (and so potentially fast) vehicle, small and not normally carrying more than two persons, mounted on two spoked wheels and drawn by a pair of horses harnessed by a yoke to a draught-pole, and used for ceremony, display, hunting and warfare. It is a vehicle of prestige, an upper-class cart if you like: the Victorian concepts of 'carriage folk' and of 'setting up a gig' have their roots deep in antiquity. By an easy development, taking place independently in more than one area, four rather than two horses could be harnessed abreast, but the primary form which concerns us here is that with simple paired draught. Two technologies are involved, that of a knowledge of wheeled transport of a heavier and clumsier form, appropriate to ox-draught, with the refinement of structure made possible by efficient carpentry, itself dependent on an adequate metal tool-kit, and that of the domestication, breaking and training of small swift draught animals, horses. The chariot, as an outcome of these two technological achievements combined, could only have originated in circumstances of time and place where both were familiar and so could be combined as a single entity. There then follows, in historically documented circumstances,

the adoption of this fast powered vehicle and its specialised employment by several ancient societies, from Mycenaean Greece in the west to Shang China in the east, as a part of the hierarchy of social structure, particularly as manifested in the aristocratic demonstration by an élite of prestige and valour in hunting and above all warfare. This institutionalised aspect we may define as 'chariotry'.

As background, I would like now to look briefly at the general question of the use of wheeled transport by ancient societies. Simplistic schemes of evolutionary progress led in the past to the assumption that 'the wheel' was an inevitable invention in antiquity, and this view is still surprisingly prevalent, but in fact the evidence implies that wheeled transport of any kind will only be developed, or adopted from outside, by communities for whom it is socially and technologically necessary and possible. It depends for instance on suitable draught animals as well as the availability of materials such as adequate wood and competent tools to work it, and these will only be employed when transport problems present themselves that cannot be or have not been solved by alternative means such as human porterage, pack animals, water transport, or sledges, or when new needs of bulk, weight, speed or ultimately the satisfaction of prestige arise. Negative examples are not far to seek. In the New World a fascinating situation presents itself, for whereas certain Middle American communities between about 200 BC to AD 900 were making little wheeled animal toys, full size vehicles were nowhere employed, almost certainly because suitable draught animals were not to be found among the local camelids such as llamas and alpacas, and neither wild cattle nor horses existed in the Americas.[2] In Egypt, transport needs were satisfied by shipping on the Nile or by sledges for heavy weights before the introduction of the chariot (and the adoption of chariotry) in the seventeenth century BC.[3] And in China there is no evidence of the use of wheeled transport until, once again, the Shang chariots under discussion. Finally, wheeled transport can be given up in favour of a preferable alternative, as happened with the adoption of the pack camel in Western Asia in the early centuries of the Christian era.[4]

With this preliminary, on present showing the earliest wheeled vehicles were wagons (with four wheels) or carts (with two) in which the wheels were worked from solid planks, either as a simple disc or in various forms of tripartite construction whereby the necessity of obtaining planks of great breadth was obviated.[5] Mesopotamia provides the earliest dated evidence for a block wheeled wagon with a sledge-like body in the Uruk pictograms of the late fourth millennium BC; from Early Dynastic times (earlier third

millennium) two or four wheeled vehicles that may best be called battle cars, with tripartite wheels, are known from finds in burials, models and representations which show they were drawn by a pair of onagers. In the third millennium too block wheeled vehicles are known from Anatolia as models, and in the South Russian Pit Graves from the Volga to the Ukraine as actual finds from burials. In Hungary, disc wheeled wagon models are as early as the beginning of the third millennium BC, while single piece disc wheels from the Netherlands and Denmark are before 2000 BC. Complete surviving carts and wagons with tripartite disc wheels come from burials in Georgia and Armenia ranging from early to late in the second millennium BC. All these vehicles are certainly or presumptively ox-drawn, and demonstrate the wide diffusion of heavy wheeled transport from before 2000 BC in prehistoric Europe. The Caucasian vehicles show highly competent carpentry, with elaborate use of mortices and dowels and bent-wood framing for tilts.

The prerequisite for one of the two technological necessities for the invention of the chariot, a knowledge of wheeled transport and its potentialities, was then available equally in Mesopotamia and among the peoples of east Europe, Anatolia, the Caucasus and south Russia from the third millennium BC. We must now turn to the second essential component, the domesticated horse. Of the seven distinct species of wild equids surviving into recent times in Asia and Africa, *Equus Przewalskii*, Przewalsky's Horse, represents the ancestor of the domestic horse of antiquity and today, *Equus caballus*, with 64 chromosomes as against the 66 of the wild horse, a process of speciation almost certainly favoured by human intervention in the form of domestication.[6] The wild Przewalsky horse had, when discovered in the 1880's, a distribution in Mongolia, north of its nearest morphological neighbour, *Equus hemionus*, the Asiatic wild ass of which the onager just mentioned is a representative: the horse may just survive in the wild and over 200 exist in zoos. Another wild horse survived in the Ukraine until 1851, the Tarpan, now exterminated and known only from a skeleton and a second skull, so that we do not know its chromosome number, though it has recently been suggested that 'perhaps the tarpan could have been the missing wild equid with 64 chromosomes, and derived from the Przewalski'.[7] This comment was made by a geneticist unaware of the archaeological evidence which on present showing places the earliest area of the domestication of the horse precisely in the southern Ukraine.

Bones of horses, not necessarily domesticated but

from animals hunted for food, appear in several cultural
contexts of the neolithic or early copper-using communities
of the Ukraine and westwards to the Romanian border in Moldavia,
of around the fourth millennium BC in radiocarbon years. In
some cultures, notably that of Sredny Stog, domesticated
animals can be confidently identified, and the percentage of
horse bones over those of other species is remarkably high,
and averages 54 per cent from all excavated sites; domestic-
ation is in the main likely to be for meat and milk. But
at one site, Dereivka on the Dnieper, about 240 kilometres
SE of Kiev, not only does th proportion rise to 63 per cent,
but the broken pieces of six antler cheek-pieces from horse-
bits have been found, with a radiocarbon date of about
3565 bc. The date has been queried but it cannot be far off
the mark; further antler cheek-pieces have been found in two
other sites of the same culture. From then on, domesticated
horses appear in a variety of sites and cultures of the third
millennium from the Ukraine to the Volga and in the Caucasus
on the one hand, and less frequently in east and central
Europe by a little before 2000 BC.[8] In western Anatolia
the first evidence is from the sixth settlement of Troy at
the beginning of the second millennium BC. At all events,
the arc of country from the Carpathians to the Caspian, an
area mainly of steppe and steppe woodland, had both the
prerequisites of chariot making, the domesticated horse and
wheeled vehicles, from the third millennium BC. It should
be remembered in passing that strictly speaking all early
horses would in modern terms fall within the pony class and
be under 14 hands at the withers. The Przewalsky range is
quoted as from 124 to 145 cm (12 hands 1½" to 14 hands 1")
and the average of east European Early Bronze Age
domesticated horses at 135 cm (13 hands 2").

The question of the early use of the horse-drawn
chariot and the beginnings of institutional chariotry in
the ancient Near Eastern civilizations has been much discussed,
and is documented less by the archaeology of actual finds
than from iconography, lexical and onomastic evidence, and
literary texts.[9] The block-wheeled battle car drawn by
onagers attested from Early Dynastic times appears to have
played a less important part in parade and war by the end
of the third millennium, and it is from about 2000 BC that
references to the horse - 'the ass from foreign parts' -
begin to appear, as in the Sulgi hymn where its waving tail
is characterised in contrast to the tufted tail of *Equus
hemionus,* and in terms of the zoological postulate that
allied wild species will not compete for territory, but
colonise adjacent and complementary ecological zones, the
'ass from foreign parts' neatly describes an equid from
outside onager territory. In the Mari archives of c. 1900

BC, King Zimri-lim's enquiry of the King of Carchemish for white horses, which were not available, and bays offered instead, argues a conscious selection for colour as already established, but does not specify the purpose for which the horses were needed. A recently published text of the period of Hammurabi (first half of the eighteenth century BC) refers to horses bringing a consignment of silver vessels, either as draught or pack animals.[10] At about the time of the Mari archives, seal impressions from the Assyrian trading colony at Kültepe (Kanesh) in central Anatolia show representations of horses harnessed to spoked-wheel chariots, and the Hittite Anitta text, which appears to be a genuine document of c. 1700 BC surviving in a late copy, mentions a force of 1400 infantry and 40 chariots with their horses: not only chariots but chariotry is implied.

But the critical events for ancient Mesopotamian chariotry were those associated with the incursion of peoples from the north: perhaps the Kassites, proximally at least from the Zagros Mountains, who founded a dynasty from around 1700 BC, and above all the Hurrians, whose place of origin has been seen on linguistic grounds in the south Caucasus and the Armenian mountains, and who had been making their way south and west as an increasingly important component in the local population for some centuries, and by the early sixteenth century had established themselves as a power in the form of the kingdom of Mitanni, centred on the head-waters of the Khabur River and extending into Syria. As Margaret Drower has put it, 'only after they had become established in this area were they joined by a small vigorous tribe of horse-breeders from far to the north or east, who, perhaps by reason of their superior armament, especially in the novel use of the light war-chariot, were able by force of arms to impose their leadership on the Hurrian-speaking majority'. Hurrian is a language allied to Urartian, later spoken in the kingdom around Lake Van and Mount Ararat, but the newcomers spoke an Indo-European dialect closely related to Indo-Iranian, with personal names such as Biridashwa, 'the possessor of great horses', or Tushratta, 'he of the terrible chariots'; swearing by gods whose names are those of members of the Vedic pantheon, and by the late fourteenth century embodying technical terms closely akin to Sanskrit in the famous horse-training manual of Kikulli the Mitannian.[11]

The appearance of the spoked-wheel horse-drawn chariot in ancient Mesopotamia appears then not to be an indigenous modification of or development from the Sumerian block-wheeled battle car, but an introduction from outside, readily accepted as a technological increment by a society already familiar with wheeled transport and at a degree of social and military

organisation in which chariotry (with its prestige class of
young warriors, the *mariannu* whose name is again of Sanskrit
affiliation) could be a valid institution. 'Though naturally
an expression of the wheel idea' Gordon Childe remarked 'the
spoked wheel was a new invention rather than a modification
of the tripartite disc',[12] and while the vehicle and its
wheels were represented in Akkadian by their traditional
names or ideograms, the words for felloe and spoke are
foreign loan-words (sometimes taken to be Kassite). Borrowed
names for borrowed things: when the Egyptians in the sixteenth
century adopted chariot warfare from the Levant they took the
Akaddian name for a chariot, *narkabtum*, with minimal alter-
ation. The Hittite word is unknown owing to the use of
ideograms in cuneiform; in Mycenaean Greek *iqquia* is used,
presupposing a substantive (probably *woka*, from the Indo
European *vegh* root),[13] the horse being considered as the
distinctive feature, as with the recent English usage of
'motor' for 'motor-car'. We are led to look outside the
urban or palatial civilisations of the ancient Near East
and Aegean, and to those areas of prehistoric east Europe
where horse domestication and wheeled vehicles were well
established features by the early second millennium BC. The
difficulty of using the model of indigenous development in
China has led archaeologists to look for an origin for the
horse-drawn chariots of Shang times outside, to the west
and specifically to the West Asiatic civilizations of the
second millennium BC just discussed. 'The conclusion seems
inescapable' wrote Professor Watson 'that some historical
connexion must exist between the war chariots of the Near
East and those of Shang', and again he looked to 'the Near
East, whence the form of the Chinese chariot must ultimately
have been derived'.[14] I am going to suggest that, if we
accept that chariotry in the Near Eastern civilizations was
itself introduced or adopted from outside early in the
second millennium, we might profitably consider looking for
an origin in the same general area whence the twin
technologies of horse draught and spoked wheels reached
Mesopotamia and adjacent regions, for an explanation for an
analogous phenomenon in Shang China.

I sketched the archaeological evidence for tamed horses
and block-wheeled vehicles in South Russia from the fourth
millennium; the successive cultures known from tomb types
as Pit Grave (yamnaya) and Catacomb Grave phases take us into
the earlier second millennium, when west of the Volga we move
into the Timber Grave (srubnaya) culture, whose eastward and
closely related version is the Andronovo culture, stretching
east of the Volga to the Yenissei River.[15] The Timber Grave
culture has plausibly been seen as ancestral to that of the
Scythians; it comprises settled agriculturalists and probably

some pastoral elements; a bronze industry based on copper from the Urals and tin from the Altai (Chernikh's Groups III and IV of his Eurasian Zone bronze complex);[16] domesticated horses with bone or antler cheek-pieces of distinctive forms to be discussed in a moment, and in one recent excavation in the central Urals a cemetery of chariot burials which must date from around or before 1500 BC. In the Timber Grave-Andronovo complex we certainly seem to be in a world suggestively similar to that for which we have been seeking, and to it we may add the Caucasus, with tumulus burials with wooden chambers of the type which give their name to the Timber Graves themselves, containing not only block-wheeled wagons and carts but at Lchashen on the shores of Lake Sevan, spoked-wheeled chariots and domesticated horses as well.

The bone cheek-pieces take us a stage further. In the general south Russian area west of the Urals there are two main types, one rectangular plaques with internal serrations, and the other discs with four internal spikes.[17] The plaques have, at Komorovka at least, been actually found with horse burials, and two burials each of two horses implying paired draught are recorded, all of Timber Grave date. The discs go back rather earlier, and also have representatives in mid second millennium Bronze Age contexts in Romania and Hungary. The connexion of these with the bronze bits of the ancient Near East with spiked plaque, disc or wheel shaped cheek-pieces seems inevitable, and they can hardly be regarded as poor men's copies among the remote barbarians: rather, as Roger Moorey has put it, 'it is no coincidence that the earliest bits so far known from Western Asia appear with the full development of chariotry as a military weapon in the fifteenth to fourteenth centuries BC. In a light war chariot, where speed, control and manoeuvrability were so important, the metal bit was indispensable'.[18] In the Mycenaean world it is even possible that bone was originally used, if the debated objects from Shaft Grave IV are in fact counterparts of the south Russian spiked discs, and that the frescoes show such cheek-pieces.[19] At all events the specialised forms of cheek-pieces do seem to link the area of early horse-breeding to the ancient Near East, and to the west of the former region, in Transylvania, the Hungarian Plain and Slovakia, we have also in the middle of the second millennium evidence of domesticated horses with cheek-pieces of curved antler tines having counterparts in Anatolia and later widely represented by metal derivatives, as in the later Assyrian world.[20]

It is worth while noting parenthetically that in this east European context we also have contemporary clay models of spoked wheels and on a Slovakian pot of the Piliny culture,

firmly antecedent to the thirteenth century BC (Pl. 1a),
representations of actual horse-drawn chariots; by a century
or so similar evidence extends to South Sweden.[21] Until recent
years this and cognate evidence was interpreted as a product of
Mycenaean influences and contacts, but this thesis can hardly
now be maintained, and we must regard the spoked-wheel chariot
as a development owing nothing to the Aegean but as a product
of the indigenous Middle Bronze Age III cultures of Hungary
and its congeners in prehistoric east Europe. Turning now to
the Caucasus, geographically intermediate between the Volga
steppes and the mountain frontiers of ancient Mesopotamia,
and within the area where the origin of the Hurrians has been
sought, the Bronze Age tombs at Lchashen on Lake Sevan, of
about the fourteenth to twelfth centuries BC, have produced
domestic horses, wheel-disc bronze bits, models of chariots
with eight-spoked wheels, and actual remains of others with
28 spokes and two-piece bent felloes (very much in the Chinese
manner). A radiocarbon date of 1250 \pm 100 bc (GIN-2) has
been obtained from a Lchasen tomb, which would be calibrated
to c. 1500 BC in calendar years. The only comparable (Shang)
radiocarbon date from China is that from Anyang (not directly
associated with a chariot burial) of 1000 \pm 100 bc (Zk-5), or
around 1250 BC on calibration. Derivation from the regions
southwards of the mountains is not excluded, but the circum-
stances may not now be thought to render this necessary.[22]
On the east side of the south-central Urals, and now within
the ambit of the Timber Grave - Andronovo cultures, the
recent excavation of a barrow cemetery on the Sintashta
River not far from Chelyabinsk revealed five burials in
which light vehicles each with two ten-spoked wheels had been
placed in the grave pits, with attendant horse burials and
cheek-pieces (of types unspecified in the interim report).
Pottery dates the burials to an early Timber Grave phase,
around or before 1500 BC. And most significantly, in a
burial of the Timber Grave culture near Saratov, a pot
bearing a representation of a horse-drawn, spoked-wheel,
chariot has been found.[23] Here a case for outside derivation
seems very difficult to maintain against one for regarding
the horse-drawn two-wheeled spoked vehicle to have been an
indigenous outcome of the Bronze Age communities of the
region. And although difficult to date precisely, a second
millenium BC date seems the most likely for a widely
scattered series of rock-carvings representing chariots drawn
by horses, which take the distribution beyond the Oxus on the
Karatau Range in South Kazakhstan; on the north slopes of the
Alichursko Range of the Pamirs and in Outer Mongolia on the
west slopes of the Mongolian Altai: Chinese origins might have
to be sought if outside derivation were thought inevitably
necessary.[24] There remains one important context for ancient
chariotry where archaeological evidence is totally lacking,

and we are wholly dependent on language and literature, that
of the Aryans, the first speakers of Sanskrit in northwest
India, as expressed in the text of the Rigveda. The
implications I drew from this evidence nearly 30 years
ago seem not to have been disputed, and no more complete
study than my essay has yet been made, so I can offer nothing
new.[25] But in outline the case is as follows. Of the ancient
Sanskrit religious texts which survived in oral transmission
until written down in comparatively modern times, the poems
comprising the Rigveda stand at the head of all the others,
which in fact themselves presuppose its existence. Of the
subsequent works, the Upanishads lie behind early Buddhist
Philosophy and so should date not later than Gautama Buddha's
death around 500 BC. By what I called 'a sort of philosoph-
ical dead-reckoning', and by working backwards past the
Brahmanas to the later Vedas, the ancestral Rigveda has been
dated to late in the second millennium BC and perhaps no
earlier than about 1200 BC or so. Its language of course
belongs to the Indo-Iranian branch of the general Indo-
European group, and its presence in northwest India is
therefore intrusive; philologists have stressed that its
affiliations presuppose an ultimate area of origin where
contact with the Balto-Slav Indo-European branch no less
than with the Finno-Ugrian language group could have existed,
and have looked on these grounds to such regions as the
Lower Volga.[26] As we saw earlier, onomastic and lexical
evidence for the use of an Indo-Iranian language closely
allied to Sanskrit among the Mitanni goes back to at least
the middle second millennium BC, presumably deriving from
the same common area of dispersal.

The Rigveda recalls an heroic past in the manner of
epic poetry such as the Iliad. It depicts a non-urban
society economically based on agriculture and pastoralism,
using bronze or copper but not iron, with domesticated
animals including the horse, and hierarchically structured
with a warrior-aristocracy who fight with a bow from a
chariot drawn by a pair of horses yoked to a draught-pole.
The wheels are spoked, with hub, felloe and a metal tyre,
held on the axle with a lynch-pin; a metaphor implies a
bent-felloe construction. The chariot held warrior and
charioteer, and as well as for use in war, it was used
for sport in racing. Like the horse itself, it was a
prestige symbol for men and gods. The implications are
surely inescapable. In the second half of the second
millennium BC a group of people with linguistic origins
within the Indo-European group, and from an area likely to
have been south Russia, whose concern with horses and
chariots is comparable with that of the Mitanni of the
ancient Near East, appear in northwestern India to establish

an ascendancy and a new social order in which chariotry plays an essential part. If we accept the case I have made for the introduction of the horse-drawn chariot into the ancient urban civilizations of Western Asia early in the second millennium from an area inferentially comprising that demanded by the linquistic evidence for Sanskrit, there is no reason to see Vedic chariotry as derived from Mitannian or other contexts in Mesopotamia, but more plausibly they would share with India a common source, a continuum within which would also come the Sintashta River chariots in the Urals (Pl. 1b), or those of Lake Sevan in Armenia, or indeed those of fourteenth century BC Slovakia.

Two technological details deserve comment at this point. The first, to which Mrs. Littauer first drew attention, is the use of the yoke-saddle as an intermediary between the yoke and the horse's neck, known not only in Shang China, but in the fifth century BC carriage from Pazyryk in the Altai, in the Kazakhstan rock carvings, in second millennium Egypt and the Levant, in Mycenaean Greece and first millennium Assyria, and even possibly in Early Iron Age Ireland of the last century or so BC.[27] If the suggestion for an origin for ancient Near Eastern chariotry from outside and to the north is thought possible, presumably the yoke-saddle would also have had its genesis there. A second, more generalised point of technology is that of the use of bent wood for light, strong, construction, and especially for felloes. The two-piece bent felloe is known from China, Pazyryk and Lchashen, and the Sintashta River vehicles have wheels of such light scantling that bent felloes are inevitable; at the other end of the world of ancient chariotry, that of Celtic Europe, single-piece bent felloes are well documented in the last few centuries BC. In Egypt, wood was bent for felloes and even for complex hub and spoke elements, and commenting on this Western has recently written that such techniques 'were devised by people knowledgeable about the working properties of timber, and with a good choice of local material. It has often been suggested' he goes on ' that the most likely region was within the arc of foothills and mountains running through Anatolia, Syria, and northern and north-eastern Iraq'.[28] This is not the place to go into the question of imported woods or complete chariots into Egypt, and the problem is bedevilled by botanical confusion. The woods of the famous Rosellini chariot in Florence were identified in 1836, 1912, 1931 and 1951: none of the lists agree *in toto* and all suffer, my colleagues in the Flora of Turkey Unit in Edinburgh tell me, from considerable naiveté in taxonomic botany. But whatever the status of the *Ulmus* and *Fraxinus* identifications, the presence of Birch *(Betula)* bark or bast seems certain, and

41

points to relatively northern latitudes. The use of a bent wood felloe of some kind is indicated in the Rigveda as we saw, in a metaphor 'I bend with song, as a wright bends his felloe of solid wood', and again in the Iliad - the poplar tree that 'a maker of chariots fells with the shining iron, to bend it into a wheel for a fine-wrought chariot'.[29] Childe's comment on the spoked wheel as an invention not necessarily derived from a block wheel may be apposite here, and it may be that the bent felloe was an original feature: its use survived in Central Asia (Bokhara for instance) until half a century ago, and it still flourishes in Anatolia, where it may have been introduced by the Turks rather than surviving as a legacy of the Galatians. Bending wood needs damp heat - boiling or steaming in modern contexts - and so must have presented a peculiar technological problem of its own, but in passing we might remember that a dung-heap of horse manure generates considerable moist heat, and was used in recent times for bending the crooks of ash walking-sticks.

My outsider's view towards which all this has been leading, would then be as follows. In the urban and literate civilizations of the ancient Near East, the adoption and development of the chariot in the earlier second millennium BC, though it had a background of onager-drawn block wheel battle cars, was not an internal evolution from this, based on improved carpentry techniques and the substitution of a new draught equid *Equus caballus,* for the previous *Equus hemionus*. It was rather the result of a ready social acceptance of the light, spoked-wheel, horse-drawn vehicle from alien, non-urban, non-literate communities to the north; prehistoric peoples within the natural territory of the wild horse, who included some within the Indo-European language family, whose vocabulary contributed to the jargon of chariotry just as early motoring in this country adopted from France chauffeur and chassis, tonneau and coupé. Transmission to Egypt from the seventeenth century, with the Akkadian loan-word, is clear; Mycenaean Greece could have taken its horse-car from Anatolia, Syria, Egypt, or indeed the east European mainlaid.

If then we regard the ancient civilizations of Western Asia as recipients and not originators of the light horse-drawn vehicle of prestige, accepting it as a technological increment because they had reached a stage of social and military development when it could be usefully adopted, we should look attentively at the area from which they are likely to have acquired this innovation, which must have included the archaeologically defined area of the Timber Grave - Andronovo continuum. It is surely very difficult

to regard all evidence for the use of chariot-like vehicles outside the Near Eastern civilizations in the second millennium BC - Slovakia, the Caucasus, the Urals - as indications of derivation from these civilizations, and with Vedic India we have a clear case of derivation linguistically established from sources in common with those which gave rise to the Mitannian and Kassite Indo-European element in Western Asia. And so, turning to our critical case, why not thus regard the chariotry of Shang China?

If the Shang adopted the chariot and developed chariotry from the complex literate and urban civilizations of Western Asia, some 7000 kilometres away, it seems incredible that no other evidence of contact can be detected at either end. As a cultural borrowing which involved the breeding, breaking, training and maintenance of such temperamental animals as chariot-horses it almost inevitably must have demanded imported technicians in the form of trainers, grooms and stable-boys together with the actual stock in its initial stages: the Kikulli manual shows the degree of sophistication in management reached by the fourteenth century. To adopt the horse-drawn chariot especially if one were to have no prior knowledge of horse management and indeed of wheeled transport, would have been impossible in terms of the transmission of an abstract idea: it would have demanded what in modern jargon would be called technical back-up facilities of a kind impossible to imagine as between Shang China and, say, contemporary Assyria in the reigns of Shalmaneser I and Tiglath-pileser I, around 1270 to 1070 BC. But if, as a civilization developing on the eastern marches of a barbarian region already traditionally accustomed to trained horses and light spoked-wheel vehicles, in for instance the broad context of the Andronovo culture, China could have profited from this circumstances as I have suggested did its western counterparts. The Caucasian evidence indeed suggests, and I have pointed out elsewhere, that constructional features here (notably the many-spoked wheel) were shared with China rather than with contemporary Near Eastern chariot design. The Chinese phenomenon would represent the internal emergence of a form of society which could usefully adopt a barbarian technology (with presumably in its initial stages some of its actual practitioners) and exploit it to its own advantage without acquiring other cultural modifications. It would belong to the general picture of Chinese contacts with the northwest and the Urals explicit in the Seima-Turbino and Karasuk phases of Russian Bronze Age metallurgy around the fourteenth to eleventh centuries BC which have long been recognised. Other ancient civilizations have borrowed from barbarian neighbours: the Roman Empire in the west would offer a partial parallel in

the adoption of the rotary corn-mill from Celtic or Celt-Iberian sources in the second century BC[30] and even, in a minor but amusing way, the fashion for men-about-town in early Imperial times to sport a Gaulish or British chariot and pair. And for a reversed situation in land transport, we have already noted the virtual disappearance of wheeled transport in the urban civilizations of Western Asia from the early centuries AD, as a result of the wholesale adoption of the pack camel from adjacent nomad societies.[31]

Stuart Piggott

NOTES

1.	W. Watson, *Cultural Frontiers in Ancient East Asia*,
	Edinburgh 1971, 63.

2.	Cf. S.de Borhegyi, 'Wheels and Man', *Archaeology*
	XXIII, 1970, 18-25 with refs.

3.	Cf. W. S. Smith, *Interconnections in the Ancient
	Near East*, Yale 1965, 22 ff.

4.	R.W. Bulliet, *The Camel and the Wheel*, Harvard 1975.

5.	S.Piggott, 'The Earliest Wheeled Vehicles and the
	Caucasian Evidence', *Proc.Prehist.Soc.* XXXIV, 1968,
	266-318.

6.	E.Mohr, *The Asiatic Wild Horse*, London 1971; S.Bökönyi,
	The Przewalsky Horse, London 1974; R.V. Short, 'The
	Evolution of the Horse', *Journ. Reprod. Fert.*
	Supplement XXIII, 1975, 1-6.

7.	Short, *loc.cit*, 5.

8.	E.E. Kuzmina, *Earliest Evidence of Horse Domestication*...
	(VIII Cong.Internat.Sci.Prehist.Protohist.: Rapports
	et comm. de l'URSS), Moscow 1971; D.J.Telegin, *Über
	einen der altesten Pferdezuchtherde in Europa (ibid.)*;
	S.Bökönyi, *Hist.Domest. Mammals in C. and E. Europe*,
	Budapest 1974, 230 ff.

9.	W.Nagel, *Der mesopotamische Streitwagen* ..., Berlin 1966;
	A.Salonen, *Die Landfahrzeuge des alten Mesopotamien*,
	Helsinki 1951; *Hippologica Accadica*, Helsinki 1955.

10.	S. Dalley, C.B.F. Walker and J.D. Hawkins, *Old
	Babylonian Tablets from Tell al Rimah*, London 1976,
	no. 85.

11.	M.S. Drower, 'Syria c. 1550-1400 BC', *Camb.Anc.Hist.*
	(rev.ed.) Chap.X, Pt.1, Cambridge 1970, 3 ff.;
	A. Kammenhuber, *Hippologia Hethitica*, Wiesbaden
	1961; M. Mayrhofer, *Die Indo-Arier im alten
	Vorderasien*, Wiesbaden 1966.

12.	V.G. Childe, 'Rotary Motion', in C.Singer *et al.* (edd.),
	A History of Technology I, London 1954, 214.

13. M.Lejeune, 'La Civilisation Mycénienne et la Guerre', in J.P. Vernant (ed.) *Problèmes de la Guerre en Grèce ancienne*, Paris 1968, 31-51.

14. W.Watson, *op.cit.* 65; *BM Handbook Coll.Early Chinese Antiqs.*, London 1963, 35.

15. S.Piggott, *loc.cit.*; M.Gimbutas, *Bronze Age Cultures in Central and Eastern Europe*, The Hague 1965; T. Sulimirski, *Prehistoric Russia*, London 1970, Chap.4.

16. E.N.Chernikh, 'Metallurgische Bereiche der jüngeren und späten Bronzezeit in der UdSSR' *Jahresb.Inst. Vorgesch.Univers.Frankfurt AM* 1976, 130-49.

17. K.F. Smirnov, 'Arkheologicheskie dannye o drevnikh vsadinkakh Povolzhsko-Uralskikh stepey', *Sov.Arkh.* 1961,i,46-72; M.Gimbutas, *op.cit.* 540, fig. 363; A.M.Leskov, 'Dreveneyshie rogovye psalii iz Trakhtemirova', *Sov.Arkh.* 1964, i, 299-303; V.A. Latynin, 'Arkhaicheskie kruglye psalii s shipami', *Materialy* 130, 1965, 201-204.

18. P.R.S. Moorey, *Cat.Anc.Persian Bronzes in the Ashmolean Mus.*, Oxford 1971, 104; cf. J.A.H.Potraz, *Die Pferdetrensen des alten Orient*, Rome 1966.

19. M.A.Littauer and J.Crouwel, 'Evidence for horse-bits from Shaft Grave IV at Mycenae?', *Prähist. Zeitschr.* XLVIII, 2, 1973, 207-13; Tiryns frescoes conveniently in J.Wiesner, *Fahren und Reiten* (Arch.Homerica I.F.), Göttingen 1968, 59, Abb.15.

20. A. Moszolics, 'Mors en bois de cerf sur la territoire du bassin des Carpathes', *Acta Arch.Scient.Hung.* III, 1953, 69-111; 'Die Herkunftfrage der ältesten Hirschgeweihtrensen', ibid., XII, 1960, 125-135.

21. J.Vizdal, 'Erste bildliche Darstellung eines zweirädigen Wagens ...' *Slov.Arch.* XX, i, 1972, 223-131; Kivik in Scania is well known, cf. L.G.Grinsell, 'The Kivik Cairn, Scania', *Antiq.* XVI. 1942, 160, Pl. III.

22. S.Piggott, 'Chariots in the Caucasus and China', *Antiq.* XLVIII, 1974, 16-24; C.Chard and R.Powers, 'Soviet radiocarbon dates III', *Arctic Anthrop.* V, no.1, 1968, 224-233. The date is said to be from 'remains of a ritual chariot', but in default of a reference

to the original publication of the Geological
Institute's GIN-2 date it is uncertain whether a
chariot *sensu stricto* is meant, or one of the
several elaborate block-wheeled carriages from the
same cemetery (Russian *kolesnytsa* e.g. might
denote either). A further confusion has arisen
in E.C.Bunker *et al*, *'Animal Style' Art from East
to West*, Asia Soc. New York, 1970, 55, entry 24,
where the date 3150 \pm 100 BC is quoted (and
rejected). This is the Lchasen date as given by
Chard and Powers, but their list is of dates BP
(Before Present, by convention AD. 1950).
Subtraction yields a date of 1200 \pm 100 bc
(radiocarbon years), from which a date of
c. 1500 BC (normal calendar years) is obtained
by dendrochronological calibration. For the
further complications involved in correlating
Chinese radiocarbon dates with the Western
system, N.Barnard, *The First Radiocarbon Dates
from China,* Canberra 1972; R.Pearson 'Radiocarbon
dates from China', *Antiq.* XLVII, 1973, 141-43.

23. S.Piggott, 'Bronze Age chariot burials in the Urals',
 Antiq. XLIX, 1975, 289-90.; L.L. Galkin, 'Sosud
 kultury c yuzhetnym risunkom iz Saratovskogo
 zavolzh'ya', *Sov.Arkh.* 1977.3., 189-196.

24. Referred to here by kind permission of Mrs. M.A.
 Littauer in advance of her paper in *Proc.Prehist.
 Soc*, forthcoming; E.E.Kuzmina, *V Stane Kavata i
 Afrasiaba,* Moscow 1977, 12, Fig. 1 (Karatau).

25. S. Piggott, *Prehistoric India,* Harmondsworth 1950,
 Cha.VII; cf. S.D.Singh, *Ancient Indian Warfare ...,*
 Leiden 1965.

26. T.Burrow, *The Sanskrit Language,* London 1955.

27. M.A.Littauer, 'The function of the yoke saddle in
 ancient harnessing', *Antiq.* XLII, 1968, 27-31;
 C.Johns, 'Spur-shaped bronzes of the Irish Early
 Iron Age', *Prehist. & Rom. Std. (BM Quarterly
 XXXV)*, London,1971, 57 61; R. Haworth, 'The Horse
 Harness of the Irish Early Iron Age', *Ulster
 Journ.Arch* XXXIV, 1971, 24-49.

28. A.C. Western, 'A Wheel Hub from the tomb of
 Amenophis III', *Journ.Egypt.Arch.* LIX, 1973,91-94.

29. Rigveda VII, 32; Iliad IV, 482-86.

30. L.A. Moritz, *Grain-mills and Flour in Classical Antiquity*, Oxford 1958.

31. R.W. Bulliet, *op.cit.*

PLATES

1a. Representation of horse-drawn chariot on pot of Piliny
 culture, Horné Trakovce, E.Slovakia. Mid second
 millennium B.C.

1b. Remains of Chariot Burial, Sintashta River cemetery.
 Barrow 30, Middle Urals. Mid second millennium B.C.

Map

Chariots and chariotry, second half of second millennium B.C.

1. Bounds of 'classic' chariotry in West Asia.

2. Bounds of Timber Grave and Andronovo Cultures.

3. Evidence for chariots outside West Asian area.

4. Evidence for spoked wheels outside West Asian area.

5. Spiked disc cheekpieces in bone.

6. Spiked disc cheekpieces in bronze.

7. Serrated plaque cheekpieces in bone.

8. Serrated plaque cheekpieces in bronze.

9. Land mass over 1000 metres.

49

Plate 1

a

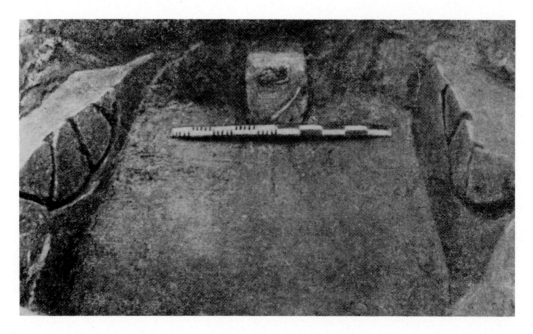

b

Plate 2

THE TRANSFORMATION AND ABSTRACTION OF ANIMAL MOTIFS

ON BRONZES FROM INNER MONGOLIA AND NORTHERN CHINA

I intend to discuss a limited type of material within the broad terms of the title of this paper. The subject of this discussion will be three groups of small bronzes in the shape of animals which have hitherto received little attention. This may in part be the result of their small size. Almost all the items to be described are small harness ornaments used especially on the bridle or as cheek pieces.[1] They have been found both in the areas bordering China to the north-west, frequently known as the Ordos region, and also occasionally in north-eastern areas.

The three motifs to be considered in turn are: the head of a bird of prey (Pl. 2a); a tiger shown with several ibex heads (Pl. 3); and a coiled tiger (Pl. 4b). These are all motifs which are common to the animal art of Central Asia and South Russia, and indeed they have all been found, in one form or another, on objects from sites in the Black Sea area.[2] This may be because the peoples of all these areas took these motifs from a common source. But the ultimate origin of many motifs is in fact likely to remain a matter for debate. For the purposes of this paper, which will concentrate on the different adaptations of the motifs after the sixth century BC, such questions are relatively unimportant. More significant is the relationship of the bronzes to the material which has been excavated at sites in Siberia, especially those in the Altai mountains.[3] In the last section of the paper a fourth group of bronzes will be considered to illustrate both the contrasts and the comparisons with the types of pattern-making to be observed in the first three groups.

The bird of prey is taken first because it provides the greatest variety of changes in the rendering of the motif. It is also a theme which had wide distribution in Western Asia and the steppe lands as well as in the Far East. On the borders of China it is found as early as the Western Chou period used in three dimensions to decorate short daggers or knives.[4] One particular example found in tomb 3 at Ch'ang-ping-hsien in Hopei province, on a knive with a notched blade, has a modelled head, protruding eyes, and an open curved beak easily recognised as the predecessor of a fitting in the British Museum (Pl. 2a).[5]

Before turning to the small fittings in the shape of a
bird's head, two later knives, one from the borders of China
and the other from Siberia, illustrate two different
contributions to the elaboration of this theme (Pl. 1). The
knife on the right is a type commonly ascribed to the Tagar
culture of Siberia. It shows two birds' heads on the hilt,
each with a pronounced beak, a rounded eye, and a neat but
prominent ear. The comparable Chinese version next to it has
been cast with a much more schematic version of birds on its
hilt. These birds, in which the element of pattern rather
than representation is insistent, appear to be in direct
descent from the knife from Ch'ang-ping-hsien. The absence
of the ear and lack of emphasis on modelling distinguishes
this second knife from the Tagar example. Here then despite
the typological similarity of the knives there appear to be
two traditions of representation of the bird.

A close parallel to the Chinese rather than the Tagar
knife can, somewhat surprisingly, be found further west in
Kazakhstan on a bird's head excavated at Ouigarat from a
kurgan of the seventh - sixth century BC.[6] This small piece
shows the same emphasis on line rather than modelling, and
is without an ear, as are the birds on the Chinese knife.
The parallel suggests some contact between Central Asia and
the borders of China at this sort of period, a contact which
will be cited again in connection with the motif of the
coiled tiger.

However, more immediately important for the elaboration
of the bird's head as an independent motif in the area of
Inner Mongolia is the type of bird found on the Tagar knife.
The ear seen on this piece is found on all the later Chinese
examples. This elaboration of the ear may ultimately have
been derived from the Western Asian griffin, but in the Far
East, both in Siberia and China it had become assimilated to
the motif of the bird of prey. Some of the most characteristic
interpretations are seen in the wooden ornaments excavated at
Pazyryk. Particularly fine is a bird shown as it were as an
eagle displayed with wings outstretched.[7] In form it is
clearly associated with eagles characteristic of Western Asia.
But as with the Tagar knife it has the same idiosyncratic
rounded ear and belongs in the present context to our second
tradition.

The three-dimensional head of a bird (Pl. 2a), already
mentioned, illustrates the meeting of the two traditions
exemplified by the two knives. It combines linear quality
with three dimensional modelling, and includes a rounded
ear hitherto absent from the Mongolian or Chinese examples.
Such three-dimensional fittings are not easy to date owing

to the dearth of parallel excavated examples. Most finials
in the shape of animals from Inner Mongolia are thought to
belong to the earlier part of the Warring States.[8] One
example in the shape of a bird has been found in the Tsungar
Banner area of Inner Mongolia. It lacks, however, the ear
which is such an important distinguishing feature.[9]

The development of variants on this theme was prolific
(Pl. 2b). Among the many small flat harness fittings the
most straight-forward type is illustrated by the left-hand
example (Pl. 2b left). In this the different features are
retained:- a small hook for the ear, a round eye, and a
linear elaboration of the beak. This last feature is not
far removed in character from the linear patterning seen on
the hilt of the Chinese dagger already described (Pl. 1).
This first of three examples is already much more of a
pattern than the three-dimensional head. However, a more
extraordinary variant is seen on the right (Pl. 2b right).
Three ribbed ibex-horns have been inserted into the
composition with no reference to the original scheme. The
points all lead inwards and the round ends are left gaping.
The end of one of the horns has replaced the ear of the
bird, the eye remains but wrapped around by a comma element,
the beak pattern has been reduced, and an area unfilled
appears appended as a cheek. This second example is
ingenious and unexpected in the context of the use of the
bird motif in other areas of the Eurasian Steppe.

However, it is seen from three further examples that
this creation of abstracted patterns was an important element
in the interests of the peoples living on the borders of
China (Pls. 2b centre & 2c). The central ornament between
the two already described is directly related to them (Pl.2b
centre). Instead of one head it now appears doubled, one
each side of a central ring. They are symmetrically organised
as if rotating in a clockwise direction. Thus the beak of the
upper bird is to the right, and that of the lower one to the
left. A small hook for the ear is retained in both. Without
the other two examples as a guide this piece might have
appeared as a maze of lines forming a pattern of enclosures
unrelated to any animal or bird.

An interesting contrast is seen in a small openwork
ornament (Pl. 2c left) where the design depends on comprehending
the meaning of the holes rather than of the outlines. The two
inner holes are unimportant, but the two outer ones represent
the eyes. The beak appears as an openwork hook while the ear
hardly exists except for a small tendril at the back of each
head. At a site T'ao-lung-pa-la this and the adjacent example
have their parallels in Hs'iung-nu contexts of late Warring

States date, that is to say they presumably date from the fourth to third century BC. The second type shown here (Pl. 2c right) retains the central boss as in the first of the paired example cited (Pl. 2b centre). While the second paired bird head was an exercise in openwork the interest of this last one is in flat smooth surface. The eyes are still marked by holes but the head and beak are outlined by a groove. The ear flies off behind, and a lower cheek element is once again used to fill out the form. Other excavated examples from Yü-lung-tai confirm the date late in the Warring States already suggested by the finds from T'ao-lung-pa-la.[11] This progression in the development of patterns originating in a simple bird's head seems to belong to the period of the Warring States from about the fifth to third century BC. Such items are thus slightly later in date than comparable material from Pazyryk.[12]

The bird head was shown to derive both from Siberian and Chinese examples. For the next motif, a crouching tiger surrounded by four ibex heads the immediate origins are to be found primarily in material from the Altai region (Pl. 3). In the most complicated example illustrated here (Pl. 3c) the striated elements on the body of the tiger, and the trans-formation of horns of the ibexes into their necks is immediately remarkable. In other words the creation of a pattern was already well advanced. An earlier stage in the assembly of the component elements of this treatment, and of the theme itself, has to be sought elsewhere. A tiger cut-out in leather from barrow I at Tuekta in the Altai, of the sixth century BC, has bold S-shaped spirals making up the body, the prototype for the C-shaped whirls of the bronze. To the same tiger from Tuekta has been added long trailing antlers. This is a fantasy parallel to the pattern created by the ibex horns in the Mongolian example. Further more detailed comparison can be drawn between the claws on the two pieces which are both elaborated by a curl within a triangle to mark the actual claws.[13]

The striations on the body are derived from carvings in bone and wood rather than leather cut-outs. A saddle bow in bone, for example from the Altai region is decorated with an ibex neatly confined within the rectangular shape of the ornament. On it are seen the scrolling S or C-shaped divisions as on the tiger. But these have been elaborated with zig-zag points. Less complicated are the vertical groves used on wooden fittings to decorate the jaws or muzzles of animals' heads.[14]

These striated enclosures indeed come to define a whole group of bronzes from Mongolia (Pl. 5a). The importance of

prototypes in wood and bone for this style is demonstrated by comparing a carving in bone of a kneeling horse found in the Tuva[15] with a plaque in bronze from the Ordos area (Pl. 5a). Not only are the striated segments similar in these two examples, but so too is the position of the horse.

The Altai area was as important as a source of the motif as it was of its treatment. The bronze plaque with a tiger and four ibexes can well be compared with a wooden coffin from Bashadar, again of the late sixth century BC.[16] It is decorated with rows of tigers, several lowering over ibexes or rams with their heads in their jaws. The emphasis on pattern, both in the rhythm of the composition and in the play of striation and spiral carved in wood, is extremely close to the bronze example from Mongolia.

Once the motif and its form of elaboration had been adopted in Mongolia influence from the Altai must have receded. The development in Mongolia was away from these striated surfaces with their S and C-shaped enclosures, so easy to carve in wood, but apparently less attractive to bronze workers. Another example on the same theme is pertinent here (Pl. 3b). This second tiger seems in almost every aspect to be the successor of the first tiger plaque discussed at some length. The design is, however, much less clearly articulated. There are now only three ibex heads; two out of the three with striated necks rather than horns. The tail of the tiger has been transformed into another tiger's head. But this change in composition is less significant than the alteration in the detailing. This has been greatly simplified. The claws, no longer cast in the comma-shape similar to the Tuekta example as before, are reduced to a simple curved line. Eyes and ears on the tiger are simplified, but those of the ibexes are exaggerated so that they have become equal in importance with those of the tiger. A pattern based on the eye and ear elements has begun to take the place of that of textured surfaces. For the S-shaped enclosures and their striations are now much more elementary. No further influence from wood or bone carving, in which such elements were easily produced, could have been being exerted at this stage. The period with which we are here concerned can be established by comparison with a similar piece excavated at Holingol in the Tsungar area of Inner Mongolia in a Warring States context. This evidence further establishes that the development of patterning can be arranged chronologically in sequence, from the earlier elaborate examples from Tuekta and Bashadar in the sixth century, to the more summary Mongolian version probably of the fourth century BC.

A last and amusing variant on this theme is seen in the

third example (Pl. 3a). Here the emphasis on eyes and ears already noted on the second piece has taken over. The small ornament is entirely made up of the circular depressions of the tiger's ears, snout, and eye, and the comma shaped depression which are all that is left of the ibexes. There are two tiger heads one facing left and the one underneath facing right; the ibex ears lie behind the head of each tiger. As with the bird head designs this latest example in the sequence has been given a symmetry around a central point that was absent in the earlier and more complicated examples. In other words this pairing around a central point is a characteristic of the area. It is a symmetry here arranged in a circular anticlockwise direction rather than as a confronted pair.

This confrontation we shall now meet in a sub-group of the last of the three main motifs: the coiled tiger. Felines or rather lions were of course one of the most characteristic decorative motifs of the great ancient civilisations of Western Asia. In Siberia tigers take their place. Peculiar to Siberia with possible Chinese connections was the coiled tiger.[18] The most famous example is the tiger in gold from the collection of Peter the Great.[19] This magnificent piece is arguably related to the Maiemiric culture of the seventh to sixth century BC in which the coiled tiger is regarded as a prominent characteristic.[20]

One of the most important features of this type of tiger is the emphasis provided by round enclosures presumably for inlay. These later became merely pronounced circles within the design. They are perpetuated in the Chinese examples (Pl. 4b top). All the pieces which I have been able to illustrate from the collection of the British Museum appear to be relatively late in date. The top piece in Pl. 4b retains the coiled form with circles used quite accurately to emphasise the eyes and paws. This piece can be dated by comparison with an excavated example from northern Hopei province to the late Warring States or Western Han, or third to second century BC.[21] In date the five examples of the tiger (Pls. 4a,b) all appear to parallel the later stages of the sequences of birds' heads and tigers with ibexes outlined above.

The play with pattern is very obvious in Pl. 4b top, the dots bordering the tiger are almost as important as the heavy circles marking the eyes and paws. In the next example (Pl. 4b centre) a band of birds' heads has been added around the outside. The last in the sequence has lost the form of the tiger and become a round boss with two lines of dots instead of one, and enlarged birds' heads (Pl. 4b bottom).

Closely related are two examples which show confronted rather than coiled tigers. Here we have a pairing of a motif in Western Asian fashion rather than the circular symmetry described above. Indeed Scythian examples of such tigers closely following Western Asian counterparts can be cited.[22] Although the confronted treatment has a western rather than Siberian origin the detailing of these confronted tigers can be associated with the coiled tiger. The emphasis on holes for eyes, paws, and ears is similar, as is the decorative feature of the row of dots.

Finally the fourth group of ornament is distinguished from the others not by its motif but by the treatment of the surface. The difference can be seen by comparing a bird's head from this group (Pl. 5b) with those in the first series. That the ear is quite differently formed is only an incidental feature. What is important is the rows of dots which create a particular kind of texture.

Although this bird head makes a neat parallel with one of the other motifs already described, the theme of the majority of this group is an interlace of dragons of differing degrees of complexity (Pl. 5c). Another important motif is the single tiger used as a belt-hook (Pl. 6b). Thus both the themes and the surface treatment in fact set this group apart from the bronzes already discussed. Instead they are closely related to one of the main groups of Chinese bronzes known as the Li-yü type. These come from the north-west province of Shansi. An axe in the British Museum (Pl. 7a) is characteristic of the bronzes found in different tombs at Fen-shin-ling, Chang-chih in this province. Although this example is more eccentric than some, the elaborate dragon interlace enhanced with texturing is the distinguishing feature of the group. On the axe textured dotting is part used to suggest the scales of a dragon whose tail runs along the blade of the weapon. On other Li-yü type bronzes this scale design became more like dotting. In this form it appears on many of the ornaments in the shape of intertwined dragons found in Inner Mongolia (Pl. 6a).[24] The Li-yü bronzes are generally dated to the sixth and fifth centuries on the basis of inscriptions and excavated evidence. Some harness and belt ornaments were closely derived from them, such as the complex dragon inter-lace illustrated here (Pl. 5c). The raised spirals on this piece are probably taken from the upturned hooks on some of the more three-dimensional variants of the Li-yü group.[25] Such three dimensional elements are not seen in the later examples (Pl. 6a) which can be dated to the end of the Warring States, fourth to third century BC, on the basis of excavated evidence.[26] This indeed parallels the trend in the whole family of Li-yü designs, where textured

and complex types are then followed by simplified flatter versions.[27]

The dating of this textured type of bronze can be directly related to that of some of the other bronzes already discussed. Of the examples illustrated, one comparable with the most simple form of dragon in the shape of an S (Pl. 6a right) has been found at the same site as some of the later forms of bird (Pl. 2c).[28] Indeed like the late elaboration of the bird the symmetry of this piece is arranged in circular way around a central point. This smallest of the three items gives the appearance of being reduction of a more complicated design such as the one seen in the left example of the three illustrated here together (Pl. 6a left). This in turn is presumably simplification of the elaborate dragon interlace (Pl. 5c) which it can be argued is slightly earlier in date.

So although this fourth group is in many respects quite distinct in its character and origins from the three sets first described, it shares an important element namely the gradual transformation and abstraction of the design into a simple pattern. The four groups do not belong to one single tradition in this respect, but rather represent two adjacent traditions. This contiguous relationship can be illustrated by comparing a finial (Pl. 7b) with the axe from the British Museum (Pl. 7a). The smooth articulated pattern made out of the dragon on the finial is the counterpart of the textured dragon on the axe. In the same way the smooth bird heads (Pl. 2b) are the counterpart of the bird heads with textured patterns (Pl. 5b). The close relationship of the axe and the finial is established by finds of bronze exhibiting these two different styles of interlace design in the same tomb at Fen-shui-ling already cited.[29] Here an axe-like finial, similar to that illustrated here (Pl. 7b) has been found in association with bronzes with more conventional Li-yü designs similar to those in the axe. In its complexity the finial resembles the degree of detail on some of the most complex of the examples in the first three groups discussed at the beginning: for example the tiger surrounded by ibex heads.

From this examination several general conclusions can be drawn. First of all, although the themes of the bronzes are common to many areas of Central Asia and Mongolia, the interest in the creation of patterns is peculiar to the areas adjacent to China. The method of creation of patterns differs as between the first three groups and the last one. So do the origins of the motifs. The motifs of the first three groups belong to western areas - South Siberia,

Kazakhstan, and are shared even with Southern Russia. The designs in the last group are essentially Chinese. The same is also true of the detail of surface treatment. In the first three groups many details have parallels in South Siberia or further west namely; the ear of the bird; the striations on the tiger with ibexes; the coiling and pairing of the tiger. These seem to be subordinated to the pattern created, as the themes were reworked in Inner Mongolia. Similarly the features of the fourth group derive from China, and they in their turn were diminished over time. This fourth group shares with the other three the symmetry created by doubling or pairing the design, orientating the two elements in a clockwise or counter-clockwise direction. The other point in which all four groups are associated is date. They are all later than the elaborate prototypes cited for them found in South Siberia or China, which date from the sixth to the fifth century. Excavated evidence shows that in all instances the groups under discussion are contemporary with the Warring States and are possibly in some cases as late as the Han period.

Among the bronzes made in Inner Mongolia at this date, the bronzes discussed rightly occupy a relatively humble position. However they highlight the importance of the creation of patterns from representational motifs. This is a tendency which is not confined to these small ornaments, and can be examined on the larger plaques as well. It proves to be one of the special contributions of the areas adjacent to China to 'animal art'.

Jessica Rawson

NOTES

Abbreviations

K'ao-ku KK
K'ao-ku-hsüeh-pao KKHP
Wen Wu WW

1. Rudenko, S.I. *Frozen Tombs of Siberia, the Pazyruk burials of Iron Age Horsemen,* London 1970. Several bridles made up from a number of ornaments have been excavated at this site, see pls. 82-89. The small ornaments described in this paper may have had a similar use.

2. General surveys of the themes and motifs in animal art can be found in Artamanov, M.I. *Treasures from Scythian Tombs in the Hermitage Musuem, Leningrad,* London 1969.
 Bunker, E.C., Chatwin, C.B., Farkas, A. *"Animal Style" Art from East to West* (catalogue of an exhibition held at Asia House Gallery), New York 1970.

3. Rudenko *op.cit.*

4. *KK* 1976/4 pp. 246-258, fig. 9.

5. The bird's head is seen on a knife with a notched blade. This form of knife has been widely discussed c.f. Watson W. *Cultural Frontiers in Ancient East Asia,* Edinburgh 1971, pp. 103-105.
 Loehr M. 'Ordos Daggers and Knives, new material, Classification and Chronology' *Artibus Asiae* XII pp 34-36. 'The excavations at Ch'ang-ping-hsien' *KK* 1976/4 *op.cit.* support a date early in the Western Chou period c. 10th century BC.

6. *Or des Scythes, Trésors des Musées Soviétiques* (catalogue of an exhibition held in Paris), 1975. no. 115.

7. *Or des Scythes op.cit.* no. 132.

8. A number of fittings with three dimensional animals have recently been excavated at Yü-lung-t'ai, Tsungar

Banner, Inner Mongolia dating from the fifth to third century BC. *KK* 1977/2, pp. 11-114, pls. 2-3.

9. *WW* 1965/2, pp. 44-46, fig. 7.

10. *KKHP* 1976/1, pp. 131-144, fig. 6 (17,20).

11. *KK* 1977/2 *op. cit.* pl.4(4).

12. Rudenko *op. cit.* pls. 121, 136.

13. Rudenko *op. cit.* fig. 137b. For the recognition of the group of bronzes defined by C-scrolls enclosing striation see Bunker *op. cit.* nos. 109/112.

14. Rudenko *op. cit.* pl. 140 (A) pl. 110 (B,F).

15. *Or des Scythes op.cit.* no. 181.

16. Rudenko *op. cit.* fig. 136. More dramatic photographs of many of the pieces from the Altai are to be found in Griaznov M. *L'Art Ancien de l'Altai,* Leningrad 1958. For the coffin from Bashadar see fig. 42.

17. *WW* 1959/6 p. 79 fig. 5.

18. Watson, W. *op. cit.* pp. 107-109 pls. 70-74. Professor Watson concludes that the animal in a ring may include elements from both east and west.

19. *Or des Scythes op. cit.* no. 183.

20. Jettmar, K. 'The Altai before the Turks' *Bulletin of the Museum of Far Eastern Antiquities* no. 23, pp. 135-223, p. 152-156.

21. *WW* 1960/2 pp. 59-65, fig. 2.

22. Artamanov *op. cit.* fig. 3. This is an exquisite example of a pair of confronted lions on a Scythian weapon represented in a curved or coiled position reminiscent of the Mongolian version. The theme of confronted lions is found in ancient Mesopotamia.

23. The axe in Pl. 7a can be compared with a number of recently excavated bronzes of the type generally given the name Li-yü, *WW* 1972/4 pp. 30-46, pl. 1 and *KKHP* 1974/2, pp. 63-85, pl. 4, figs. 2,3.

24. The Far Eastern Archaeological Society 'Inner Mongolia
 and the Region of the Great Wall', *Archaeologia
 Orientalis* B Series, Vol. I, Tokyo and Kyoto 1935.
 This volume records the finds of items of the type
 discussed in the present paper. Among them are
 ornaments composed of intertwined dragons as well
 as representations of all other three groups. See
 fig. 66.

25. The question of the sequence of the designs belonging
 to the Li-yü family has been widely discussed but
 not fully resolved. Loehr, M. *Ritual Vessels of
 Bronze Age China* (catalogue of an exhibition held
 at Asia House Gallery), New York, 1968, pp. 142-144.
 Weber, G. D. *The Ornaments of Late Chou Bronzes*,
 New Jersey 1973.

26. *KK* 1977/2 *op. cit.* pl. 3, fig. 5.

27. An unpublished piece in the British Museum provides an
 example of this stage.

28. *KKHP* 1976/1 *op. cit.* fig. 6.

29. *KKHP* 1974/2 *op. cit.*

PLATES

1. Two bronze daggers decorated with bird's heads on the
 hilt.

 left: from north-west China 7th-5th century BC,
 length 27.6 cm.

 right: from South Siberia, 6th-5th century BC,
 length 27.8 cm.

 British Museum 1950 11-17 215, 67 12-13 7.

2a. Bronze fitting in the form of a three-dimensional bird's
 head. Probably from Inner Mongolia 5th-3rd century
 BC.

2b. Three flat bronze harness ornaments in the shape of
 stylized birds' heads. Probably from Inner Mongolia
 4th-3rd century BC.

 left: single bird head, length 2.8 cm.

 centre: double bird head, length 3.5 cm.

 right: single bird head with ibex horns, length
 2.8 cm.

 British Museum 1950 11-17, 33, 35, 53.

2c. Two flat bronze harness ornaments in the shape of highly
 stylized birds. Probably from Inner Mongolia 4th-
 2nd century BC.

 left: double bird head in openwork, length 3.1 cm.

 right: double bird head, the holes indicate the eyes,
 height 4.8 cm.

 British Museum 1950 11-17 59, 71.

3. Three bronze harness ornaments in the shape of a tiger
 with ibexes. Probably from Inner Mongolia 5th-3rd
 century BC.

 a. ornament composed of two tigers' heads and
 two ibex ears, length 2.5 cm.

 b. tiger with additional tiger head emerging
 from the tail, three ibex heads, length 6.9 cm.

c. tiger with reverted head, surrounded by four
 ibex heads, length 8 cm.

British Museum 1937 7-26 90, 93, 1950 11-17 39.

4a. Two harness ornaments. From Inner Mongolia or Northern
 China 4th-3rd century BC,

 top: two confronted tigers, width 2.8 cm.

 bottom: two confronted tigers, width 4.4 cm.

 British Museum 1935 4-15 1, 1936 11-18 147.

4b. Three bronze harness ornaments. From Inner Mongolia or
 Northern China 5th-3rd century BC,

 top: coiled tiger, width 3.3.cm.

 centre: coiled tiger surrounded by a band of birds
 heads, width 3.6 cm.

 bottom: boss decorated around the edge with a band
 of birds heads, width 4 cm.

 British Museum 1950 11-17 87, 85, 84.

5a. Bronze harness plaque with a design of a kneeling horse
 decorated with striated sections. Probably from
 Inner Mongolia 5th-3rd century BC, length 7.8 cm.

 British Museum 1929 1-16 1.

5b. Bronze bird's head. From Inner Mongolia or North China
 5th-3rd century BC, length 6 cm.

 British Museum 1929 1-16 12.

5c. Bronze belt-plaque composed of two intertwined dragons.
 6th-4th century BC, length 8.2 cm.

 British Museum 1973 7-26 43.

6a. Three bronze harness ornaments derived from a design of
 two intertwined dragons. From Inner Mongolia or
 North China 5th-3rd century BC,

 left: length 6.7 cm.

 centre: length 5.8 cm.

 right: length 3.4 cm.

British Museum OA 1950 11-16 20, 1947 7-12 369,
1950 11-17 32.

6b. Bronze belt-hook in the shape of a tiger. From Inner
 Mongolia or North China 5th-4th century BC, length
 9 cm.

 British Museum 1945 10-17 208.

7a. Bronze axe head decorated with intertwined dragons.
 China 6th century BC, length 13.4 cm.

 British Museum 1936 11-18 32.

7b. Bronze finial in the shape of an axe. China 6th-5th
 century BC, length 10.5 cm.

 British Museum 1947 7-12 368.

Plate 1

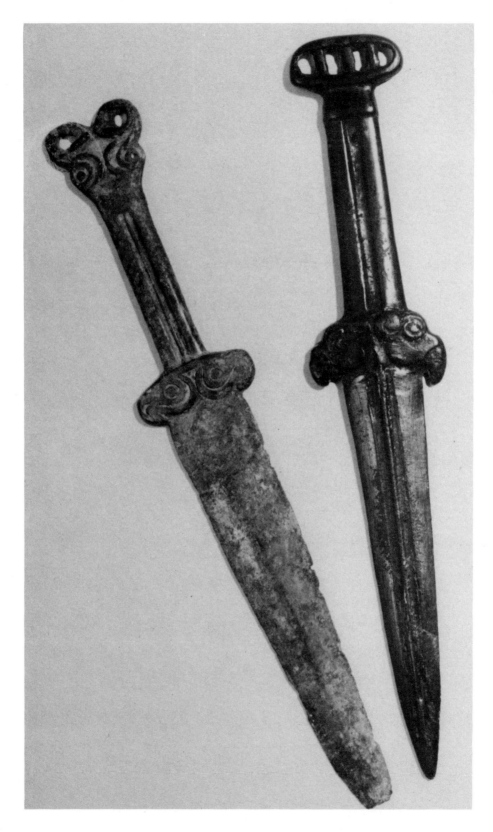

Plate 2

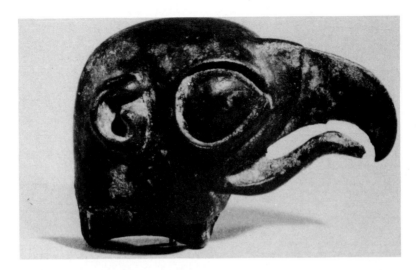

a

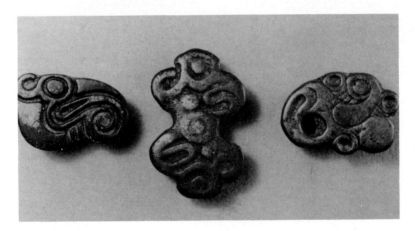

b

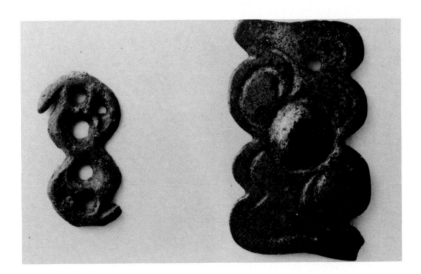

c

Plate 3

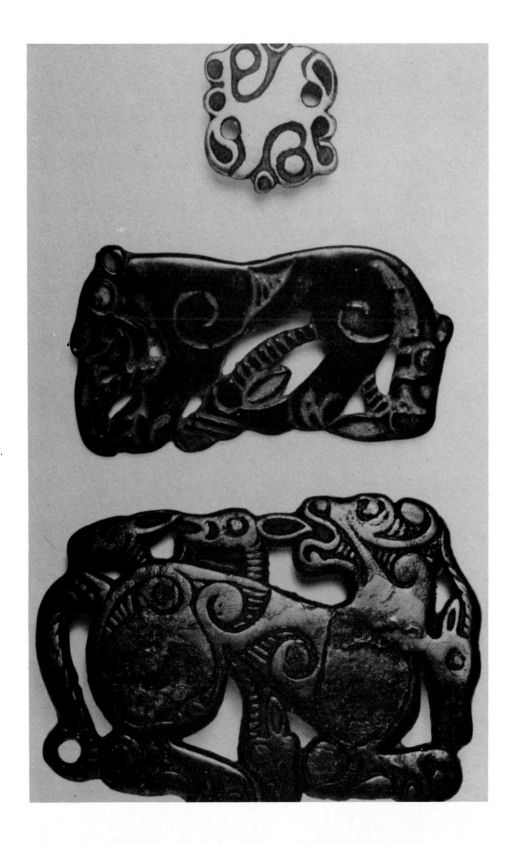

Plate 4

b

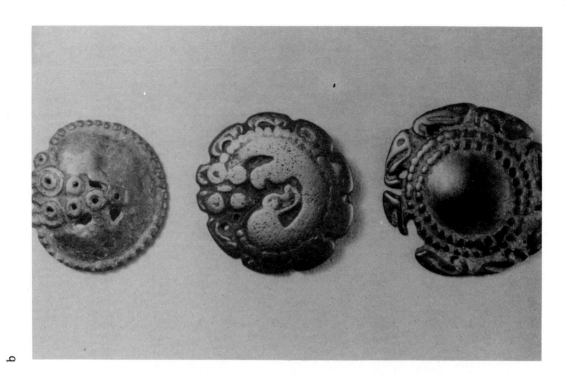

a

Plate 5

a

b

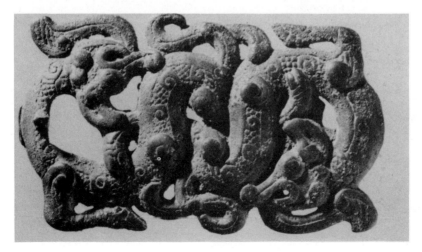

c

Plate 6

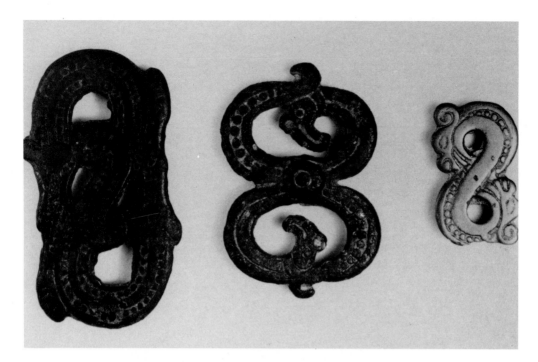

a

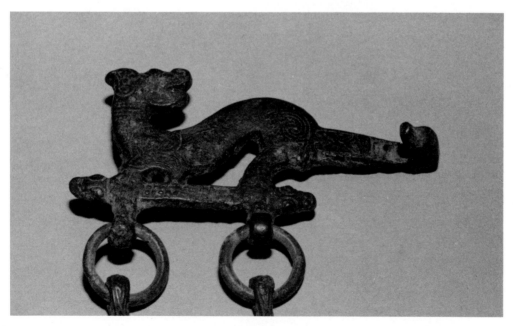

b

72

Plate 7

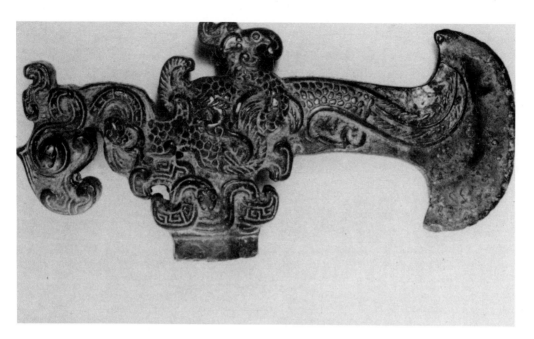

a

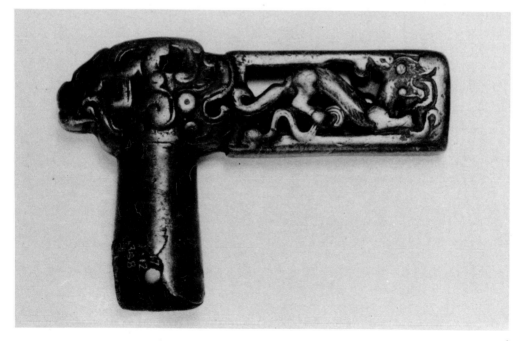

b

When considering as comprehensive and amorphous a subject as
Steppe Art, the first essential is to devise some method of
untangling and rationalising the various historical and
artistic strands that form the whole. There are many approaches
to this problem: several forms of analysis of both style and
content have already been discussed. My approach is a very
straightforward one; i.e. to attempt to trace the derivation
and subsequent progress of one particular line of artistic
movement among many others in the Steppes, by means of motif.

 The adoption of the tiger as motif is not entirely
random, but was initiated by the discovery of a *chun yü*
(a musical instrument used in military manoeuvres) (Pl. 1a)
among the recently excavated archaeological finds at the Ku
Kong. It was part of the exhibition from which the pieces
for the 73/74 Chinese Exhibition in London were selected, but
hadn't itself made the journey to England. Excavated in
Szechwan, it is dated to the Spring and Autumn period,
probably 6th or early 5th century B.C. Shortly afterwards,
in Sian, I came across another such instrument (Pl. 1b),
excavated from Ch'ang An in Shensi and dated to the same
period.

 The significance of these examples is that they
demonstrate links between centres of bronzecraft associated
with the quasi-animal style of the Shensi/Shansi/Inner
Mongolian triangle, and points further south and west.
With reference to stylistic association, they also represent
possible connections between, on the one hand, such early
pieces as the magnificent 10th century bronze tigers in
the Freer, and on the other, the numerous small belt hooks
and plaques assigned to the Ordos and Mongolia, which
feature similar crouched feline motifs. Such parallels
must obviously be drawn more from stylistic similarities
than from strict adherence to motif, and this is the case
with other examples dealt with in the paper.

 A certain type of *kuei* dragon found on bronzes of the
late Shang period, that is to say 12th-11th century B.C., is
represented on a *yu* in the British Museum (Pl. 1c). It is
characterised by the beaked head, crouched front leg with
crescentic paw, and long, hooked tail.[1] Professor Watson has
commented on the various types of humped *kuei* and their
association as a martial emblem with chariot bronzes, but
the important point with regard to my thesis is their
relationship with the semi-naturalistic tiger which is

adopted into the hieratic ornament of bronze vessels late in the Shang period. Although the *kuei* dragon represents a different conceptual tradition than the tiger, a stage is reached where the stylistic identity of the two creatures merges, to produce a polygenetic creature which while it takes on a degree of naturalism in the treatment of the body, retains the stance and beaked head of the *kuei* (Pl. 1d). Note the uprising hooked crest on the paws.[2]

This gradual metamorphasis is illustrated in other media: a marble tiger in the British Museum is carved into smooth, realistic form but yet retains the typical straight-bodied, crouching pose with curling tail (Pl. 1e): the chiming stone from the royal tomb of Wu Kuan-ts'un at Anyang bears a hybrid creature which predicts many features later typical of the style i.e. downturning head, curled feet (note again uprising crest), gaping mouth and rolled snout, and leaf-shaped ears (Pl. 1f).

The incidence of the motif is not confined to the metropolitan bronze centre of Honan at this period. In 1975 excavations at Li Ling in Hunan yielded a superb bronze elephant *ts'un*, which bore on its front leg a tiger decoration with downturning, gaping mouth, crescent-shaped paws and an indication of a formalised, spiral motif on the shoulder (Pl. 2a). It is significant that this decoration should occur on the same surface and together with creatures of much more abstracted design, and interesting that the vessel should have come from the south-west as did the *chun yu* excavated in Szechwan, while being some 500 years earlier in date.

The handles of a large *ting* excavated from Anhui in 1958 and dated by the Chinese on the basis of inscription to the reign of the third Chou King, K'ang Wang, are decorated with a pair of tigers with crouched and slightly undulating bodies, curving tails, crescentic paws with crest, and leaf-shaped ears, the treatment of which compares closely with that of the similarly dated Freer tigers (Plate 2b).

The establishment in China, during the late Shang and very early Western Chou, of a style of ornament based on realistic animal form but adapted to a format developed within the context of Chinese ritual style, results in a form of motif which thereafter becomes diversified and is carried far beyond the borders of China.

During the early Western Chou period, especially in the 9th and 8th centuries B.C., there was a general move towards abstraction in the ornament of bronze vessels, which

makes the tracing of animal form as surface decoration more difficult. The tigers on an 8th century *po* from the Shanghai museum[3] illustrate one development of the motif. The tigers still retain the stark, two dimensional quality of a bronze vessel surface decoration, but the spiral design on their bodies has become the dominant motif (Pl. 2c).

A more rounded, zoomorphic treatment is evident in the late 6th century tigers on the Chi Hsien *hu* in the British Museum, which maintain the same crouching position, but whose spirals on shoulder and hip are modelled into three-dimensional form. Further abstraction in the design is illustrated by the reduction of the body-markings to a double rhythmic spiral on a 5th century belt-hook (note leaf-shaped ears) (Pl. 2d).

Thus far the discussion has centred on pieces which, while they may be taken as coming within the influence of a Northern Animal Style, can also all be assigned to the civilising centres of Chinese bronze-craft. However, a dagger excavated from Inner Mongolia of the eighth-sixth centuries B.C., bears as its terminal a creature, which although crudely fashioned, adopts the familiar crouching position with downturned head, and is decorated with a form of debased spiral on shoulder and hip (Pl. 2e).

The two trends, development within and without the borders of China, come together in the context of an ornament in the British Museum which is subjected to a very different and simple treatment than that of its predecessors, the body smooth and undecorated, the legs crouched but the crescentic paws having evolved into circles, and the downward-turning head stylised into component parts. It is dated to the third century B.C., but comparison with bronzes unearthed at Hsuan Hua in northern Hopei which Loehr has dated convincingly to the 6th century B.C., give an earlier date for it[4] (Pl. 2f).

At this point we must expand the discussion to allow for the more complex stylistic factors affecting these pieces. The ornament from the British Museum, dissimilar though it is to other pieces within the Chinese sequence, does parallel closely certain examples from provenances further west. The smooth rendering and proportions of the body, the round feet, the serpentine neck and rendering of the facial features conform to a prototype coiled feline which occurs among the Maiemir burial finds in the High Altai of the 7th-6th centuries B.C., and to a similar example from the Kazakhstan (in the Hermitage) which Mrs. Rawson has illustrated. The Kazakhstan artefacts

have themselves been associated in style with pieces from the Kelermes Kurgan in the North West Caucausus of the early sixth century B.C., the Kelermes example which balances the series being a feline whose paws metamorphasise into coiled animals, and with down-turning head (Pl. 3a). If one accepts for the Chinese ornament a 6th century date, it would appear to be the product of two different stylistic components, one transmitted through the Caucausus and South Siberian steppelands, the other emanating from Chinese hieratic bronze art. This interpretation supports the theory that the coiled animal motif, while probably of eastern origin, was subjected, like the tiger-dragon, to a two-way communication through the length of the Steppe zone, and later re-transmitted eastward in a specifically westernised version.

The Hsuan Hua bronzes, although primitive in style, compare with the British Museum animal bronze in the smoothness of the body, the circular paws, and stylisation of the head with the large round eyes and gaping mouth. They also feature a debased form of the spiral pattern on shoulder and hip, which is now simplified into a circle (Pl. 3b).

I am indebted to Mrs. Bunker for observation of the connection between these bronzes and the ornamental fitting in the Buckingham collection, Mongolian, dated sixth-fifth century B.C.[5] (Pl. 3c). By this stage it is apparent that the development of the tiger motif takes two diverging paths; that although derived from the same root motif, tigers in China from the sixth century onwards develop towards a more rounded, naturalistic mode with greater diversity of surface decoration; whereas the Tiger motif as it is transmitted north across the borders of China, not surprisingly evolves into a simpler, less recognisable format. Such standardisation of form is further illustrated by another Mongolian fitting from the Seligman Collection in the British Museum, where all attempt at rendering rounded form has been abandoned.

There is well established evidence of cultural contact between China and the Minusinsk valley via the Ordos from the late second millenium B.C., even to the extent of a racial admixture with Mongol strain predominating at that period. Such features of early Chinese bronze art as the tiger-dragon coiled in a circle, and knives with animal terminals were transmitted, and that the crouching animal with circular feet and downturned head accompanied them, is evidenced by a scabbard of the 6th-5th centuries B.C.[6] (PL. 3d).

The Ziwiye treasure has always posed an interesting
question as to date and origins. Whilst obviously
pertaining to the Scythian animal style, it yet also
displays features indicative of contact with developments
further east, such as the animal in a ring motif. It is
unlikely that the burial occurred much after 600 B.C.,
and a seventh century date would ideally qualify the
finds for a position at the western end of an east-west
two way transmission of style discussed earlier, which
includes Kelermes, the Kazakhstan, the Altai and points
east. If one accepts this thesis it should come as no
surprise to discover among the creatures decorating a large
silver inlaid dish a crouching animal with downturning
head with leaf-shaped ear, gaping mouth and large round
eye portrayed by double concentric circles (Pl. 3e). Add
to this circular feet, rolled snout and a sort of misunderstood
spiral on the haunches, and strong parallels may be deduced.
Very similar motifs occur in gold plate on the shaft of an
iron axe from Kelermes. It is evident that the development
and transference of motif need not be the result of a single
ethnic movement, or of a single specific cultural transference,
but that the common sphere of influence extending over a
region stretching from the Carpathians to the borders of
China, engendered easy and rapid intercourse both of artefacts,
trade objects, and motif.

That this communication should continue into the middle
Sarmatian period in the Western Steppes is illustrated by the
re-emergence of a proto-Scythian animal style among the
grave-finds of the Ural and Volga steppes. It occurs on
polychromatic artefacts made of precious metals, such as
jewellery and insignia, and illustrative of these are the
finds from a group of barrows at Novocherkassk, north of the
Black Sea, which show a certain Siberian influence. An
embossed silver shield from the Sadovy barrow bears a
decoration of panthers attacking griffins and a design of
birds' heads, both reminiscent of Mongolian plaques of the
4th-3rd centuries B.C. Another royal burial of the same
group, Khoklach, of around the first century B.C., yielded
a cup with standing elk handle, a diadem decorated with stags
with rings in their mouths and stylised circular feet, and a
gold collar with a double frieze of griffins (Pl. 3f). The
history of the griffin as it relates to Siberia does not need
to be examined in depth, but links with Anamino, Minusinsk,
the border regions of China and most particularly the Altai
are focal points. A carved wooden necklet with a design of
linked lion-griffins from barrow two at the Altai offers a
similar conception in design. Possible thematic links are
indicated in the crouching posture and the way in which the
animals' bodies are linked one to another, and in the lozenge-

shaped hollows on lip and shoulder which are still filled
with the inlay missing on so many other pieces. While the
striated body is reminiscent of wood-working technique, it
is interesting that one or two of the griffins bear a type
of collar-design around the neck, a design common among
animal plaques of the eastern steppes at an earlier date.

In conclusion, it is interesting to broaden the
discussion of as basic a theme as the visible transference
of motif to include a note on the more intangible subject of
style, and the stylistic treatment of motif. For how far is
it possible to describe the collective characteristics of an
art, especially an art so diffuse and with such a varied
ancestry as the art of the steppelands? How is it possible
to evaluate the way in which wood is carved, metal cast or
twisted to create the rhythmic forms so typical of nomad art?
Perhaps again by the abstraction of certain key points and by
their referral to constants in the artistic traditions of
the settled perimeters.

Immediately apparent in the treatment of the dragon
on the rim of a jade *pi* of the Western Han period is the
strong sense of rhythm in the design: the curved, s-shaped
body, the positioning of the legs to offset the sweep of
the neck and crest which in turn are balanced by the tail
and front spiral (Pl. 4a). Minor design elements accentuate
this; the crested jaw, spiral accentuating the sweep of the
neck, the spirals on shoulder and haunch. This rhythm and
balance were features of Chinese art from the earliest times,
apparent in the ornament of Shang and Chou bronzes, in jade
carving and mirror decoration.

A plaque from Mongolia of the same period is subject
to similar linear rhythms, the body and head curved to form
an s-shape, elements of the surrounding frame adapted to fit
the pattern and to form a roughly oval shape suitable for
belt plaque or brooch (Pl. 4b). This reduction of animal
form to schemes in which the decorative element predominates
is something common to steppe art in all regions and at all
periods. Although he may be stimulated by very discrepant
and diverging influences the steppe artist is liable to
produce something which conforms to a fairly standard set
of criteria[7]; reduction and contortion of naturalistic form
to the point where it may be unrecognisable; standardisation
of form to fit into some practical shape e.g. (here) the
square or rectangular frame of a belt plaque; stylised or
symbolist pattern-making on the surfaces. The treatment of
the decoration of an armlet from Siberia goes one step
further (Pl. 4c). Not only are the cats' bodies linked in
a fluid manner and twisted into the characteristic s-shape,

but the head is actually turned through an angle. This
particular form of abstraction is carried to the ultimate
in designs from the Altai Kurgans, where the animals'
hindquarters are turned through 180°.

To return to the stylistic treatment of the tiger
motif: a significant comparison may be made between two
similar belt-hooks, one from the Buffalo Museum of Science,
which adopts the archetypal crouching position with spiral
decoration but with a degree of naturalism visible in the
rendering of the ears and feet (Pl. 4d), and the other from
the British Museum (Pl. 4e) which represents a further
degree of abstraction both in the rhythm of the body and
the stylised treatment of the rolled snout, leaf-shaped
ears and paws, and in the adoption of a typically Scythic
posture with head turned to the rear. As one moves
outwards from the metropolitan centres of Chinese culture
the abstraction accelerates. The treatment of the features
of the head on an Ordos belt-hook conform to the basic
stylistic requirements, but the body markings have been
reduced to a series of double spirals, and the feet are
circular on distorted legs (Pl. 4f).

This corroborates the thesis that the Animal Style
is based on naturalistic motifs derived from real animal
form, but that as these motifs become removed from their
point of origin they are successively subordinated to so
strong a sense of rhythm and design as to become in many
cases quite unrecognisable. The design element takes over,
and natural form is transmuted into stylised idiom, which
points are abundantly demonstrated in the transformation
of the Tiger Motif.

Rose Kerr

NOTES

1. This particular type of *kuei* dragon occurs on many of
 the finest late Shang ceremonial vessels. Among
 many examples, cf. the large *fang-yi* in the Royal
 Ontario Museum, the *chih* from the Elephant Tomb
 set at Hui Hsien, and the square *chia* in the British
 Museum.

2. Such a conjunction of naturalistic and fantastic
 decoration is very much a feature of late Shang/
 early Chou ornament, where the *kuei* may take on
 a markedly feline, bovine or even elephantoid
 appearance.

3. The *po,* although apparently similar, differs from the
 chung (鈡) chime of bells in that it is a
 relatively early percussion instrument found only
 singly or in pairs, never in a graduated set.

4. Loehr, M. 'Ordos Daggers and Knives', *Artibus Asiae*
 XII Nos. 1/2, 1949, p. 47.

5. Bunker, E. *'Animal Style' Art from East to West,* New
 York, 1970, p. 140.

6. The scabbard was actually accompanied by its own knife
 with standing horse terminal - see K. Jettmar, *The
 Art of the Steppes,* pl. 11.

7. Compare, for example, the decorative style of the
 series of late plaques from the Caucausus discussed
 in the paper read by Mr. Curtis.

PLATES

1a. *Chun yu.* 6th-early 5th century B.C. Excavated from
 Szechwan.

1b. *Chun yu.* 6th-early 5th century B.C. Excavated from
 Shensi.

1c. *Yu.* Late Shang, 12th-11th century B.C. British
 Museum.

1d. *P'an.* Late 11th century B.C. British Museum.

1e. Marble figurine of a tiger. Shang period. British
 Museum.

1f. Chiming stone. Shang period. Excavated at Anyang,
 Honan.

2a. Elephant *ts'un.* Shang period. Excavated at Li
 Ling, Hunan.

2b. *Ting.* Western Chou period. Excavated from Anhui.

2c. *Po.* Chou period, 8th century B.C. Shanghai Museum.

2d. Bronze belt-hook. 5th century B.C. British Museum.

2e. Bronze dagger. 8th-6th century B.C. Found in a tomb
 at Ho-lin-ko-erh-hsien, Inner Mongolia.

2f. Silver plaque. 6th century B.C. British Museum.

3a. Gold plaque. Early 6th century B.C. Hermitage,
 Leningrad.

3b. Bronze plaque. 6th century B.C. Found at Hsuan Hua,
 Hopei.

3c. Bronze chariot fitting. 6th-5th century B.C. Art
 Institute of Chicago.

3d. Bronze scabbard. 6th-5th century B.C. Museum für
 Völkerkunde, Hamburg.

3e. Gold plaque, formerly an overlay that decorated a
 silver plate from the Ziwiye treasure. Late 7th
 century B.C. Loan to Denver Art Museum.

3f.　　Gold diadem.　Ca. 1st century B.C.　Hermitage, Leningrad.

4a.　　Jade *pi*.　Western Han period.　Nelson Gallery, Kansas
　　　　City.

4b.　　Bronze plaque.　Western Han period.　Heeramaneck
　　　　Collection, New York.

4c.　　Gold armlet.　Ca. 2nd century B.C.　Römisches-Germanisches
　　　　Museum, Cologne.

4d.　　Bronze belt-hook inlaid with turquoise.　5th century
　　　　B.C.　Buffalo Museum of Science.

4e.　　Bronze belt-hook.　5th century B.C.　British Museum.

4f.　　Bronze belt-hook.　Ca. 2nd century B.C.　British Museum.

Plate 1

a

b

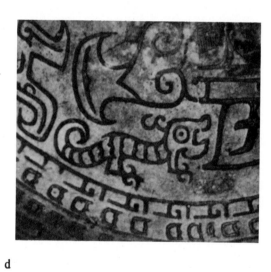

c

d

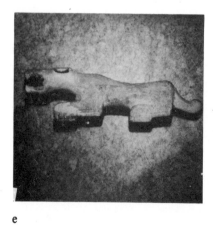

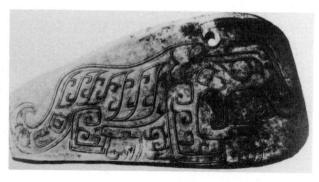

e

f

Plate 2

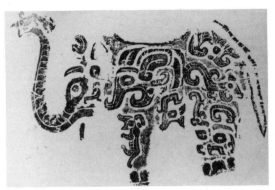

a

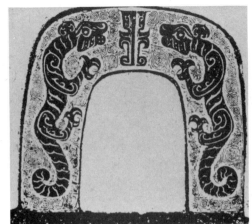

b

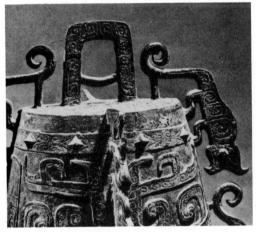

c

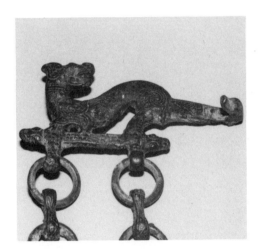

d

e

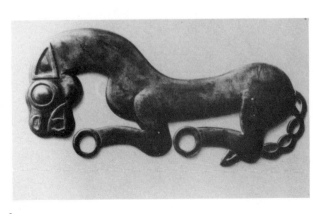

f

85

Plate 3

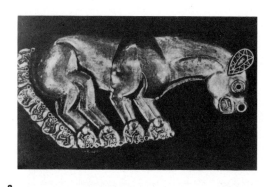

a

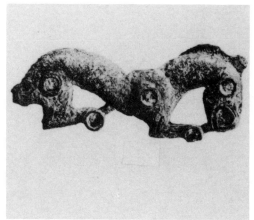

b

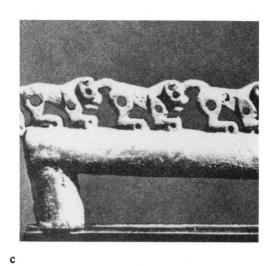

c

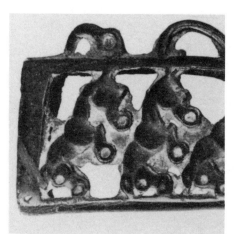

d

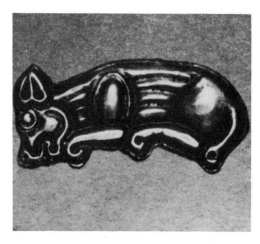

e

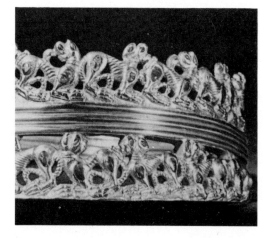

f

Plate 4

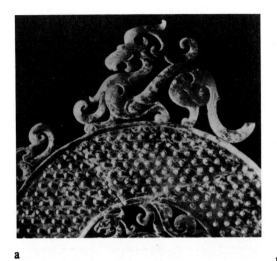

a

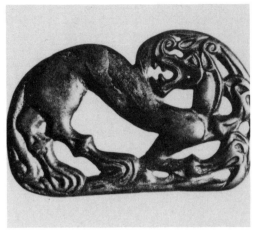

b

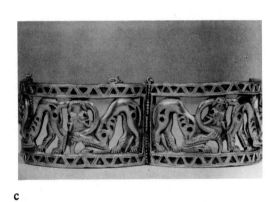

c

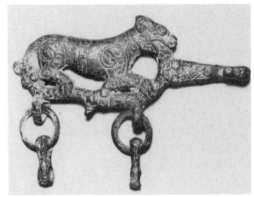

d

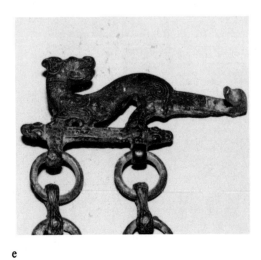

e

f

The purpose of this paper is primarily to draw to the attention
of Western scholars a book in Georgian by Dr. Manama Khidasheli
dealing with a distinctive type of bronze belt-clasp
(Khidasheli 1972), many examples of which have been found in
Western Georgia. Through the kindness of my colleague Mr.
Kenneth Painter I have had access to a partial translation of
the catalogue section of this book made by Miss Tamara
Dragadze, which is reproduced here as appendix 1. To Dr.
Khidasheli's list we can add a few belt-clasps which are now
in Western collections, and in addition there will be a short
discussion of the origins and antecedents of the motifs used
in the clasps, with particular emphasis on the manner in
which they are executed. [1]

The belt-clasps are of cast bronze, are rectangular in
shape and bear cones or bosses at the corners. They have
often been found in tombs and their identification as belt-
clasps is confirmed by the ring-fitting and tongue at the
back of each (Pl. 1a). They have wide borders covered with
spiral or plaited decoration. These are generally solid but
occasionally an openwork element is introduced, such as short
columns or a lattice-work design. In the centre of each
clasp is an intricate openwork design in the form of various
stylized animals. There is generally one principal figure,
a deer, a horse or a goat to which are added subsidiary motifs
such as birds, dogs, fish, snakes, foals, oxen and animals'
heads. Human representations are rare, occurring just twice
as far as I know (clasps nos. 86, 144). Sometimes the clasps
are divided into four compartments by intersecting bands, and
in these cases the same design is repeated four times. In
all cases the animals are highly stylized, with pronounced
fore- and hind quarters and wasp-like waists, arched backs,
rounded, bulbous eyes and, in the case of the deer, accentuated
and fanciful antlers. Such is the extent of this stylization
that identification is sometimes difficult. For example the
oxen have long tails and a generally bovine appearance, but
at the same time their horns are more readily recognizable
as a goat's. The goats themselves present something of a
problem because the shape of their horns identifies them as
the markhor *(Capra falconeri)*, but the modern distribution
of this goat does not include the Caucasus, being restricted
to the mountainous area from Kashmir and Turkestan to
Afghanistan. More probably, then, the goats depicted on the
clasps belong to the breed native to the Caucasus, the tur
(Capra caucasica)[2], but with the horns shown in an unrealistic
manner.

In her book Dr. Khidasheli has collected together one
hundred and seventy one of these belt-clasps, of which seventy
are in the various national collections in Tbilisi, forty-
seven are in local museums and private collections in Georgia,
seventeen are in the Kutaisi State Museum, thirteen in the
Hermitage, twelve in the Moscow Museums, and a single example
in Kiev.[3] Five of the clasps she has assembled are in museums
outside Russia, and to this figure we can add ten further
examples in western collections: one in the British Museum,
one in the Norbert Schimmel Collection, two in the Metropolitan
Museum of Art, two formerly in the Colville Collection, and
four in the Musée Cernuschi.[4] Dr. Khidasheli has divided the
clasps into five groups according to the type of figure in
the centre of the clasp, and although as we shall see it is
doubtful whether this sort of division is particularly
meaningful, it is convenient to follow it for the purpose of
describing the material. In addition she has made sub-types
within the main groups, dependent on the number and type of
subsidiary motifs that are added to the principal figure,
but we shall not go into those here.

The first group comprises clasps in which the principal
figure is a stylised deer looking back over its shoulder
(Pls. 1b,1c). The same figure appears in group two, but now
looking to the front (Pls. 1d, 1e). A particularly interesting
clasp in this group two (no. 86) shows a two-headed deer with
a human figure seated on its back. In her third group, Dr.
Khidasheli puts together clasps featuring horses and what she
calls "horse-deer" figures. An example of the latter is seen
on a British Museum clasp (Pl. 1f) where the figure retains
many of the characteristics of a deer but has a horse's tail
and no antlers. Some of the so-called horse-deer figures,
however, appear to me to be deer comparable to those seen
on the clasps of group two. In stark contrast to the deer,
many of the horses are naturalistically depicted, even down
to the intricate details of the harness (Pl. 2a). One of
the group three clasps (no. 144) again features a human
figure, this time showing a man on horseback. The central
figure in group four is a goat, probably the Caucasian tur
as we have seen, with its head turned to the front. It is
in the fourth group that the five clasps which are divided
into four compartments belong; the pattern on the interlacing
bands repeats that round the border of the clasp. Group five
brings us back to groups one and two in that the central
figure is again a stylized deer, looking either over its
shoulder or to the front, but now its legs are so positioned
as to indicate a running posture (Pl. 2b). A curious feature
of the figures in this group is the way their legs are made
to curl round at the ends. In the past a number of attempts
have been made to evaluate the significance of the different

motifs on these clasps but this is not, I think, a subject which we can enter into here. However, I would like to draw attention to Miller's idea (1926, p. 88) which seems to me very plausible. He suggested that in most cases the inspiration for the composition derives from scenes of the chase, best illustrated by the scenes depicting a deer surrounded by dogs.

Of these five groups the best represented are the second and third, where the central figures are a deer facing forwards, a "horse-deer figure" or a horse. In both these groups there are more than fifty examples. Whether this typology should be regarded as having any chronological significance is debatable. My own feeling is that it doesn't, and of course there are many other ways in which these clasps might be classified. For instance, instead of concentrating on the principal figure in the composition one might study the subsidiary motifs, and make a typology accordingly. Alternatively, the clasps could be classified according to type of border. Again, it would be possible to divide them by the degree of stylization. Tekhov (1969, p.60) believes that the clasps with naturalistically portrayed animals are the earliest and that the animals become progressively stylized with the passage of time. However, as we shall see, it is doubtful whether there are enough well-dated clasps to support this theory. In any case those clasps with the most elaborate (and most highly-developed?) borders, in group 5, often exhibit the greatest degree of naturalism, expressed in the prancing posture of the deer. On the whole, in the lack of any firm evidence to the contrary, it seems safest to assume, as did Kuftin (1941, pp. 28-29), that all stages were concurrent. Perhaps the different types of clasp represent the outputs of different factories, but this of course is only a suggestion and there is not at my disposal sufficient documentation about the clasps to verify it.

Fortunately, using Dr. Khidasheli's catalogue it is possible to draw up some sort of distribution map (Pl. 3) of the belt-clasps. The numbers inside circles represent the number of clasps found in a certain district or province. Thus from the Ratcha district there are thirty-nine clasps, and from Kartli province there are three clasps. It has not been possible for me to draw up a proper distribution map, with differing sizes of dots, because the provenances are given either as such and such a district or such and such a province. In some cases the districts marked on the map are within provinces which are also marked. Further, a number of the provenances are "alleged", or the clasps have been found in secondary contexts such as churches.

Nevertheless, the map does give an approximate indication of the distribution of the clasps. Clearly the centre of production must have been somewhere in the triangle outlined by Oni, Chiatura and Tskhinvali. Other examples have been found to the east, south, and particularly the west, and there are a few occurrences on the north side of the Caucasus, but nevertheless there is a clear concentration in the provinces of Imereti and Western Kartli.

The dating of these clasps is a little more problematic than their distribution. As we have seen, more than one hundred and eighty examples are known but unfortunately the vast majority come from undated contexts, many having been recovered from early excavations where no careful note was taken of the related materials, and many having been found by chance. Indeed, we must always bear in mind the possibility that some of the clasps may be faked. In other cases clasps have been found in excavations but sometimes these excavations have not been properly published. As late as 1926 (p. 86), Miller was able to write: "Il faut remarquer que, jusqu'à présent, on n'a encore enregistré aucune travaille authentique de pareilles boucles dans les tombeaux". Hence it is not surprising that the dates suggested for these belt-clasps have varied considerably. Rostovtzeff (1920, p. 40) ascribed them to the period from the 2nd century BC to the 3rd century AD on the basis of the examples found in the cemeteries of Kamunta and Kambulta which date predominatly from the Hellenistic and early Roman periods. His successors, though, have not all followed this dating. Hančar (1930, p. 157) dates them vaguely between the appearance of the Scythians and the beginning of the Christian era. Kuftin (1941, pp. 25-30) believes that they belong to the first few centuries BC as a result of examining the finds associated with belt-clasps found at Rosenberg near Moltovo and in Manglissi, and the types of grave in which they occurred, and comparing them with those of other sites including Trialeti. Unfortunately, he was not able to locate some coins associated with the Manglissi finds. Carter (1957, p. 125) attributed the clasps to "the beginning of the Christian era". Tekhov's dating (1969, p. 59) is close to Rostovtzeff's in that he believes the earliest examples appeared in the 3rd century BC, but that the bulk of the clasps date from the 2nd century BC to the 1st-2nd centuries AD. Dr. Khidasheli (1972) argues for the same dates as Rostovtzeff, namely 2nd century BC to 3rd century AD. Professor Lorthkiphanidze of the Georgian Academy of Sciences broadly agrees with her opinion, but in a letter to Mr. Painter[5] he says that "such bronze clasps have, as far as I know, not yet been found in contexts reliably dated to a time earlier than the 1st century AD. They

normally occur in contexts of the 1st-3rd centuries AD". If this is true, I think we should certainly question the justification for pushing these belt-clasps back to the 3rd century BC. It seems unlikely that they should have been produced over a period of more than 500 years, although it is not impossible. In any event, those few examples which I have been able to follow up certainly date from the first two centuries AD. Thus there is a belt-clasp from the cemetery at Kldeeti near Zestaphoni which Lomatatidze (1957) dates to the 2nd century. The material from the cemetery clearly supports his dating, there being a glass unguentarium of typical 1st-2nd century type (Lomatatidze 1957, pl. XX:2), fibulae of the sort common in Roman contexts from the 1st century AD onwards (Lomatatidze 1957, pl. XIII:1-3), and jewellery in which extensive use is made of garnets (also a common feature in contemporary Parthian jewellery). Most convincing, however, is the numismatic evidence (Lomatatidze 1957, pl. XVIII): there are coins of Augustus and Antoninus Pius, a Parthian coin of the late 1st century AD, and a local imitation of a stater of Alexander with a distorted head of Athena on the obverse. At Sokhta in the Tskhinvali district the material associated with the belt-clasp found in Sepulchre 2 (Kuftin 1949(1), pl. II) indicates a similar sort of date.

Surprisingly the date that seems to be appropriate for most of the clasps - 1st-2nd centuries AD - receives support from an unexpected quarter. All the clasps in the British Museum were analysed by Dr. Paul Craddock (see appendix 2) using the X-ray fluorescence technique, and while one of them (no. A1) was found to be a leaded tin bronze the other two (nos. 34, 124) transpired to be brass. Dr. Craddock's research has shown that although brass was known before the first century BC, it was extremely rare. A technological innovation, however, made the large scale production of brass feasible and by the 1st century AD brass was being widely used for decorative metalwork. The form of the two brass alloys, with insignificant quantities of lead and tin, leads Dr. Craddock to believe that the belt-clasps date from the 1st and 2nd centuries AD when alloys of this kind were most common.

Given that the belt-clasps come mainly from Imereti and Western Kartli and that they date from the 1st-2nd centuries AD, into what sort of cultural context can they be fitted? The Surami Mountains separate the modern provinces of Imereti and Kartli and, traditionally, the ancient kingdoms of Colchis and Iberia. As we have seen most, though certainly not all, of the clasps come from the mountainous area of Eastern Colchis. However, there is a difficulty in accepting that the clasps

were made by Colchian craftsmen. This is because certain
scholars, particularly Professor Lorthkiphanidze, are of
the opinion that at least from the 3rd century BC the
eastern areas of ancient Colchis were under the influence,
both cultural and political, of the East Georgian tribes.[6]
Lorthkiphanidze cites the results of his excavations at
Vani in Samtskhe province to support this point, and claims
that in addition to the archaeological evidence the
historical record also indicates that in the first centuries
AD the eastern provinces of Colchis were under the political
control of Iberia. Thus, Lorthkiphanidze concludes that the
belt-clasps must have been produced in the workshops of
Iberia. However, it seems to me that if this were really
the case then more clasps would undoubtedly have been found
in the centre of Iberia, in the area immediately to the
west of Tbilisi. Instead, we have only isolated examples
whose occurrence there is no doubt the result of trade.
Thus, I think we can fairly confidently ascribe these belt-
clasps to Colchis. As to what was happening in this area
in the 1st-2nd centuries AD, Colchis was conquered by Pompey
in 63 BC. A certain Aristarchus was appointed regent, and
Colchis became a Roman province. The population fiercely
resisted the Roman yoke, however, and the rebellion organised
by the Colchian slave Aniket in the late 1st century AD
brought Colchis a fair measure of independence, although
she remained under Roman domination (Mepisaschwilli and
Zinzadse 1977, pp. 17-18). In these circumstances the
degree of Romanization is not likely to have been considerable,
and we may imagine that Colchian craftsmen in the more
inaccessible mountainous areas of the country went on
producing locally-inspired works of art such as these belt-
clasps. I say "locally-inspired", and our next step must be
to see what justification there is for this. Are the clasps
the results of indigenous artistic traditions, or if not
where do the motifs and the manner in which they are executed
come from? Again, various opinions have been expressed about
the inspiration behind the clasps.

Rostovtzeff (1922, p. 40) believed that "they present
a curious mixture of Caucasian traditions and new motives
which were brought to the Caucasus by the Sarmatians from
Central Asia". On the other hand, Hančar (1930, p. 157)
thought that the clasps represent "altkaukasisches Kulturgut
in skythischer Kunstform". In Tekhov's opinion (1969, p.
59) both Sarmatian and Scythian influence may be detected in
the clasps, but he nevertheless emphasises the contribution
of local Caucasian tradition. Other scholars (e.g. Miller
1926, p. 88) have demonstrated the close connections between
our clasps and the incised belts of the Koban culture, and
Ann Farkas (Bunker, Chatwin and Farkas 1970, p. 57) suggests

that "the plaques may represent a very late product of the Koban culture of the north-central Caucasus". This idea has much to commend it, for as we shall see it is certainly true that many of the motifs on the belt-clasps and their manner of execution may be traced back to the products of the Koban culture.

The Koban culture (sometimes called the Koban-Colchian culture), named after a village in Northern Ossetia, seems to have had its origins in Transcaucasia. At its widest extent it was distributed over most of Western Georgia and a part of Eastern Georgia, as well as modern Ossetia including the north and south flanks of the Caucasus. The highpoint of this culture was from about the 11th to the 8th centuries BC, and to this period belong the beautifully incised bronze axes and belts that are well-represented in Western collections. Two of these bronze belts are now in the British Museum and although both were reputedly found in Iran, one in Azerbaijan and the other in Ardebil, they clearly have a Transcaucasian connection and can be associated with the Koban culture. On the first (Pl. 4a)[7] we see the curious interplay of figures that appears later on the belt-clasps: thus the bulls(?) at the right-hand end of the belt have birds perched on their backs and snakes in the front of their bodies. Similar birds are again associated with the bulls at the left-hand end, and beneath the pair of goats in the centre is another serpent. On the second belt (Pl. 4b)[8] there is a frieze of running animals, apparently bulls and goats, and again the presence of a bird. Both belts bear the framework of geometric ornament that characterises the belt-clasps, and some points about the treatment of the animals bear direct comparison. Of particular note are their arched backs and bowed necks, their slender waists, the gaping mouths of some of the beasts and the horns of an exaggerated size which, in the case of one pair of bulls, are viewed in a different plane to the animal's body. Another feature which both belts and clasps have in common is the occasional fantastic rendering of the animal's feet. More points of comparison may be noted on a bronze belt from the Trialeti area, now in the Georgian State Museum (Lang 1966, p. 46, fig. 5): here there are animals with their heads twisted over their shoulders, there are dogs between the legs or quadrupeds biting at their bellies, and amongst the other motifs there is even a fish. Some of the same features can be seen on a Koban-type axehead, now in the British Museum (BM 132619: Pl. 2c); on both sides of the blade is depicted the same prancing animal, with twisted neck and stylized feet.

To sum up, then, there are good grounds for thinking that the designs on our belt-clasps are essentially developments

of local Caucasian art-styles. Indeed, the selection of
motifs can be traced even further back than the Koban
culture. For example, on one of the silver vases from
Maikop (Hančar 1937, pl. XLVII), dating from the end of
the 3rd millennium BC, we have the familiar interplay of
animals, namely a snake, various quadrupeds and a bird
perched on the back of one of the animals. It has been
suggested that some Greek influence may be detected in the
belt-clasps, but I find this improbable unless it is in the
realistic portrayal of some of the horses. In any case,
the presence of Greeks in Colchis left little mark on its
material culture. There were Greek colonies on the eastern
coast of the Black Sea from about the 6th to 4th centuries
BC, but Greek culture does not seem to have spread inland
and even at the coastal sites there seems to be little
evidence for Hellenization (Lorthkiphanidze 1966, pp. 178-9).
Similarly, it seems unnecessary to look for Cimmerian,
Sarmatian or Scythian influences in the belt-clasps. In
fact, the Scythians seem to have assimilated ideas and
styles during their passage through the Caucasus rather
than imparting them to the local inhabitants. It may be
thought that the dates suggested for the belt-clasps, 1st-
2nd century AD, removes them too far from the Koban material
that we have looked at for there to be any direct line of
descent, but according to Sulimirski (1970, p. 359) current
opinion is that the Koban culture lasted until the 4th century
BC. And we must remember, as Rostovtzeff pointed out (1922,
p. 36), that the bronze belt-clasps are probably imitations
of similar plaques, he says made of gold or silver but we
may add wood, which were ornamented with filigree and attached
to some backing, perhaps of leather, by means of nails at the
corners. Thus we can certainly push the tradition back beyond
the 1st century AD and the connection with Koban metalwork
becomes clearer.

J. E. Curtis

Khidasheli's Catalogue

In the list below information about each piece is given in
the following order:-

a) Present location of the belt-clasp, followed by the
 inventory number of that institution, if known. The
 following abbreviations have been used for institutions:-

 BLKM - Borzhomi Local Knowledge Museum.

 BM - British Museum.

 GAM - Georgian Art Museum, Tbilisi.

 GSM - Georgian State Museum, Tbilisi.

 IHA - Institute of History of Art, Tbilisi.

 IHAE - Institute of History, Archaeology and
 Ethnography, Georgian Academy of Sciences,
 Tbilisi.

 KLKM - Kutaisi Local Knowledge Museum.

 KSM - Kutaisi State Museum.

 L - Hermitage, Leningrad.

 MC - Musée Cernuschi.

 MHM - Moscow History Museum.

 MMA - Metropolitan Museum of Art, New York.

 OLKM - Oni Local Knowledge Museum.

 SMKV - School Museum in Koreti Village, Sachkhere.

 TISR - Tskhinvali Institute of Scientific Research.

 TLKM - Tskhinvali Local Knowledge Museum.

b) Measurements, if known.

c) Figures appearing on the clasp in addition to the
 principal figure. These are indicated by the following
 letters:-

 B - Bird

 D - Dog

 DH - Deer's head

DHD	–	Double-headed deer or tur
F	–	Fish
FL	–	Foal
O	–	Ox
OH	–	Ox's head
RH	–	Ram's head
S	–	Snake
SP	–	Spiral design
T	–	Tur
X	–	Figure damaged or missing

In every instance I have listed Dr. Khidasheli's identifications, but in a few cases where it seems to me that these are incorrect I have indicated the alternative identification by placing in brackets the appropriate letter. For the difficulties involved in identifying some of the animal types, see above.

d) Find-spot, if known.

e) Publication references. I have added some to those given by Dr. Khidasheli in order to make it easier for Western scholars to find illustrations of the various clasps.

GROUP I: Central figure of deer with head turned back over its shoulder.

1. GAM: 2174. 9.5 cm x 9 cm. Figs. – DH(RH). Abkhazia. Khidasheli 1972, pl. I.

2. GAM: 3665. 9.5 cm x 9 cm. Figs. – DH. Ninotsminda Village, Kakheti.

3. L: KZ 5328. 9.6 cm x 8.4 cm. Figs. – DH.

4. MHM: 78939. 8.5 cm x 8 cm. Figs. – DH.

5. KSM: 54 06/5. 10 cm x 9.5 cm. Figs. – DH. Tchilvani Village, nr. Shorapani.

6. School Museum in Speti Village. 9 cm x 8.5 cm. Figs. – DH. Speti Village, Sachkhere.

7. IHAE. Figs. - DH. Bril Village, Ratcha, found in
 sepulchre by archaeological expedition in 1939.

8. GSM: 9-12:1. 10 cm x 9.5 cm. Figs. - B. Khidasheli
 1972, pl. II. Koridze 1961, pl. 12:2.

9. MHM: 78939. 10 cm x 9.5 cm. Figs. - B.

10. KSM: 5508. 10 cm x 9.5 cm. Figs. - B. Jrutchis
 Monastery, Imereti.

11. SMKV. 9.9 cm x 9 cm. Figs. - B. Koreti Village,
 Sachkhere. Koridze 1961, pl. 12:1 = p.86, fig. 18.

12. SMKV. 9.5 cm x 8.5 cm. Figs. - B. Mghvimevi Village,
 Sachkhere.

13. GAM: 2165. 11 cm x 10.5 cm. Figs. - B.

14. GAM: 2165. 10 cm x 9.5 cm. Figs. - B.

15. L: KZ 5209. 8.4 cm x 7.8 cm. Figs. - B. Purchased
 in Vladikavkaz (Dzaudzhikau).

16. L:KZ 5341. 8.3 cm x 7.5 cm. Figs. - B. Khidasheli
 1972, pl. III.

17. GAM:1273. 10 cm x 9.5 cm. Figs. - B. Katskhi Village,
 Chiatura; Amiranashvili 1961, pl. 19, top;
 Khidasheli 1972, pl. I.

18. GSM: 4-31:1. 10 cm x 9.5 cm. Figs. - B. Imereti.
 Koridze 1961, pl. 12:3.

19. OLKM:22. 8 cm x 7.5 cm. Figs. - B. Ontchevi Village,
 Ratcha.

20. OLKM:22. 8 cm x 7.5 cm. Figs. - B. North part of
 Ratcha district.

21. GSM: 66 - 09:70. Figs. - B. Nr. Manglissi Village,
 Kartli. Koridze 1961, pl. 12:4; Kuftin 1941, p. 27,
 fig. 29a.

22. IHA: 611. 10.5 cm x 10 cm. Figs. - B. Dorqashi
 Village, Sachkhere.

23. TLKM:$\frac{896}{759}$. 8.5 cm x 8 cm. Figs. - B. Ursdzuari
 Village, Tskhinvali. Tekhov 1969, p. 54,
 fig. 3:2.

24. IHAE. Figs. - B. Bril Village, Ratcha, found in
 sepulchre by archaeological expedition in 1939.

25. IHAE. Figs. - B. Provenance as 24.

26. IHAE. Figs. - B. Provenance as 24. Gobejishvili 1952,
 pl. L:3.

27. IHAE. Figs. - B. Provenance as 24.

28. IHAE. Figs. - B. Provenance as 24.

29. GAM:2180. 10.5 cm x 10 cm. Figs. - D. Abkhazia.
 Amiranashvili 1971, pl. 5, bottom; Khidasheli 1972,
 pl. II.

30. GAM: 2176. 10.5 cm x 10 cm. Figs. - D. Abkhazia.

31. GAM: 2179. 10. 5 cm x 10 cm. Figs. - D. Abkhazia.

32. IHA: 54. 10 cm x 9.5 cm. Figs. - D. Tchiora Village,
 Ratcha.

33. Kiev History Museum. Figs. - D. Cemetery of Kamunta.
 Chantre 1886, p. 54, fig. 29; Uvarov 1900, p. 350,
 fig. 276.

34. BM: 1921 -6-28, 2, (Pl. 1b). 10.2 cm x 9.7 cm. Wt.
 261 g. For analysis, see appendix 2. Figs. - D.
 Rioni Valley. British Museum 1925, pl. VII, top;
 Miller 1922, pl. XXVIII:2; 1926, pl. XXX:2; Read
 1921, pl. XXXII.

35. KSM: 5406/6. Tchilovani Village, Shorapani.

GROUP II: Central figure of deer looking straight ahead,
 except the unique plaque no. 86 which has as its
 principal figure a two-headed deer with a man
 sitting on its back.

36. GAM: 2175. 10.2 cm x 9.3 cm. Figs. - B, D, DH (OH).
 Abkhazia. Khidasheli 1972, pl. IV.

37. MHM: 78939. 10. 5 cm x 9.6 cm. Figs. - B, D, DH.

38. TLKM: 1792/302. 10. 3 cm. x 9.5 cm. Figs. - B, D, DH
 (OH). Ojora Village, Tskhinvali. Tekhov 1969,
 p. 54, fig. 3:1.

39. Whereabouts unknown. Figs. - B, D, DH (OH). Rioni Valley.
 Miller 1922, pl. XXIX:1; 1926, pl. XXXI:I.

40. KSM: 5424/2. 9.2 cm x 8 cm. Figs. B, D, DH. Church
 of the Archangel, Chebi Village, Ratcha.

41. KSM: 5447. 9.3 cm x 9.5 cm. Figs. - B, D, DH. Ratcha.

42. KSM: 5506. 10 cm x 9.5 cm. Figs. - B, D, DH. Church
 in Putieti Village.

43. Collection of David Kakabadze, Tbilisi. 10.5 cm. x 9
 cm. Figs. - B, D, DH.

44. GAM: A 64. 10.5 cm x 10 cm. Figs. - B, D, DH.
 Possibly from Khevsureti.

45. IHAE. Figs. - B, D, DH (OH). Bril Village, Ratcha,
 found by archaeological expedition. Gobejishvili
 1952, pl. XLIX:2.

46. IHAE. Figs. - D, DH, DH. Bril Village, Ratcha, found by
 archaeological expedition in 1939.

47. GAM: 2178. 9.5 cm x 9 cm. Figs. - B, D, F. Abkhazia.
 Khidasheli 1972, pl. IV.

48. MHM: 41865. 12 cm x 11 cm. Figs. - B, D, F.

49. IHA: 611. 11.5 cm x 11 cm. Figs. - D, D, F. Darqa
 Village, Sachkhere.

50. KSM: 5507. 12 cm x 11 cm. Figs. - D, D, F. Ghoresha
 Village, Kharagouli (Ordzhonikidze).

51. GAM: 8977. 11 cm x 10.5 cm. Figs. - B, D, F.

52. KSM: 5502/1. 11.3 cm x 10.5 cm. Figs. - D, D, F.
 Church of St. George, Gomi Village, Kharagouli
 (Ordzhonikidze).

53. Whereabouts unknown. Figs. - D, D (B), F. Rioni Valley.
 Miller 1922, pl. XXIX:2.

54. GAM: 2171. 11 cm x 10.3 cm. Figs. - D, D, S. Abkhazia.

55. GAM: 2172. 11 cm x 10.3 cm. Figs. - D, D, S. Abkhazia.

56. L: KZ 5327. 10.7 cm x 11 cm. Figs. - D, D, S.

57. GSM. 8.9 cm x 8.2 cm. Figs. - B, D, S. Dzami River
 Valley, Kareli.

58. GAM: 195. 10.8 cm x 8.2. cm. Figs. - D, D, S.
 Khidasheli 1972, pl. V.

59. MHM: 78939. Figs. D, D, S.

60. OLKM: 3442. Figs. D, D, S. 11 cm x 10 cm. Ratcha.

61. KSM: 5406/4. 12.5 cm x 11.3 cm. Figs. - D, D, S.
 Tchilovani Village, Zestaphoni.

62. School Museum in Speti Village. 10.5 cm x 9.8 cm.
 Figs. - D, D, S. Speti Village, Sachkhere.

63. IHA: 611. 12 cm x 11.5 cm. Figs. - D, D, S. Darqa
 Village, Sachkhere.

64. GAM: 01, no. 4. 11 cm x 10.5 cm. Figs. - B, D, S.

65. L: KZ 3318. 11 cm x 10.5 cm. Figs. - B, S, X,
 Komunati Village, Ossetia. Khidasheli 1972,
 pl. IV.

66. IHAE. Figs. - B, B, S. Ratcha, found by archaeological
 expedition.

67. Collection of T. Beridze. 8.5 cm x 8 cm. Figs. - B,
 D, SP. Dighomi, nr. Tbilisi.

68. GSM: 5 - 47:1. 9.5 cm x 9 cm. Figs. - B, D, SP.
 Tsalka district.

69. IHA: 416. 10.5 cm x 10 cm. Figs. - B, D, SP. Nestgum
 Village, Upper Svaneti.

70. KSM: 7351. 9.5 cm. x 9 cm. Figs. - B, D, SP.
 Skhvitori Village, Sachkhere.

71. Collection of J. Odisheli. 10.5 cm x 10 cm. Figs. -
 D, D, SP. Tskhrukveti Village, Chiatura.

72. MMA: 21.166.5 (pl. 1e). 11.4 cm x 11.4 cm. Figs. -
 B, SP, SP (B). Bunker, Chatwin and Farkas 1970,
 p. 47, top left; Carter 1957, pl. 32: C;
 Rostovtzeff 1922, fig. IE.

73. GSM: 66-08. Figs. - B, B, D. Manglissi Village, Kartli
 Koridze 1961, pl. 13:2; Kuftin 1941, p. 27, fig. 29b.

74. L: KZ 7644. Figs. - B, B, D. Khidasheli 1972, pl. VI.

75. KSM: 5502/2. 10.5 cm x 10 cm. Figs. - B, B, D.

76. TLKM: DP 1703:3. 10.3 cm x 10 cm. Figs. - B, B, D.
 Tskhinvali. Tekhov 1969, p. 53, fig. 2:7.

77. TLKM: DP $\frac{897}{780}$. 10.3 cm x 9.2 cm. Figs. - B, B, D.
 Sokhta, found in sepulchre 2 in 1926 by
 Sokhta archaeological expedition led by V.
 Pchelina. Kuftin 1949 (1), pl. III:2; Tekhov 1969,
 p. 53, fig. 2:6.

78. TLKM: DP 758. Figs. - B, B, D. 10.5 cm x 10.1 cm.

79. GSM: 9 cm x 8.6 cm. Figs. - B, B, D. Tabagreba
 Village, Chiatura.

80. School Museum in Tchala Village. 10.5 cm x 9.7 cm.
 Figs. - B, B, D. Prob. found nr. Tchala Village,
 Sachkhere. Koridze 1961, p. 91, fig. 21.

81. GSM: 6 - 49:4. 10.5 cm x 9.3 cm. Figs. - B, D.

82. GAM: 141. 11.5 cm x 10.5 cm. Figs. - B, B, D.
 Katskhi Village, Sachkhere.

83. GSM: $\frac{24-29}{2}$. 10. cm x 9.5 cm. Figs. B, B, B. Vani.

84. GAM: 2177. 10 cm x 9.5 cm. Figs. B, B, D. Abkhazia.
 Amiranashvili 1961, pl. 19, bottom; 1971, pl. 5,
 top; Khidasheli 1972, pl. V.

85. MHM: 99573. 9.2 cm x 8.3 cm. Figs. B, B, D. Qvirila
 Valley.

86. MHM: 54321. 10 cm x 10.5 cm. The composition comprises
 a 2-headed deer with snakes in front of each head, a
 human figure seated on its back and a dog beneath
 its belly. Ghebi Village, Ratcha. Gobejishvili
 1952, pl. XXXIII:3; Hančar 1935, pl. 13:2;
 Khidasheli 1972, pl. VII; Uvarov 1900, pl. CXXXIV:4.

87. GAM: 10 cm x 9.5 cm. Figs. - B, D, D. Putaro Village,
 N. Ossetia. Khidasheli 1972, pl. VII.

88. GSM: 13-59:1. 9.5 cm x 7.5 cm. Figs. - D, D. Ratcha.

89. IHAE. Figs. B, D, D. Bril Village, Ratcha, found by
 archaeological expedition.

90. KSM: 5505. 12.5 cm x 12 cm. Figs. - D, D, D. Valaeti
 Village, Ratcha.

91. KSM: 5463/1. 12.5 cm x 11.6 cm. Figs. - D, D, D.
 Sochkheti Village.

92. KSM: 5504. 12 cm x 11.5 cm. Figs. - D, D, O. Gomi
 Village, Ratcha.

93. TISR. 13.3 cm x 12.5 cm. Figs. - B, D, D. Patkneti,
 nr. Znauri. Tekhov 1969, p. 53, fig. 2:2.

GROUP III: Central figure of a "horse-deer" or a horse
 looking straight ahead. Miss Khidasheli regards
 nos. 119-20, 128-44 as proper depictions of horses,
 the remainder as composite beasts. I should
 prefer to regard most of the latter as deer, as
 they still retain antlers and appear to me to
 possess few equine characteristics.

94. GM: $\frac{6-02}{109}$ (1022). 13 cm x 12.5 cm. Figs. - D, D, D.
 Akhalsopeli Village, Ratcha. Koridze 1961,
 pl. 13:1.

95. GSM: 2;36:2. Figs. - D, D, D. Argveta Village,
 Sachkhere. Koridze 1961, p. 87, fig. 19.

96. GAM: 149. 11.5 cm x 11 cm. Figs. - D, D, D. Tluli
 Village, Ratcha. Khidasheli 1972, pl. VIII.

97. MHM: 54321. 11.5 cm x 11 cm. Figs. - D, D, D. Ratcha.
 Uvarov 1900, pl. CXXXIV:3.

98. TLKM: $\frac{1439}{428}$ 11.5 cm x 10.4 cm. Figs. - D, D, D.
 Jeri Village, Tskhinvali. Tekhov 1969, p. 53,
 fig. 2:5.

99. TLKM: DP 431. 11.5 cm x 10.5 cm. Figs. - D, D, D.
 Zghubiri Village.

100. GSM: 4-34:1. 14.5 cm x 14 cm. Figs. - D, D, D. Ghari
 Village, Ratcha.

101. KLKM: 5406/3. 12 cm x 11.5 cm. Figs. - D, D, D.
 Tchilovani Village, Shorapani.

102. Collection of V. Beridze. 12.6 cm x 12.1 cm. Figs. -
 D, D, D. Kldeeti, nr. Zestaphoni. Lomatatidze
 1957, pl. XIV:2.

103. GSM: 24-29:2. 10.5 cm x 9.6 cm. Figs. - B, D, D.
 Sadzeguri Village, Ksani Valley, Kartli.

104. BLKM: $\frac{751}{8-15}$ 13 cm x 12 cm. Figs. - B, D, D. Ratcha.

105. TLKM: DP 1813/306. 13.5 cm x 12.5 cm. Figs. - B, D,
 D. Tsnelisi Village, Tskhinvali. Tekhov 1969,
 p.53, fig. 2:1.

106. MHM. Figs. - B, D, D.

107. IHAE. Figs. - B, D, D. Shosheti Village, Ratcha, found
 by archaeological expedition in 1939.

108. IHAE. Figs. - B, D, D. Provenance as 107.

109. L: KZ 5202. 14.2 cm x 13.3 cm. Figs. - D, O, X.
 Cemetery of Kambulta. Khidasheli 1972, pl. VIII;
 Uvarov 1900, pl. XCVI:7.

110. TLKM: DP 1440/796. 13.5 cm x 12.4 cm. Figs. - D, D,
 O. Zghburi Village, Tskhinvali. Tekhov 1969, p. 51,
 fig. 1:5.

111. Wiener Völkerkundesmuseum. 14.4 cm x 13.5 cm. Figs. -
 D, D, O. Hančar 1930, p. 148, fig. 2; 1935, pl. 13:1.

112. TLKM: DP $\frac{892}{795}$ 13.5 cm x 13 cm. Figs. - D, D, O. Sokhta,
 found in Sepulchre 3 in 1926 by V. Pchelina.
 Tekhov 1969, p. 51, fig. 1:3.

113. TLKM: DP 757. 13 cm x 12 cm. Figs. - D, D, O (T).
 Orteushi Village, Tskhinvali. Tekhov 1969, p. 51,
 fig. 1:6.

114. TISR. 13 cm x 12.5 cm. Figs. - D, D, O. Patkneti, nr.
 Znauri, found in Sepulchre 3 in 1961 by B. Tekhov.
 Tekhov 1969, p. 51, fig. 1:1.

115. TLKM: 1704. 14.5 cm x 13.5 cm. Figs. D, D, O. Gromi
 Village, Tskhinvali. Tekhov 1969, p. 51, fig. 1:2.

116. MHM: 99573. 13 cm x 12 cm. Figs. - D, D, O. Qvirila
 Valley.

117. GSM: 43-06:1. Figs. - D, D, O. Surami area. Koridze
 1961, pl. 13:3=p.98, fig. 24.

118. TISR. 13.3 cm x 12.5 cm. Figs. - B, D, T. Provenance
 as 114, but Sepulchre 10. Tekhov 1969, p. 51, fig.
 1:4.

119. L : 5203. 14.2 cm x 13.8 cm. Figs. - D, FL, T.
 Dirgoni Village, Tskhinvali. Hančar 1935,
 pl. 13:3; Khidasheli 1972, pl. IX.

120. GAM: 140. 14 cm x 13 cm. Figs. - D, FL, O. Katskhi
 Village, Chiatura. Amiranashvili 1961, pl. 20,
 top; 1971, pl. 7; Khidasheli 1972, pl. IX; Koridze
 1961, pl. 14:1.

121. GAM: 3230. 13 cm x 12 cm. Figs. - B, D, DHD.
 Sachkhere. Khidasheli 1972, pl. X.

122. GSM: 2122-64. 13.5 cm x 13 cm. Figs. - B, D, DHD.
 Itkhvisi Village, Chiatura, found in a sepulchre.

123. GAM: 1195. 13 cm x 12 cm. Figs. - B,D, O.

124. BM: 1921-6-28, 1, (pls. 1a, 1f). 14 cm x 13.2 cm.
 Wt. 353 g. For analysis, see appendix 2. Figs. -
 B, D, O. British Museum 1925, pl. VII, bottom;
 Hančar 1935, pl. 13:4; Khidasheli 1972, pl. X;
 Read 1921, pl. XXXII.

125. GAM: 2170. 13 cm x 12 cm. Figs. - B, D, O.
 Bazaleti Village, Dusheti.

126. GAM: XV, 125. 13 cm x 12 cm. Figs. - B, D, O.

127. IHAE. Figs. - D, D, O. Shosheti Village, Ratcha,
 found by archaeological expedition. Gobejishvili
 1952, pl. L:1.

128. KLKM: 5424. 14 cm x 13 cm. Figs. - B, O, SP. Ghebi
 Village, Ratcha.

129. KLKM: 5509. Figs. - B, D, O. Kedisubani Village,
 Ratcha.

130. KSM: 5511. Figs. - B, D, O.

131. IHAE. 14 cm x 13.5 cm. Figs. - B, D, O. Nr.
 Avashkhieti Village, Ratcha, found in sepulchre
 by archaeological expedition in 1953.

132. IHAE. 14 cm x 13 cm. Figs. - B, D, O. Kvashkhieti
 Village, nr. Ratcha, found in a sepulchre by
 archaeological expedition in 1962.

133. L: 5338. Figs. - D, FL, O. Zegishi Village,
 Lechkhumi.

134. L: KZ 5200. Figs. - D, FL, O. Khidasheli 1972,
 pl. XI.

135. GSM: 13-28:1. 13 cm x 12.5 cm. Figs. - D, D, O.
 Gomi Village, Ratcha. Gobejishvili 1952, pl.
 XLIX:1; Koridze 1961, p. 100, fig. 25.

136. GSM: 8-52:1. 14.5 cm x 14.2 cm. Figs. - D, FL, O.
 Zekota Village, Khashuri.

137. KLKM. Figs. - D, FL, O. Akhalsepeli Village, Ratcha.

138. MMA: 21.166.7 (pl. 2a). 15.2 cm x 14.6 cm. Figs. -
 D, FL, O. Purchased in Gori. Carter 1957,
 pl. 32:b; Miller 1922, pl. XXX:2; 1926, pl.
 XXXI:2; Rostovtzeff 1922, fig. 1C.

139. GSM: $\frac{6-02}{108}$ (1021). 13 cm x 12 cm. Figs. - D, FL(B),
 O. Ghebi Village, Ratcha district. Hančar
 1930, p. 149, fig. 3; 1935, pl. 13:6;
 Kondakoff et al. 1891, p. 471, fig. 424;
 Koridze 1961, pl. XIV:3; Uvarov 1900, p. 351,
 fig. 277.

140. GSM: 9-25: 1-2. Figs. - B, D, O.

141. SMKV. 15.5 cm x 15 cm. Figs. D, FL, O. Mukhvi
 Village, Sachkhere.

142. SMKV. 14.5 cm x 14 cm. Figs. - D, FL, O(T). Koridze
 1961, pl. 14:2=p.92, fig. 22.

143. TISR. Only main figure can be distinguished.
 Patkneti, nr. Znauri, found in sepulchre in 1964
 by B. Tekhov.

144. TLKM: DP $\frac{893}{790}$ 9 cm x 8 cm. The composition comprises
 a man on horseback, with a bird sitting
 on the horse's rump and a spiral design
 in front of it. Ersdbuari Village,
 Tskhinvali, found in a sepulchre.
 Kuftin 1949 (1), pl. III:1; Tekhov
 1969, p. 54, fig. 3:4.

GROUP IV: Central figure of a goat, probably a tur (Capra
 caucasica) with its head turned to the front. In
 nos. 152-6, the plaque is divided into four equal
 compartments by bands decorated in the same way as
 the border of the plaque, and the same composition
 is reproduced in each of the four compartments.

145. OLKM: 244. Figs. - B with snake in its beak, D, D. Ratcha district.

146. BLKM: $\frac{750}{13}$. 12.5 cm x 12 cm. Figs. - D, D, D. Ratcha. Khidasheli 1972, pl. XII; Kuftin 1949 (2), p. 85, fig. 20.

147. GSM: 1-53:1. 10.4 cm x 10 cm. figs. - B, B, D. Khidasheli 1972, pl. XII.

148. MHM. 7.5 cm x 7.5 cm. Figs. - B, B, B (or animal's head?). Khidasheli 1972, pl. XII; Uvarov 1900, pl. CXXXIV:2.

149. GSM: 108-67:16. 10.5 cm x 9.5 cm. Figs. - B, D, D. Itkhvisi Village, Chiatura.

150. Akaki Tsereteli School, Sachkhere. 10.5 cm x 9.7 cm. Figs. - B, D, S. Speti Village, Sachkhere.

151. TLKM: 499. 10.5 cm x 9.5 cm. Figs. - B, D, S. Tighva Village. Tekhov 1969, p. 54, fig. 3:3.

152. GSM: 108-67:19. 11 cm x 10 cm. Itkhvisi Village, Chiatura.

153. OLKM: 3648. 13 cm x 12.5 cm. Figs. - B, S.

154. Kept in Speti Village, Sachkhere. Figs. - S. Found in Speti Village. Koridze 1961, p. 94, fig. 23.

155. Original missing. Figs. - S, S. Eichwald 1834-37, part II, pl. I:1. Kuftin 1949 (2), p. 82, fig. 19a.

156. Original missing. Figs. - S. Gvimé, Sachkhere. de Montpereux 1839-43, Atlas IVe Série, p. 33, fig. 2. Kuftin 1949 (2), p. 82, fig. 19b.

GROUP V: Central figure of a deer in running position, generally with legs curved round at the end, either looking straight ahead or back over its shoulder.

157. MHM: 44-31/2. 7.5 cm x 6.5 cm.

158. Akhaltzikhe Local Knowledge Museum. 7.5 cm x 6.6 cm. Khidasheli 1972, pl. XIII.

159. GAM: 2173. 9.3 cm x 8.2 cm. Figs. - DH(OH). Khidasheli 1972, pl. XIII.

160. L: KZ 5326. 8.9 cm x 8.6 cm. Figs. - DH(OH).
 Khidasheli 1972, pl. XIV.

161. L: 2051/1. 11.5 cm x 10.5 cm. Figs. - DH. Mingrelia.

162. KSM: 2706. 12.5 cm x 12 cm. Figs. - DH(OH), SP.
 Pipileti Village, Ratcha. Khidasheli 1972, pl. XV.

163. KSM: 5906. 12.2 cm x 11.3 cm. Figs. - DH(OH).
 Tchilovani Village, Shorapani. Khidasheli 1972,
 pl. XV.

164. L: KZ 5339. 16.3 cm x 17.5 cm. Figs. - D, DH(OH).
 Khidasheli 1972, pl. XVI.

165. GAM: 787. 9.5 cm x 9 cm. Figs. - D. Amiranashvili
 1961, pl. 18, top; 1971, pl. 6; Khidasheli 1972,
 pl. XVIII.

166. Akhaltzikhe Local Knowledge Museum. 9.6 cm x 9 cm.
 Figs. - DH(OH), SP. Khidasheli 1972, pl. XVIII.

167. BLKM: $\frac{753}{m-14}$. 16 cm x 13 cm. Figs. - D ?. Balanta
 Village, nr. Borzhomi. Khidasheli 1972,
 pl. XVII.

168. BLKM: $\frac{750}{m-12}$. 12.5 cm x 12 cm. Figs. - D ?
 Amiranashvili 1969, pl. 18, bottom;
 Khidasheli 1972, pl. XVII.

169. Collection of A. Sikharulidze. 17 cm x 15.5 cm.
 Trialeti.

170. OLKM. 8.5 cm x 7.6 cm. Figs. - B, D, SP. Ratcha
 district.

171. GAM: 7940. 12 cm x 11 cm. Sachkhere district.
 Khidasheli 1972, pl. XVIII.

<u>Addenda</u> - clasps in western collections not included in
K's catalogue.

A1 BM: 135977 (fig.4). Formerly in the Seligman Collection.
Central figure = deer looking straight ahead. 10.8 cm
x 9.7 cm. Wt. 176 g. For analysis, see appendix 2.
Figs. - B, D, F. Hansford 1957, no. A127, pl. LII.

A2 MMA: 21.166.2. Central figure as above. As extant,
10.2 cm x 8.9 cm. Figs. - D, X, X.

A3 MMA: 21.166.6 (fig. 8). Central figure = deer in
running position. 13.7 cm x 12.7 cm. Figs. - SP.
Rostovtzeff 1922, fig. ID.

A4 MC: 6853. Central figure = deer with head turned back
over its shoulder. Figs. - B. Watelin 1925, pl. IX.

A5 MC: 7193. Central figure = deer looking straight ahead.
Clasp fragmentary. Figs. - D, X, X.

A6 MC: 7194. Fragmentary.

A7. MC: 8984 (fig. 3). Central figure = deer with head
turned back over its shoulder. Figs. - RH.

A8 Formerly in collection of Col. N.R. Colville. Central
figure as above.

A9 Formerly in collection of Col. N.R. Colville, Central
figure = deer looking straight ahead. 11.4 cm x
10.8 cm. Figs. - B, D, S. Sotheby's 1975, no.
242 (illust.).

A10 Norbert Schimmel Collection. Central figure as above.
12.8 cm x 12.3 cm. Figs. - D, D, D. Bunker, Chatwin
and Farkas 1970, p. 47, top left; Muscarella 1974,
no. 166.

NOTE ON THE COMPOSITION OF THE THREE BELT CLASPS IN THE
BRITISH MUSEUM

By P.T. Craddock

A semi-quantitative analysis of the uncleaned surfaces of the
buckles was performed by X-ray fluorescence in order to
determine the nature of the alloy used. It must be stressed
that these analyses are not exact and that any trace elements
present were not determined.

The clasp cat. no. A1 was made of leaded tin bronze
containing about five to ten percent each of tin and lead in
the copper. The two clasps, cat. nos. 34, 124 are both of
brass, containing about ten percent of zinc with about one
percent of iron, and only traces (below one percent) of
lead and tin in the copper.

Recent research (Craddock 1977) has shown that although
brass was known, its use was exceedingly rare before the first
century B.C. when the cementation process which involved
smelting the zinc ore, calamine with charcoal *in situ* with
pellets of copper in a closed crucible was introduced. After
this brass became very popular in the Roman Empire for most
of the articles for which tin bronze had once been used, and
the two alloys were used simultaneously. Brass proved
especially popular for decorative metalwork such as the belt
clasps discussed here, and by the first century A.D. three
quarters of the decorative metalwork had zinc as a definite
addition with an average zinc content of about 12 percent.
Little is yet known of the contemporary alloys produced by
the peoples living on the fringes of the Empire, but within
Rome's trading area, and therefore these analyses provide a
useful insight into this problem.

It is especially interesting to note that the composition
of this small group by including both leaded bronze and brass
is a microcosm of the whole range of Roman decorative metal-
work, suggesting that there was either strong technical
influence or direct importation of brass metal from the
Romans. The latter is thought more probable, the suggestion
(Caley 1964) being that such brass as was used beyond the
frontier of the Empire was made within the Empire and
exported as ingots, or as finished articles which were
subsequently melted down and re-used. An analogous situation

exists with the massive arm bracelets from the North of Britain, dating from the first centuries A.D., and made just outside the Empire (Brailsford 1975, p. 80). Of the seven for which analyses were published, four were of bronze and the remainder were of brass containing about ten percent of zinc with several percent of tin and lead.

Brass produced by the cementation process usually contains between twenty two and twenty eight percent of zinc, but from the first century A.D. the Romans preferred an alloy containing between ten and fifteen percent of zinc, made up by diluting the cementation brass with roughly its own weight of scrap bronze or copper. Now, the private smiths making fibulae, rings, etc. tended to add scrap bronze to their brass, whereas the Imperial smiths making coins or military trappings tended to mix their brass with pure copper, and the diluted brass contains only traces of tin or lead. The two brass belt clasps discussed here come in this latter category, in contrast with the British arm bracelets which contain several percent in tin and lead. This suggests that the metal from which the clasps were made emanated originally from an Imperial workshop either in the form of an ingot or a finished product, to be used later by the makers of the belt clasps. Alloys of this kind were only common during the first and second centuries A.D. and this would suggest the belt clasps are of this date rather than earlier.

Thus the study of the composition of these ancient pieces of metalwork can yield information not only on the artefacts themselves, but also throw some light on the trading and commercial relations at and beyond the edges of the Roman World.

BIBLIOGRAPHY

Amiranashvili, S., 1961, *Karthuli Khelovnebis istoria*, Tbilisi. (In Georgian, no summaries).

Amiranashvili, S., 1971, *Georgian Metalwork from Antiquity to the 18th century*, London.

Barnett, R.D., and Curtis, J.E., 1973, 'A Review of Acquisiitions 1963-70 of Western Asiatic Antiquities (2)', *BMQ* XXXVII, pp. 119-137.

Brailsford, J., 1975, *Early Celtic Masterpieces from Britain*, London.

British Museum, 1925 = *British Museum : Guide to the Iron Age Antiquities*, 2nd ed., London.

Bunker,E.C., Chatwin,C.B., and Farkas, A.R., 1970 *'Animal Style' Art from East to West*, New York.

Caley,E.R. 1964, *Orichalcum and Related Ancient Alloys*, New York American Numismatic Society, no. 51.

Carter,D., 1957, *The Symbol of the Beast: the Animal-Style Art of Eurasia*, New York.

Chantre, E., 1886, *Recherches Anthropologiques dans le Caucase*, vol.2, Paris.

Craddock, P.T., 'The Composition of the Copper Alloys used by the Greek, Etruscan and Roman Civilizations,3: The Origin and Early Use of Brass', *Journal of Archaeological Science* IV (forthcoming).

Eichwald, E., 1834-37, *Reise auf dem Caspischen Meere und in den Kaukasus*, vol.I, 2 parts, Stuttgart.

Gobejishvili, G., 1952, *Arkeologiuri gathkhrebi sabdchotha Sakarthveloshi*, Tbilisi. (In Georgian, no summaries).

Hančar, F., 1930, 'Gürtelschliessen aus dem Kaukasus', *Eurasia Septentrionalis Antiqua*, VI, pp. 146-58.

Hančar, F., 1935, 'Ross und Reiter im Urgeschichtlichen Kaukasus', *Ipek*, pp. 49-65.

Hančar, F., 1937, *Urgeschichte Kaukasiens*, Vienna.

Hansford,S.H., 1957, *The Seligman Collection of Oriental Art*, vol. 1, London.

Khidasheli,M.S., 1972, *Brinjaos mkhatvruli damushavebis istoriisathvis anticur Sakarthveloshi*, Tbilisi. (In Georgian with Russian summary).

Kondakoff, N., Tolstoi,J., and Reinach,S., 1891, *Antiquités de la Russie Méridionale*, Paris.

Koridze, D.L., 1961, *Materialuri kulturis udzvelesi dzeglebi Sachkheris Raioni*, Tbilisi. (In Georgian with Russian summary).

Kuftin, B.A., 1941, *Arheologiceskie Raskopki v Trialeti*, Tbilisi.

Kuftin, B.A., 1949(I), *Arheologiceskaya marsrutnaya ekspediciya 1945 goda v Yugo-Osetiyu i Imeretiyu*, Tbilisi.

Kuftin, B.A., 1949(2), *Materialy k Arheologii Kolhidy*, vol.I, Tbilisi.

Lang, D.M., 1966, *The Georgians*, London.

Lomatatidze, G.A., 1957, *Kldeetis samoravani akhali dseltaghritskhvis II saukunisa*, Tbilisi. (In Georgian with Russian summary).

Lorthkiphanidze, O.D., 1966, *Anticuri samqaro da dzveli Colkethi*, Tbilisi. (In Georgian with Russian and English summaries).

Lydekker, R., 1898. *Wild Oxen, Sheep and Goats of All Lands, Living and Extinct*, London.

Mepisaschvili, R., and Zinzadse, W., 1977, *Die Kunst des alten Georgien*, Leipzig.

Miller, A.A., 1922, 'Izobraženiya sobaki v drevnostyah Kavkaza', *Izvestiya Rossiĭskoĭ Akademii Istorii Materialnoĭ Kultury*, II, pp. 287-324.

Miller, A.A., 1926, 'Les Représentations du Chien dans les Antiquitiés du Caucase', *Revue des Arts Asiatiques* III, pp. 81-102.

de Montpereux, F. Dubois, 1839-43, *Voyage autour du Caucase*, 6 vols. + atlas, Paris.

Muscarella, O.W.(ed.), 1974, *Ancient Art : The Norbert Schimmel Collection*, Mainz.

Painter, K.S., 1973, 'Four bronze belt-clasps from Georgia, U.S.S.R.,' *AJ* LIII, pp. 274-5.

Read 1921 = Anon., *Charles Hercules Read. A Tribute on his Retirement from the British Museum.....*, London 1921.

Rostovtzeff, M., 1922,'Bronze Belt-Clasps and Pendants from the Northern Caucasus', *Bulletin of the Metropolitan Museum of Art* XVII, pp. 36-40.

Sotheby's 1975 = *Catalogue of Sale of Antiquities on 21st April, 1975.*

Sulimirski, T., 1970, *Prehistoric Russia : an Outline,* London.

Tekhov, B.V., 1969, 'Ob ažurnyḫ poyasnyḫ pryažkaḫ iz Yugo-Osetii', *Sovetskaya Arheologiya* no. 4, pp. 49-61.

Uvarov, P.S., 1900, *Mogilniki Svernago Kavkaza* (Materialy po Arheologiya Kavkaza VIII), Moscow.

Watelin, L.-Ch.,1925, 'Les Scythes et l'Art', *Revue des Arts Asiatiques* II, pp. 27-30.

NOTES

1. It was originally Mr. Painter's intention to publish an
 article on these belt-clasps himself, and with this
 in mind he prepared a preliminary account of them which
 appeared in 1973 (Painter 1973). Since then he has
 been deflected onto other projects and has very
 generously passed on to me his files on these belt-
 clasps. I am much indebted to Miss Dragadze for her
 translation, without which this work would not have
 been possible. The drawings of the bronze belts
 are by Miss Ann Searight, to whom best thanks are
 due. I am also very grateful to Prof. D. M. Lang,
 who helped with the location of a book in Georgian,
 and to Dr. P. Luft, Mr. T. Forbes and Miss G.
 Tesmer who translated for me some passages in Russian.

2. For descriptions of the tur and markhor, with excellent
 illustrations, see Lydekker 1898, pp. 242-53, 286-96.

3. Published clasps which Dr. Khidasheli has apparently not
 included in her catalogue, and the whereabouts of
 which are unknown to me, are: Uvarov 1900, pl.
 CXXXIV:1; Eichwald 1834-7, part II, pl. I:2; de
 Montpereux 1839-43, Atlast IVe Série, pl. 33, fig. 3.

4. It has recently been brought to my attention by Dr. E. C.
 Bunker that there are three belt-clasps, apparently
 of similar type, in the Heeramaneck collection at the
 Los Angeles County Museum.

5. Dated June 1973. I am most grateful to Mr. Painter for
 putting this letter at my disposal.

6. Letter to Mr. Painter of June 1973.

7. BM 134734. L. 82 cm. Photograph published Barnett and
 Curtis 1973, pl. LII a.

8. BM 135153; L.75 cm.

la. Reverse of bronze belt-clasp. British Museum no.
 1921-6-28,1 (pl. lf) showing tongue and ring
 fitting.

lb. Bronze belt-clasp. British Museum no. 1921-6-28,2.

lc. Bronze belt-clasp. Courtesy Musée Cernuschi.

ld. Bronze belt-clasp. British Museum no. 135977.

le. Bronze belt-clasp. Courtesy The Metropolitan Museum
 of Art, Rogers Fund, 1921.

lf. Bronze belt-clasp. British Musuem no. 1921-6-28,1.

2a. Bronze belt-clasp. Courtesy the Metropolitan Museum
 of Art, Rogers Fund, 1921.

2b. Bronze belt-clasp. Courtesy The Metropolitan Museum
 of Art, Rogers Fund, 1921.

2c. Bronze axehead of Koban type. British Museum no.
 132619.

3. Map of Georgia showing distribution of the belt-clasps.

4a. Bronze belt with incised decoration in the Koban style.
 British Museum no. 134734. Drawing by Miss A.
 Searight.

4b. Bronze belt with incised decoration in the Koban style.
 British Museum no. 135153. Drawing by Miss A.
 Searight.

Plate 1

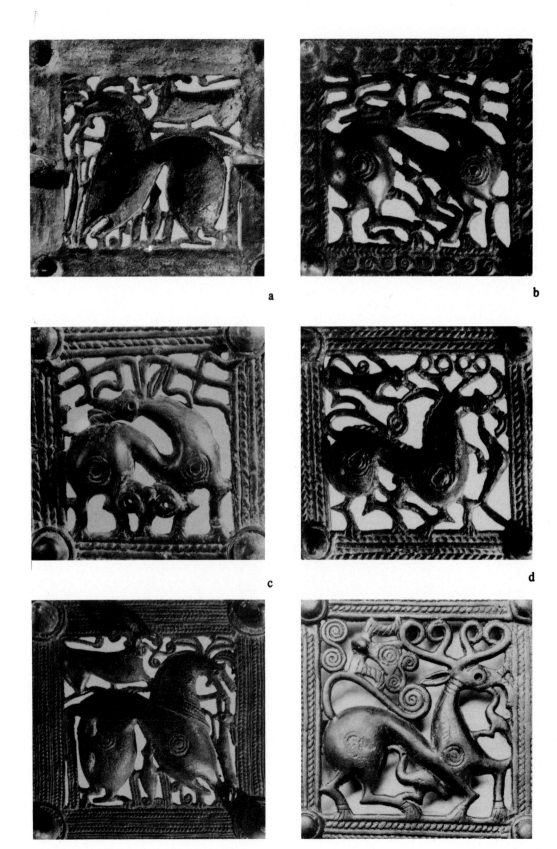

a

b

c

d

e

f

Plate 2

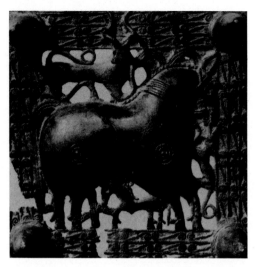

a

b

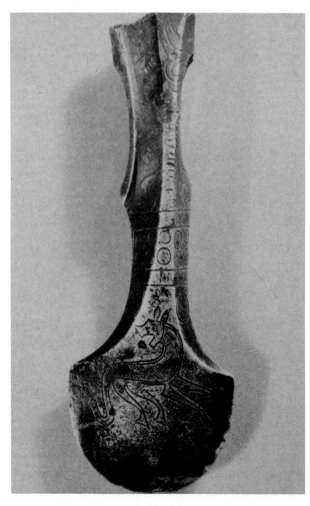

c

118

Plate 3

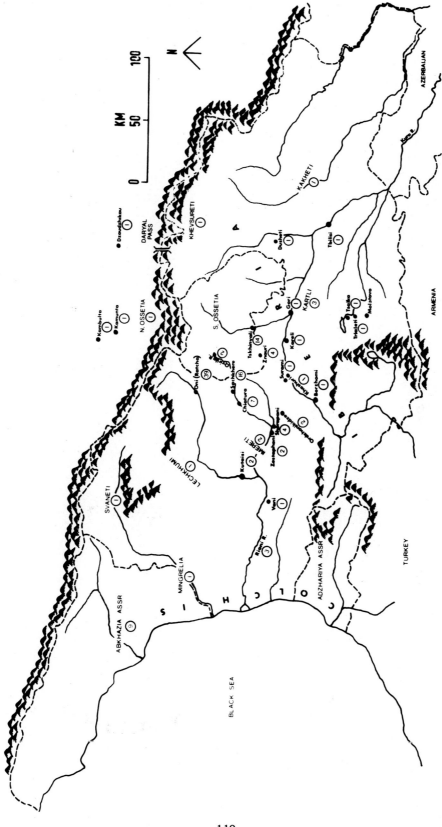

119

Plate 4

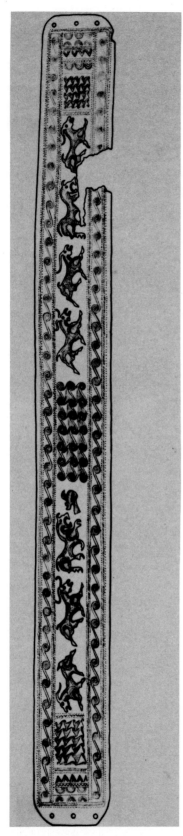

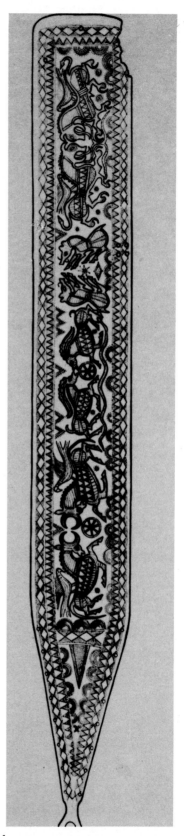

a

b

The importance of the few small 'Anecdotal' Plaques, which
depict scenes of human activity in a landscape setting, and
the highly accomplished pictorial tradition they reflect has
been greatly overshadowed by the more exotic appeal of the
numerous 'Animal Style' plaques with their intriguing
configurations of birds and beasts.

These small 'Anecdotal' Plaques originally adorned the
belts of the horse-riding tribes who roamed the Eastern Steppe
regions during the latter half of the first millennium B.C.
as part of their personal paraphernalia. A great oral epic
tradition[1] which emphasized heroic deeds and rituals evolved
among these tribes, which must have been illustrated on
brilliantly coloured textiles, the knowledge of which would
have perished with time except for their faint echoes on
the 'Anecdotal' plaques. Many of these plaques can now be
dated in accordance with recently excavated examples and
shown to be contemporary with certain 'Animal Style' Plaques,
which adds a narrative dimension to the Art of the Steppes,
a feature sorely overlooked by the authors of the Animal Style
Show,[2] while a careful examination of their stylistic sources
and continuations reveals tantalizing relationships, not only
with the early cultures of Asia but those of Medieval Europe.

The first group consists of a pair of mirror-image gold
openwork horizontal B-shaped plaques which illustrate a
reclining warrior with Mongoloid features. His head lies in
the lap of a seated female and his body across the knees of
an accompanying warrior who holds the reins of two waiting
horses beneath a weeping leafy tree on which hangs his gorytus
(Pl. 1a). The pair first entered the Collection of Peter the
Great of Russia in 1716, with other pieces as a gift from
Prince Gagarin, the Governor of Siberia, with no precise
provenance.[3]

Scholars have already noted the many similarities
between these plaques and the famous 4th century B.C.
Pazyryk wall hanging[4] which depicts a mounted warrior wearing
a gorytus approaching a seated goddess, an exotic scene for
the Siberian area.[5] The tall, aquiline horses with long
slender legs, the warriors' clothing and the female's head-
dress on the plaques are not typical of the Altai, but point
to a Central Asian origin by comparison to the seated man
with Mongoloid features and his horse on a bronze 5th-4th
century B.C. altar (Pl. 1b) from Alma Ata,[6] an area which
was inhabited by a composite group of tribes comprehensively

known as "Saka" from about the 7th to 4th centuries B.C.

Parallels for the composition of the Pazyryk hanging are numerous in the art of the Scythians and Sarmatians.[7] A most elaborate version can be identified among the Roman-period tomb murals at Kerch,[8] a Bosphoran kingdom with a Scythian-Sarmatian heritage. There the deceased is represented as a mounted hero approaching a goddess seated beside a tent near a tree on which his gorytus is hung. The same basic scene occurs much later in Scandanavian art[9] where it illustrates a mounted warrior's welcome to Valhalla. The composition of a seated deity being approached by a lesser deity or mortal goes back ultimately to ancient Near Eastern conventions, but the warrior on horseback, frequently holding or receiving a vessel, seems to be an invention of the Steppes. Curiously enough, the vessel-toting horseman reappears among the 7th century figures at Dandan Uilig,[10] presumably then to attract the local knightly princedoms to Buddhism. In spite of the exotic nature of the subject matter, the Pazyryk hanging was locally made copying something foreign. The woman interred in Kurgan V with the hanging wore a wooden headdress similar to those on the plaques. Jettmar[11] has suggested that she was a foreign princess with her own customs, which inspired the hanging and perhaps even the belt plaques.

The plaque scene has no counterpart in either the early art of China or the Near East, but can be found centuries later in early Medieval Hungary where it illustrates a motif in the St. Ladislav legend,[12] which preserves earlier pagan myths from the ancient Turkish epic Er Targhyn, suggested by Haskins as a possible interpretation for this scene.[13]

This second group consists of a pair (Pl. 2a) of magnificently inlaid gold openwork plaques of horizontal B shape which illustrate a mounted warrior pursuing a boar while his companion still holding his horse's reins climbs a tree for safety in a landscape setting inhabited by an ibex. This pair of plaques was also part of the Gagarin gift to Peter the Great, so again has no specific provenance.[3]

These have been published extensively,[14] but there are still a few points that need to be mentioned here. The galloping hero-hunter of epic tradition obviously represents an entirely different tradition than that which inspired the previous plaques discussed. Ethnically he is a Europoid with his long hair caught up in a knot at the nape of his neck, and his weapons are a long sword on the left and a bow with a long case[15] which hangs on the right. The sword is

attached to the belt by means of a scabbard slide, first
invented along with the long equestrian sword and leather
belt in South Russia from where it ultimately spread to
the north borders of China.[16] The hunter's horse is shown
racing along in a 'flying gallop' with the back hooves
flipped up to emphasize the great speed.

The panoramic hunt with such superb integration of
figures and landscape has no existent prototype either in
the Far East or Western Asia, only later examples. There are
no mounted riders on the late Chou pictorial vessels;[17]
echoes only of this motif occur as exotic intrusions in the
art of Han China[18] and Koguryo Korea.[19] In both, the back
hooves are flipped up in the same fashion as those on the
belt plaques.

An Archaemenid example from the Oxus Treasure shows
a galloping horseman, but there is no setting and the back
hooves turn down, resulting in a strangely earthbound quality
typical of Near Eastern Art.[20] The same result is achieved
by the representations of mounted horseman in Parthian art.[21]
The closest parallel, including the sword carried on a slide
and the back hooves flipped up, occurs on a provincial
Sasanian-period hunting plate from Perm which depicts
Shapur II.[22] The hooves are not flipped up on most Sasanian
examples in typical Near Eastern fashion,[23] but on a few
provincial works what must have been a Central Asian
convention prevails rather than a court fashion. When the
hooves flip up in T'ang art, the motif can be traced to a
Sasanian-derived style which has been filtered through Central
Asia. The motif with flipped-up hooves also occurs in early
Medieval Europe on an Avaric strap end,[24] further proof of
a Steppe origin[25] for this motif which the Avars must have
brought with them when they migrated from Asia in several
waves from the 6th century A.D. on.

The third group (Pl. 2b) consists of several
rectangular bronze plaques which depict two male figures
wrestling while their horses watch patiently and a bird
hovers above in a wooded area. A pair of these plaques was
recently excavated by the Chinese in a late Warring States
burial level and ascribed to the Hsiung-nu, a powerful horse-
riding tribe who dominated the Eastern Steppe regions during
the latter part of the first millennium B.C.[26] They were
found close together at the waist, which further supports
their identifications as belt buckles.[27] The horse-trappings,
costumes and hair styles are identical to those portrayed on
the pair of hunting plaques.

The combat is apparently ritualistic, as neither

opponent is designated the winner nor is death implied.
Rostovtzeff pointed out that such wrestling matches could
be found in Tibetan and Mongolian versions of the Kesar
Saga,[28] which usually ended in comradeship. The fashion in
which the bodies of the wrestlers cross each other as they
grab for each other's belts has a long history in Near
Eastern art.[29] It is significant to emphasize the importance
attached to a warrior's belt in most equestrian cultures
which by Avaric times was the exclusive horseman's regalia
denoting clan and rank and was never worn by an infantryman.[30]

The artistic continuations of this composition are
intriguing and far-reaching. Two wrestlers in the same pose
occur alone on a small Scythian gold plaque from Chmyreva
Mogila,[31] the Avaric Snartino sword,[32] and on a 12th-13th
century A.D. relief in Kubachi,[33] while the full scene
including horses and trees can be recognized on a Sasanian-
period bowl from the Urals.[34] In the Far East, the wrestlers
with crossed bodies occur under a tree at T'ung-ku[35] in
Korea, but seem not to have appealed to the Chinese.

The fourth group of plaques (Pl. 3a) are horizontal
B-shaped and illustrate a two-wheeled cart drawn by a pair
of reindeer. A feline stalks the cart top, while a mounted
rider with drawn sword reaches out toward a dog struggling
with a pot-bellied demon. Several examples of these exist
and a pair was recently excavated in a cemetery at Hsi-ch'a-
kou, North East Liaoning province, which has been dated 2nd
century B.C. and credited to the Hsiung-nu,[36] whose northern
campsites were in the Baikal regions where reindeer-using
groups are recorded.[37] The costume and hairstyle continue
the same fashions worn on the Hunting and Wrestling plaques,
and the trees are rendered in a similar manner. The fore-
shortened view of the horse and rider suggests knowledge of
a highly developed pictorial tradition which could achieve
a certain three dimensionality, a convention already found
in Greek painting which was well known in the Bactrian
area of Central Asia by the end of the 4th century B.C.[38]

The fifth type (Pl. 3b) is represented by a single
bronze openwork horizontal B-shaped plaque in the Sackler
Collection which depicts a standing male holding a sword
in front of a two-wheeled cart drawn by three horses or
asses with a bird on their rumps and a dog behind.[39] There
are no excavated examples of this type, but the style is
certainly a continuation of the previous group which was
assigned to the Hsiung-nu, whose form of sword worship as
a symbol for their God of War may well be indicated here.[40]
A related rectangular plaque (Pl. 4a) displays two very
similar standing warriors wearing the same trousers and

belted jackets. The figures have knotted hair and appear to hold swords in the same manner; otherwise, the design is too disintegrated to discuss.[41] The addition of four swans suggests a remote Altaic ancestry, but the blank space in the centre is presently inexplicable.

There is only one example of the sixth type, (Pl. 4b) a heavy bronze openwork plaque illustrating two mounted warriors, one of whom carries a hunting falcon on his right fist. This was also excavated at Hsi-ch'a-kou,[36] but displays an entirely different style than the other plaques from this site. According to the Chinese, the major graves belong to the Hsiung-nu, while the minor ones are Wu Huan, a subjugated sub-tribe.[42] The published reproduction is rather poor, but a careful study shows that the costumes, horse trappings and weapons appear to be related to those on the Hsiung-nu plaques, but the mounts are fantastic creatures, of which the last displays a tail which terminates in an eared birdhead of Altaic style. Stylistically, the plaque belongs with the type of plaque illustrating a wolflike creature with the same eared birdhead mane and tail ends, which was found in a Hsiung-nu context in Minusinsk,[43] where it was again an exotic element but an obvious descendant of a creature[44] which adorns several of the Peter the Great plaques (Pl. 5a).

The seventh type (Pl. 5b) is an unpublished bronze openwork plaque depicting a nomad family on trek. No excavated examples exist, but certain stylistic similarities in the tree forms relate it to the Hsiung-nu plaques already discussed.

The last type is a bronze fragment of a rectangular openwork plaque recently excavated at Djalainor, Heilungkiang province in North China and described by the Chinese as depicting men slaughtering a cow.[45] The accompanying illustration makes it impossible to comment further, other than to point out that it adds a hitherto unrecorded scene to the list of 'Anecdotal' plaques. Several badly degenerated versions of earlier plaques found in Hsiung-nu context also occur at Djalainor, which is dated Eastern Han and credited to the Hsien-pi, the tribe which superseded the Hsiung-nu in 155 A.D.

Draft animals and carts, domesticated hunting dogs and falcons, superbly armed horsemen and equipped horses, human figures in landscape settings, a rich narrative tradition, and the ability to illustrate it - these are the major characteristics of Far Eastern Steppe art demonstrated by the 'Anecdotal' plaques, which appear to range in date from the fourth century B.C. until the 2nd century A.D. The first

plaques discussed can be safely dated to the 4th century B.C. by their affinities with the scene on the Pazyryk hanging. The Hunting plaques belong to the same period for technical reasons. Both have the appearance on the reverse of a coarse fabric, a briefly-employed method for strengthening the wax model in the casting process.[46] Several of the 'Animal Style' horizontal B- (Pl. 5a) and rectangular-shaped pairs of belt plaques in the Peter the Great Treasure also display this feature,[47] conclusive evidence for the co-existence of both schemes in the art of the Far Eastern Steppe tribes. The majority of pieces that were cast in this manner are of precious metals, and only an unimpressive handful are of gilt bronze or just bronze.[48] This casting peculiarity must have been shortlived and mainly employed when using gold, since it strengthened the mold, while allowing for a thin final product desirable for economic reasons which were no longer as important when working with bronze. None of the other 'Anecdotal' plaques were cast with fabric, and are therefore later in date, a fact borne out by recent excavations. The excavated bronze Wrestling plaques show no sign of this technique though found in a late Warring States level. The rest of the plaques are stylistically related to or identical to excavated examples from Han-period tombs, so can be dated accordingly. Nevertheless, there is a curious feeling of time lag, and it may be that some of the excavated belt plaques are earlier than their interment due to their symbolic value, and therefore treasured items which would have perhaps been passed down to subsequent generations rather than buried.

There is no doubt that the 'Anecdotal' plaques are translations into metal of a highly advanced pictorial tradition about which we know very little. Although many of the artistic conventions used had their ultimate origin in the art of the ancient Near East, their unique combinations on these plaques must echo a tradition which evolved and flourished in the Central Asian mileu away from the court centres along the ancient trade routes where the added element of Hellenism enriched the artistic blend. This would explain their artistic continuations in the Far East and differences from Near Eastern court art, as well as affinities with the Migration period of the Middle Ages, so much of whose culture stemmed from the Steppe equestrian cultures of Central Asia, the area in which Jettmar[49] and Hancar[50] suggested that the 'Animal Style' was born and the best horses were bred.

The existence of narrative wall hangings and carpets in Assyria and Persia, referred to by Xenophon,[51] and an early flourishing textile trade would explain the strong

Near Eastern flavour.[52] There is plenty of evidence in the Eastern Steppes for timber construction adorned with wall hangings and carpets on which epic narratives could have been represented, along with the traditional nomad tent.[53] Further evidence occurs among the textile finds at a Hsiung-nu cemetery in Noin-ula, some of which Barnett pointed out originated in Hellenized Bactria,[54] while others were obviously locally made. The Chinese had no strong narrative tradition until too late in the 1st millennium B.C., so the nomadic tribes of the Eastern Steppes continued to draw on the Near Eastern and Greek-inspired Central Asian traditions they already knew. On the other hand, the Scythian world changed from a Near Eastern to a Greek-dominated art, so that the few scenic textile fragments from their tombs only smack of the Classical world.[55]

The importance of ornate pairs of belt buckles is more than proven by recent excavations of Hsiung-nu tombs,[56] where even the high-ranking women were so adorned. Presumably they must have had some meaning, endowing the tribal wearer with either a rank or clan distinction, or the powers inherent in the 'Anecdotal Scenes' or the animal combats, both of which were equally employed. It is not without reason that the plaques would have copied a textile narrative design, or vice versa. On the great Noin-ula felt carpet the griffin's wings echo the inlay of a plaque in the Peter I Treasure,[57] while the curious stepped design on the border of the 'Anecdotal' Plaque (Pl. 3a) reflects a design found on Pazyryk textiles.[58]

The realism of details and frequent use of landscape elements must have been derived from Near Eastern Art,[59] but there is romanticism and poetic quality about the first two pairs of 'Anecdotal' Plaques that are unique for the period. The rush of the hunt (Pl. 2a) is echoed by the windswept trees, just as the weeping treeleaves introduce a quiet note of sadness into the Rest plaques (Pl. 1a). None of these qualities occur in either the art of the Far or Near East. Ghirshman is mystified by the realistic and dynamic qualities of a mounted archer whose horse has flipped-up hooves in Kirghiz art of the 7th-8th centuries A.D.,[60] so credits it to an amalgamation of Sasanian Persian and Chinese Art, without recognizing that the motif must have obviously come from an earlier Central Asian tradition, since Chinese T'ang art did not have the power to vitalize Sasanian art to this extent. A search for a source for this obviously non-Chinese motif led Alec Soper to the conclusion that it was based on a 'lost Achaemenid hunt',[61] which, had it existed, would have been a far more brutal combat, rather than a panoramic chase. Now, it seems more plausible to see

the hunting plaques and Central Asia as a source.

The question of authorship of the 'Anecdotal' Plaques is an extremely complex problem. All the excavated examples post-date the Peter the Great 4th century B.C. plaques and are associated with the Hsiung-nu. The same duality of 'Anecdotal' and 'Animal Style' plaques found among the 4th century B.C. plaques occurs again in the Hsiung-nu Han-period burials. The costumes and horsetrappings on the Han-period-excavated Hsiung-nu 'Anecdotal' Plaques continue the fashions earlier displayed on the 4th century B.C. Hunting plaques and the slightly later Wrestling Plaques. The 'Animal Style' plaques in the Hsiung-nu Han-period cemeteries continue to portray many of the same animals and compositions favoured on the 4th century B.C. fabric-constructed plaques. Some are horizontal B-shaped and some are rectangular, but almost all occur in pairs. The tree forms with lavishly inlaid leaves in the Hunting plaques are echoed by the tree forms with vestigial inlay cells on the late Warring States-period Wrestling plaques and the excavated Han-period plaques. The other Han-period plaques relate stylistically to the excavated ones, so belong to the Hsiung-nu scene, except for the Djalainor example which is too poorly illustrated to discuss. That cemetery has been credited by the Chinese to the Hsien-pi, another Mongolian tribe who vanquished the Hsiung-nu in 155 A.D., but the plaques from this site are really badly degenerated versions of earlier Hsiung-nu examples suggesting the last gasp of enervated Hsiung-nu work acquired by the conquerors.

The man on the Rest plaque has Mongoloid features. The Pazyryk kurgans contained Mongoloid as well as Europoid types. The tattooed man in Kurgan II had Mongoloid features,[62] and one of his major adornments was a horse-like creature with a beak whose antlers and tail terminate in eared birdheads like those on the 4th century B.C. plaques (Pl. 5a) and the 2nd century B.C. 'Anecdotal' Plaques (Pl. 4b). The quirk of turning an antler's endings into eared birds' heads is an exotic intrusion of Scythian invention[63] in the Altaic artistic scene and comes from the same world as the ritual of the Pazyryk hanging.

The long equestrian sword, slide, leather belt and the rest of that equestrian equipment were introduced into the Chinese world by the Yüeh-chih, according to Trousdale's recent masterful study on the subject.[64] The sword carried by the hunter on the gold plaques appears to be of Chinese manufacture,[65] but the features of the rider too closely recall early Gandharan representations of Kushans, the dominant group among the Yüeh-chih, who first preceded the

Hsiung-nu on the north Chinese border and were then driven West by them in the 2nd century B.C., ultimately to Bactria from where they eventually migrated to found the great Kushan empire of early India. Both of the gold 'Anecdotal' Plaques belong to the same technically related group as numerous 'Animal Style' examples with strong stylistic affinities with the Altai as well as continuations in the art of Noin-ula.[57] The Yüeh-chih may already have been on the north border of China by the 6th century B.C.,[66] so it would be perfectly possible that by the 4th century B.C. the equestrian sword they had inspired the Chinese to adopt was by workmanship superior and more desirable. According to the excavation reports, the swords in the later Hsiung-nu Han-period tombs were Chinese-made.[67]

The resulting archaeological picture is one of a vastly complicated cultural admixture among the Far Eastern Steppe tribes.[68] The Chinese tended to look down on all the barbarians as culturally inferior, in much the same way as the Greeks did the Scythians. Consequently, the term Hsiung-nu may well have actually been a glorified catch-all term employed by the Chinese for a huge confederacy[69] of related but ethnically mixed tribes of which the Hsiung-nu had become the dominant group by the 3rd century B.C.

It may be that the epic traditions, costumes, horse-trappings and weapons of the Europoid Yüeh-chih, the earlier ruling group, were adapted by the predominately Mongoloid Hsiung-nu, who must have been part of the vast Far Eastern tribal conglomeration long before they achieved supremacy, which would explain the continuation of 4th century B.C. Europoid features, costumes and traditions into later Hsiung-nu art, where the designs slowly tend to lose their vitality and degenerate into meaningless masses.[70] That both of these tribes must at one point have been part of the Altaic confederacy is evidenced by both a study of the artistic relationships and the burial affinities. The grave goods at Noin-ula, a major late Hsiung-nu site, differ from those in the Altai in that horse skulls and pigtails replace animals and women, nevertheless they represent a continuation of the same kind of rituals.[71]

No 'Anecdotal' Plaques postdate the fall of the Hsiung-nu in the 2nd century A.D. and no later great kurgans like those of the Altai or on the Noin-ula have been found. Apparently a rich period of Far Eastern Steppe culture had come to a close, but hopefully further excavations may uncover more textiles and plaques which may solve some

of the many still unanswered questions, and throw a new
light on their Central Asian sources.

Emma C. Bunker

NOTES

1. Chadwick, Nora K. and Zhirmunsky, Victor, *Oral Epics of Central Asia,* Cambridge, 1969.

2. Bunker, Emma C., Chatwin, C. Bruce and Farkas, Ann R., *Animal Style Art from East to West,* The Asia Society, New York, 1970.

3. Haskins, John F., "Targhyn - The Hero, Aq-zhunus - The Beautiful and Peter's Siberian Gold", *Ars Orientalis,* vol. IV, 1961, pp. 155-157.

4. Haskins, John F., "The Pazyryk Felt Screen and the Barbarian Captivity of Ts'ai Wên Chi," *BMFEA,* no. 35, 1963, p. 141, suggested that the felt hanging was originally used as a tent screen, but the Russians consider it a hanging. Rudenko, S., *Frozen Tombs of Siberia,* Berkeley and Los Angeles, 1970, p. 64.

5. Haskins, John F., *Ars Orientalis, op. cit.,* p. 159, and Maenchen-Helfen, O., "Crenellated Mane and Scabbard-Slide, "*Central Asiatic Journal,* Vol. III, no. 2, 1957, pp. 85-138.

6. Martynov, G. S., "Issykskaia nakhodka," *KSHMK,* vol.59, 1955, pp. 150-156, figs. 65-66.

7. Rostovtzeff, M., *Iranians and Greeks in South Russia,* Oxford, 1922, pl. XXIII, no. 2, and pages 104-105.

8. *Ibid.,* pl. XXVIII, 1. Rostovzeff considered this purely a family scene, but in the light of the numerous versions of this scene, its ritualistic, funerary nature is apparent. It is interesting to note the early representation of the typical nomad tent which continued for centuries in Asia, evidenced by the illustration in a Sung period Scroll., Bunker, *op.cit.,* fig. 1. For years these tents have been incorrectly referred to as yurts, actually a misnomer, whose general meaning is camping place, camp or native country, and not merely a tent, seen Andrews, P.A., "The White House of Khurasan: The Felt Tents of the Iranian Yomut and Göklen," *Iran,* vol. X, 1973, pp. 93-94.

9. Davidson, H. R. Ellis, *Scandinavian Mythology,* London, 1969, p. 45.

10. Rice, Tamara Talbot, *Ancient Arts of Central Asia*, New York, 1965, fig. 196.

11. Jettmar, Karl, *Art of the Steppes*, New York, 1967, pp. 183-184.

12. Metropolitan Museum of Art, "From the Land of the Scythians: Ancient Treasures from the Museums of the USSR", (catalogue), section by Helmut Nickel, "The Dawn of Chivalry", pp. 150-152.

13. Haskins, *ibid.*, pp. 153-169, and László, Gyula, *The Art of the Migration Period*, Coral Gables, 1974, pp. 111-123.

14. Haskins, *ibid.*, p. 154, and Rostovtzeff, M., "The Great Hero Of Middle Asia and His Exploits," *Artibus Asiae*, vol. 4, 1930-32, pp. 99-117. Amusingly enough both scholars mistook the ibex for a hunting dog.

15. It is interesting to note that arrows in Siberia as evidenced among the grave goods at Pazyryk have shafts of about 80 centimeters, while the typical Scythian ones are only 50-60 centimeters long, which would explain the difference in bow case lengths between those illustrated in the first two plaque groups.

16. Trousdale, William, *The Long Sword and Scabbard Slide in Asia*, Washington, 1975, p. 118-119.

17. Weber, C.D., "Chinese Pictorial Bronze Vessels of the Late Chou Period," *Artibus Asiae* XXVIII, nos. 2/3, 1966, XXVIII, no. 4, 1966, XXIX, nos. 2/3, 1967, and XXX, nos. 2/3, 1968.

18. Ghirshman, Roman, "Persian Art," *The Parthian and Sassanian Dynasties*, New York, 1962, fig. 345, and fig. 342.

19. Sullivan, Michael, *The Birth of Landscape Painting in China*, Berkeley and Los Angeles, 1962, pl. 98.

20. Dalton, O. M., *The Treasure of the Oxus*, London, 1964, pl. X. Even horses in Assyrian reliefs are still earthbound.

21. Ghirshman, *op. cit.*, pl. 62 and pl. 340.

22. Trousdale, *op. cit.*, fig. 76.

23. *Ibid.*, fig. 75 and Ghirshman, *op. cit.*, pl. 247.

24. Erdélyi, István, *The Art of the Avars*, Corvina, 1966, fig. 8.

25. Haskins, John, "Northern Origins of Sassanian Metalwork," *Artibus Asiae*, vol. XV, 3., 1952, pp. 241-267 and XV, 4, 1952, pp. 324-347, does not discuss the hoof situation.

26. Chung-kuo K'o-hsüeh-yüan K'ao-ku Yen-chiu-so, *Feng-hsi Fa-chueh Pao-kao*, Peking, 1962.

27. Nickel, *op.cit.*, p. 152, suggested that these were all scabbard mounts but the excavation reports and a careful study by David Goodrich of Yale University in an unpublished master's thesis proves conclusively their use as belt buckles., Goodrich D., *Anecdotal Plaques Excavated in China*, 1976.

28. Rostovtzeff, op. cit., *Artibus Asiae*, p. 113.

29. Frankfort, Henri, *The Art and Architecture of the Ancient Orient*, London, 1958 (revised), pl. 20c. and also in numerous early cylinder seals.

30. László, *op. cit.*, p. 54.

31. Minns, E., *Scythians and Greeks*, Cambridge, 1913, p.43.

32. László, *op. cit.*, fig. 69.

33. Baer, Eva, "The 'Pila' of Jativa. A Document of Secular Urban Art in Western Islam," *Kunst des Orients*, vol. VII, 1970-71, no. 2, fig. 35.

34. László, *op. cit.*, fig. 65b.

35. Sullivan, *op. cit.*, pl. 100.

36. Sun Shou-tao, "Hsi-ch'a-kou ku mu chün pei chüeh shih-chien ti chiao-hsun," *WWTKTL*, 1957/1, pp. 53-6, and "Hsiung-nu Hsi - ch'a-kou wen-hua ku mu chün ti fa-hsien," *Wen-wu* 1960/ 8/9, pp. 25-35. The reindeer are too worn away to recognize in the excavated example.

37. Lattimore, Owen, *Studies in Frontier History*, London, 1962, pp. 142-143.

38. Swindler, Mary H., *Ancient Painting*, New Haven, London and Oxford, 1929, fig. 269.

39. Rostovtzeff, op. cit., *Artibus Asiae*, fig. 7.

40. Maenchen-Helfen, Otto, *The Huns*, Berkeley, p. 253 and 280.

41. Ratton, M. Charles, *Bronzes Antiques des Steppes et de l'Iran, Collection D. David-Weill*, Paris, 1972, no. 59. Design is clearer here and swords are obvious.

42. Tseng Yung, "Liao-ning Hsi-ch'a-kou ku mu chün wei Wu-huan wen-hua i-chi lun", *KK* 1961/6, pp. 334-6.

43. Kiselev, S.V., *Drevnyaya istoriya Yuzhnoi Sibiri*, 2nd ed., Moscow, 1951, pl. XXI, no. 18., and Bunker, *op. cit.*, fig. 15.

44. Rudenko, S.I., *Sibirskaya kollektsiya Petra I*, Moscow and Leningrad, 1962, pl. VIII, where just a lone animal is shown.

45. Chen Lung, "Nei Meng-ku Cha-lai-no-erh ku mu chun tiao-ch'a chi", *Wen-wu* 1961/9, pp. 17-18.

46. Bunker et al, op. cit., p. 110 and Bunker, E.C. and Ternbach, J., "A Variation of the 'Lost Wax' Process," *Expedition*, vol. 12, no. 3, Spring 1970, pp. 41-43. The date for this process proposed there was 3rd century B.C. and should now be changed to the 4th century B.C. Apparently use of fabric in such a manner in the casting process also exists in the art of the Avars. László, G., *Art of the Migrations Period*, op. cit., pp. 85-87, and further west in Europe, see Lamm, Kristina, "Early Medieval Metalworking on Helgo in Central Sweden", in *Aspects of Early Metallurgy*, edited by W. A. Oddy, London, 1977, p. 110.

47. Rudenko, 1962, *op. cit.*, lists all the Peter I Treasure examples.

48. Bunker et al., *op. cit.*, pp. 109-110.

49. Jettmar, K., "Cross-Dating in Central Asia", Lecture delivered at Harvard University, Cambridge, Mass., March 12, 1969.

50. Hancar, F., *Das Pferd in prähistorischer and früher historischer Zeit,* Vienna and Munich, 1956, pp. 355-372.

51. Attenborough, David, *The Tribal Eye,* New York, 1976, pp. 90-92.

52. I am extremely grateful to Dr. Ann Farkas for the following references and for sharing her research for a future article on 'Textile Trade in the Ancient World Through Its Reflections in Art". Oppenheim, A. Leo, "Essay on Overland Trade in the First Millenium B.C.," *Journal of Cuneiform Studies,* vol. XXI, no. 1-4, December 1967, pp. 236-254. Felt, the nomadic material 'par excellence' originally developed in the Mesopotamian world, see Oppenheim, Leo, *Ancient Mesopotamia,* Chicago and London, 1964, p. 319. Rostovtzeff, *op. cit., Artisbus Asiae,* pp. 111-112 suggested Near Eastern Wall paintings such as a source which they may have been ultimately, but textiles seem much more possible in view of the Persian-inspired carpet at Pazyryk, see Jettmar, *Art of the Steppes,* New York, 1967, plate 19.

53. Rudenko, Sergei I., *Frozen Tombs of Siberia,* Berkeley and Los Angeles, 1970, pp. 62-64.

54. Barnett, R.D., "The Art of Bactria and the Treasure of the Oxus," *Iranica Antiqua,* vol.VIII, p. 51.

55. Minns, *op. cit.,* p. 335.

56. Davydova, A. V., "Kvoprosu o khanskikh khudozhestvennykh bronzakh," *Sovetskaya arkheologiia,* Moscow, 1971, vol. I, p. 96.

57. Bunker et al, *op. cit.,* p. 110 and figs. 19a and 21.

58. Rudenko, *op. cit.,* 1968, pl. 176,c. and pl. 162.

59. Landscape elements are frequently used in the Assyrian reliefs as stage setting for the narratives and also on cylinder seals, where a single tree may be combined with an animal combat or scene, see Moortgat, *The Art of Ancient Mesopotamia,* London and New York, 1967, pls. 261-279.

60. Ghirshman, *op. cit.,* fig. 437 and page 327.

61. Soper,A., "Early Chinese Landscape Painting". *Art Bulletin* **XXIII**, no. 2, June 1941, p. 147.

62. Jettmar, *op. cit.*, 1964, p. 104.

63. Leskov, A., *Treasures from the Ukrainian Barrows*, Leningrad, pl. 13.

64. Trousdale, *op. cit.*

65. *Ibid.*, p. 117.

66. *Ibid.*, note 516.

67. *Ibid.*, p, 67.

68. Jettmar, Karl, "The Altai Before the Turks," *BMFEA*, no. 23, 1951, pp. 135-210.

69. Maenchen-Helfen, *op. cit.*, p. 372, notes nineteen tribes in the confederacy.

70. Jettmar, *op. cit.*, p. 200, points out that "the stronger the Mongoloid elements are, the more the 'Animal Style' retreats into the background."

71. Chard, Chester S., *Northeast Asia in Prehistory*, Wisconsin, 1974, pp. 145-166.

1a. Warrior Resting, plaque, 4th century B.C.
 Gold, length 16.2 cm.
 Siberian collection of Peter I, Hermitage.

1b. Portable Altar, 5th-4th centuries B.C.
 Bronze.
 Alma Ata, Kazakh SSR.

2a. Hunting Plaque, 4th century B.C.
 Gold, length 19 cm.
 Siberian collection of Peter I, Hermitage.

2b. Wrestling Plaque, late Warring States,
 Bronze, length 14.4 cm.
 Victoria and Albert Museum.

3a. Plaque, 2nd century B.C.
 Bronze, length 10.3 cm.
 The Nasli M. Heeramaneck Collection of Ancient Near
 Eastern Art, gift of The Ahmanson Foundation.

3b. Plaque, 2nd century B.C.
 Bronze, length 13.3 cm.
 The Sackler Collections, New York.

4a. Plaque, 2nd century B.C.
 Bronze, length 11.2 cm.
 The Nasli Heeramaneck Collection of Ancient Near
 Eastern Art, gift of The Ahmanson Foundation.

4b. Plaque, 2nd century B.C.
 Bronze.
 After Hsin Chung-kuo Ti K'ao Ku Shou Huo,
 Peking, 1962, pl. XC, 1.

5a. Plaque, 4th century B.C.
 Gold, length 16 cm.
 Siberian collection of Peter I, Hermitage.

5b. Trek Plaque, Han Period.
 Bronze, length 11.1 cm.
 The Nasli Heeramaneck Collection of Ancient Near
 Eastern Art, gift of The Ahmanson Foundation.

Plate 1

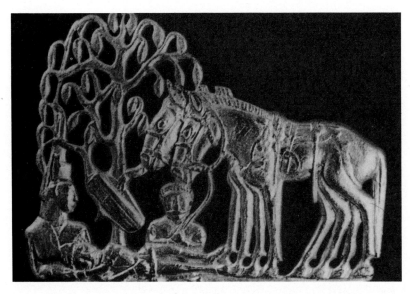

a

b

Plate 2

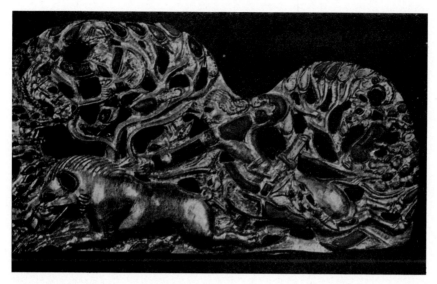

a

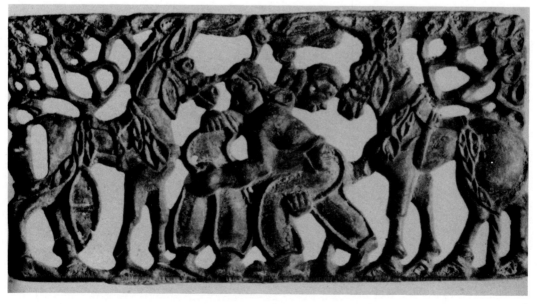

b

Plate 3

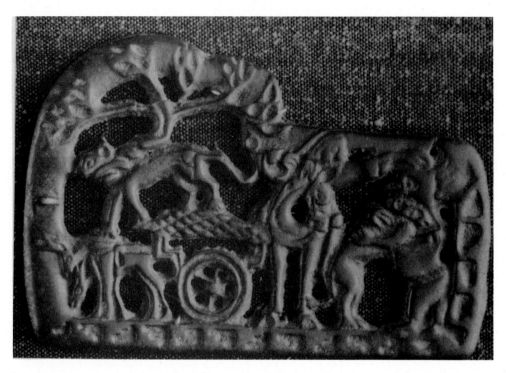

a

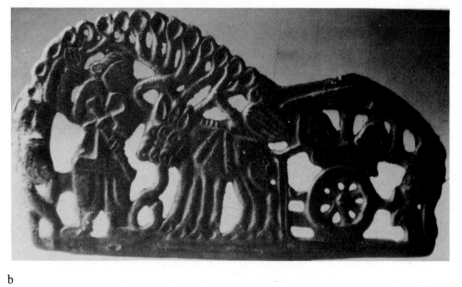

b

Plate 4

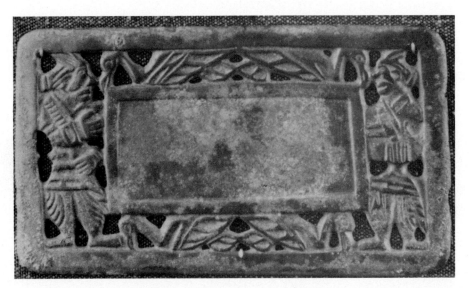

a

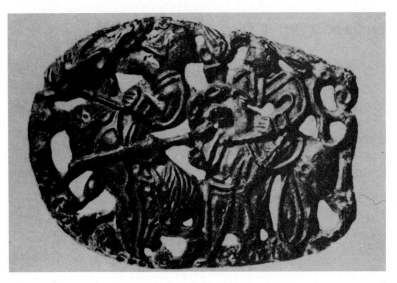

b

Plate 5

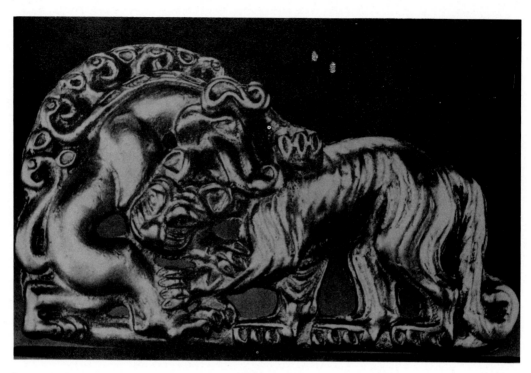

a

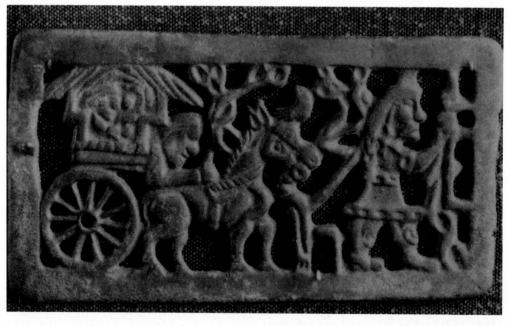

b

THE TENTS OF TIMUR

AN EXAMINATION OF REPORTS ON THE QURILTAY AT SAMARQAND, 1404

For Timur, tents were more than just tents. They were a means
of advertising the splendour, power, and wealth of his empire.
Display of this kind was to be expected, for fine tentage had
long been part of the apparatus of kingship in the Middle
East. It had already been adopted into the nomadic tradition
of Central Asia by the time of Ogedey Qa'an in the early
thirteenth century,[1] and Timur's descendants were to give it
great importance in India until the 1750s. Yet the tents
of Timur himself deserve our particular attention not only
because of their magnificence in a period of remarkable
ostentation, but because they attracted a comprehensive and
consistently detailed account, which can be compared with
paintings done at about the same time.

 This account, written by the Castilian ambassador Ruy
Gonçalez de Clavijo is well known,[2] but this part of it has
not until now been analysed in a way that does justice to
the material. Clavijo is extraordinarily painstaking: the
general accuracy of his work can be confirmed from his very
lively descriptions of the strange animals he saw.[3] He uses
words very consistently in a limited vocabulary, as a
practical man rather than a man of letters. This quality
does not emerge from the existing translations into English,
so for the clearest possible understanding I have returned to
the Spanish text. The first edition was not published until
1582, nearly 180 years after the report must have been
written. Therefore, in making my own translations I have
compared this with the critical edition prepared by Lopez
Estrada from fourteenth and fifteenth century manuscripts,[4]
and with the fourteenth century manuscript in the British
Library, which he was unable to examine, and which appears
to be in Aragonese.[5]

 The material can be supplemented from passages in the
Żafarnāma of Sharaf al-Dīn ᶜAlī Yazdī, compiled from previous
records and eye-witnesses' accounts between 1419 and 1425.[6]
Despite the floridity of his style, he uses tent terms
consistently in what appears to be accurate rather than purely
conventional usage. Tāj al-Salmānī gives little help, but
Ibn ᶜArabshāh,[7] in spite of his preoccupation with rhyming
prose, adds some useful details based on his own experience
as a prisoner of Timur. Together, these authors show that
the extravagant tents portrayed in paintings of the period
were at least matched in reality.

There is a great deal of material here: far too much to be dealt with adequately in an hour's paper. By way of introduction, however, I should explain that two traditions of tentage are represented: the nomadic, and the princely. The nomadic tradition here is that of the Turkic and Mongol peoples of Central Asia; the princely tradition is Middle Eastern, going back to the Achaemenids and beyond. The fact that these two traditions interpenetrated from time to time, when nomads rose to power, has led some commentators to confuse the two; but there can be no doubt that to the ordinary Çağatay tribesman, for whom tent making was fixed in a tradition of inherited vernacular skills, many of his leader's tents must have been an exotic luxury, made by artisans and townsmen, and used in a restricted context. In Timur's camp the difference is complicated by the way in which some basically nomadic forms are dressed up in expensive alien materials, but this does not, as I shall show, place them outside the nomadic context; indeed, parallels were to be found in the nomadic world until recently. Chiefs of the Şahsevän of Azärbaijan, for example, used to line their felt tents with silks and velvets of different colours.[8]

The main event recorded by Clavijo is the *qurıltay* or assembly held in autumn 1404 outside Samarqand in the plain known as Kān-i Gil, or the claypit. This was a recognised site for such occasions, for a lavish tent had been pitched there for the reception of Hülegü in 1255.[9] These celebrations were for the simultaneous wedding of six of Timur's grandsons, on his triumphal return to the capital. They had a festival, rather than a military character, and it is clear from the accounts of the displays put on by the townspeople that every effort was made to set out as impressive a show as possible. It is safe to assume that the tents were the finest available.

The tentage which made up the camp centre consisted, broadly speaking, of enclosure screens, trellis tents, guyed tents, and awnings. Clavijo pays particular attention to two gigantic guyed tents, which he calls pavilions, *pavellon,* and to a linked complex of tents belonging to Timur himself. The splendour was not confined to the camp centre. In Clavijo's words:

> "And in this royal camp (*ordo*) there was not
> only His Majesty's enclosures, but many
> others belonging to the Mirzas and his
> favourites, of many different kinds that
> were marvellous to see; so that on every
> side a man could see beautiful tents and

çalapardaes, which they call the enclosures,
and in this camp which His Majesty held there,
there could have been as many as forty or
fifty thousand tents, which was a beautiful
thing to see; and besides these tents there
were many others which stood throughout the
gardens and fields and watercourses near the
city..." (fo.55 recto) (this and following
references are to the 1582 edn.).

For the purposes of this paper, I intend to confine
my attention to the trellis tents alone, as the nomadic
elements in the camp. The character of the princely
element can, however, be understood from the following
passage, which leads up to the first description of a
trellis tent:

"There stood an enclosure just like that of
a town or castle, made of silken material of
many colours pieced together in many ways, with
merlons on the top, and with guys on the outside
and the inside which held it up, supporting
some poles on the inside; and this enclosure
was round, and it could have been as much as
three hundred feet[10] across, and the wall was
as high as a man on horseback; and it had a
tall gateway made in an arch, with gates
inside it, and it was of the same work outside
as the enclosure which it secured;[11] and on the
top of the gateway there stood a square tower
with merlons, and however fine the enclosure
might be with arabesques and needlework upon
it, the said gateway and arch and tower were
so much more finely worked than the other; and
they call the said enclosure *zalaparda,* and
within this enclosure there were many tents
and awnings pitched in many ways ..." (fo.48
recto).

Zalaparda or *Çalaparda* is of course the Persian term
sarā-parda, which appears to have been used in the sense of
enclosure since the time of Firdausī at least.[12] This one
belonged to Timur's principal wife, Saray Mulk Xatun. Like
the four others described, the essentially plain screen is
treated somewhat inappropriately as though it were
architecture. The merlons along the top, for instance,
could not be made without some special stiffening. In
parallel with this observation, it is perhaps fitting that
in certain paintings of garden scenes, it is very difficult
to tell whether a real wall is intended, or a screen

resembling one, as the guys are often omitted by convention.[13] The gateway too is conceived in the same way, contrived as a symbol of dominion and security, rather than developed naturally from the nature of the materials. The description of Timur's enclosure given by Ibn ᶜArabashāh stresses this theatrical quality:

> "And an enclosure surrounded all his tents and trellis tents, furnished with a wide entrance, which gave admission from a great hall into his inner dwelling, and had two lofty horns, on which heads could be broken, and at whose sight the soul would shudder, whence clung to it the name 'Two-Horned', *Dhū'l Qarnain*".[14]

It is clear that in these enclosures, and in the other guyed tentage, we are dealing with an elegant, sophisticated, and well-developed tradition which drew on all the available resources of imported materials and craftsmanship. Their shapes were full of architectural allusions, from tilework to turrets, and indeed their closeness together, with no more than the width of a street between, must have recalled a city in itself. Only the circular shape remained at odds with this image; perhaps practical considerations of wind resistance were too important to allow adaptation.

For the trellis tent, Clavijo always uses the same expression, "one of the tents which are not supported by guys", in distinction to the guyed tents with which he was more familiar. If we exclude the bender tent of withies stuck into the ground, there has in the past been only one kind of tent which dispensed with guy ropes, and that is the type supported on a framework of radiating wooden *struts* arranged like a cone. Here the framework is inherently stable, and the covering simply rests upon it, playing no structural role. In the Central Asian context this frame was usually supported in turn on a cylindrical wall formed of a number of sections of *trellis* which interlock with one another (Pl. 1a). This is prevented from collapsing under the load imposed by the struts above, by *girths* which run all around it. The top of the tent frame is formed by a hoop of timber with cross spokes, the *roof wheel*, into which the top ends of the struts are fitted by means of slots in the rim. A *door* is needed, of course, and this is made by placing a frame between trellis sections in such a way as to prevent the collapse of the whole cylinder (Pl. 4b). The door cannot be much higher than the trellis, because the receding slope of the roof struts does not allow enough headroom. Nor is it generally any lower, partly because the trellis is normally only shoulder high, and partly because

this would require special trellis sections over the lintel to make up the height. When covered with felt, this is the type known in the West, though incorrectly, as the yurt.[15]

This is now the basic dwelling of the steppes, and the lighter types of felt tent, consisting of the struts without the trellis, are regarded as inferior versions of it. Just how these two types were distributed, either regionally or within the tribe, in Timur's time is unclear. It is possible that in Çiñgis Xan's time the trellis tent was much less widely used than it is now, for the phrase *terme ger* (*terme* meaning trellis) occurs in the Secret History, as Professor Róna Tas has pointed out, only as the dwelling of the Kereit Oñ Qan, and the Tangut leader Asha- gambu.[16] Unfortunately authentic paintings of nomadic life are extremely rare, if one excludes pictures of monarchs or princes. The earliest to show tents adequately is the Sung dynasty Wen-chi scroll, which has been identified as showing details of life among the Xitan, an early Mongol people, in the eleventh century. This shows consistently, and with obvious precision, two types of trellis tent (Pls. 1b, 1c), one being what is now accepted as the Turkic type with curved roof struts, and in this case a pronouncedly convex roof wheel; the other might be closer to the present Mongolian type, with apparently straight struts, and a shallow roof wheel, though its proportions are not what one would expect.[17] Confusingly, they are pitched side by side (the paintings are, incidentally, of interest as showing an early use of enclosure screens for a nomad prince's camp). From the accounts of Giovanni de Piano Carpini and Willem Rubruck we know that in the mid-thirteenth century, two types of tent were used by the Chingisid armies, one, perhaps the usual trellis tent, which could quickly be taken down and put up again, and was carried on pack animals, and the other which could not be taken down, but was moved about on carts.[18] Tents mounted on carts were still being used by the early Qazaq in 1509,[19] and in fact the use of both types together was to be seen among the Noğay in the mid-nineteenth century. A painting done for Pallas in 1793 conveniently shows the two,[20] and it can be seen that the roof profile of the trellis tent is not very different from the straight-strut type in the Wen-chi scroll. We can accept this combination, then, as typical of the Golden Horde. For the Timurid period there is one particularly interesting painting in the Freer Gallery manuscript of the poems of Sulṭān Aḥmad Jalair, dated 1402.[21] This shows, it seems, a group of ordinary nomads with their tents, quite exquisitely drawn (Pl. 4a). The tents here, however, do not have cylindrical sides; the slope of the dome continues gently to the ground, and it seems that these are trellis-less tents with curved roof struts and a smallish

convex roof-wheel. Unfortunately the text gives no indication of the setting of this scene; the drawing itself has been ascribed to both Samarqand and Tabriz, though the latter seems more likely.[22] The suggestion of Tabriz is interesting, for the tents shown most closely resemble the trellis-less tents of the Şahsevän,[23] not far to the east, where the Mughān Steppe has been a wintering place for nomads since the Mongol period. Timur himself wintered in the neighbouring Qarābāgh district in 1401-2 and again in 1403-4, the date of the picture.[24] Might one take it that these are the tents of the Çağatay horde?

The trellis tent proper, though it was intimately associated with nomadic life, had achieved recognition in another sense. It had, because of its elaborate framework, and perhaps the very nature of its shape, greater value and prestige than the ordinary guyed tent. It was a dwelling fit for the nobility. In Persian the word *khargāh* had come to be used for this type of tent since the time of Juyainī (about 1260) or earlier.[25] In Timur's history, Yazdī frequently uses the stock phrase *khayma u khargāh*, or its reverse according to the scansion of a line, just as "tents and pavilions" are referred to in mediaeval English.[26] Only *khiyām*, though, are mentioned as having either ropes or poles : it is clear that the *khargāh* had neither. Occasionally the Arabic word *qubba* (plural *qibab*), or "dome", which had long been established as denoting Turkic tents, is substituted for *khargāh*, as though to demonstrate that the trellis tent was intended.[27] At Kān-i Gil, he tells us specifically that two hundred *khargāh* were set up for the private apartments: a measure of the kudos with which they were endued.[28] The *khiyām* remain uncounted.

These were no ordinary trellis tents however; the camp must have been full of those. We can take up Clavijo's description again where he refers to the tents within Saray Mulk Xatun's first enclosure:

> "Within this enclosure there were many tents and
> awnings pitched in many ways, among which there
> stood a very tall tent: it was not supported
> by guy ropes, and it was round, and the walls
> were of rods about as thick as lances, which
> were placed crosswise like a net, and above these
> rods there was something like a tall dome, also
> of very tall rods, and this dome and the walls of
> the tent were fastened one to the other with belts
> as broad as a hand, and they came down below and
> were fastened to some stakes set next to the walls
> of the tent, and it was so tall that it was

marvellous that it could be held with these
bands; and it was covered above with crimson
velvet, and it was sheathed below in cotton like
a bedspread: so that the sun should not pass
through, and it had no appliqué work or designs of
any kind, except that on the outside it was girded
around the middle by some white bands which went
crosswise, which passed all around, and these
bands were covered with thin silver plates as
broad as a hand, gilded over, in which stones
were set in many ways; and this tent was girded
all around the middle with a white sheet pleated
into small folds like those of a woman's skirt
which were embroidered with drawn gold thread,
and when there was a wind the pleats of the
said sheet moved from one side to the other,
which appeared very beautiful; and it had a
tall doorway with doors made of very small canes
covered with coloured velvet ... (fo.48 recto-
verso).

 Clavijo was evidently able to look inside the tent, or
he would not have seen the roof struts. We must bear in
mind therefore, that some of the features described are
likely to be internal, some external. The obviously
identifiable elements are the trellis, which he probably
saw exposed on the inside, the roof struts, and the stakes
used to stabilise the trellis, which are still found in
certain tents today. Surprisingly, no mention is made of
a roof wheel. Rather more is said of the details than of
the general shape and size, so we are left to deduce these
as best we can from the data at hand.

 The word he uses to describe the roof, *chapitel*,
should mean a finial or spire, but in his account of
Constantinople, Clavijo uses it consistently for the domes
of the churches he visited, such as Haghia Sophia and St
John the Baptist.[29] This contrasts with his use of *boveda*,
meaning an arch or vault, with which he compares two of
the gateways at Kān-i Gil, and the roof of the great
pavilion.[30] When writing of trellis tents he repeatedly
emphasises their height; Yazdī too writes of *khargāh* in
particular as reaching up to the sky,[31] and one realises
that this is more than a conventional image. In this
passage the height of the dome itself is stressed: it appears
that what Clavijo intended was a steep, perhaps somewhat
conical structure. He tells us that the roof struts were
very long, but he makes no mention of a roof wheel. If the
wheel had been large, he could hardly have failed to notice
it, particularly as it would almost certainly have been

decorated. It is therefore likely to have been relatively
small. In fact the stability of such a structure, a cone
with the weight concentrated low down near the centre of
the tent, would be greater than that of a tall hemispherical
dome. He makes no mention of a smoke hole either, which
suggests that the wheel was covered. The apex of this
tall roof would therefore be dark, and the details of its
construction unclear. It was, presumably, no more common
then than now to burn a fire within a fine tent, for the
smoke would spoil its coverings, but later in the fifteenth
century the roof wheel was often opened for ventilation. In
this case, apparently, it was not.[32]

A suggestion of the height can be found in the statement
that the doorway was tall: this can hardly be taken as less
than 2 m, and might well be as much as 2.5 m. The doors of
trellis tents nowadays are low, and never more than 1.6 m
high.[33] The usual trellis is generally some 15 cm lower
than the top of the lintel, that is about 1.5 m high. Now
if the Queen's doorway was tall, and the trellis corresponded
with it in the usual way, a practical difficult would arise,
for the length of the trellis laths would be such that the
folding sections would be too unwieldy for manipulation and
transport, and likely to be broken. There is another kind
of trellis, however, in which two tiers of trellis sections
are placed one on top of the other (Pl. 1d); in these cases
the height is about the same as the door frame. The use of
a trellis of this kind would overcome the problem: I shall
return to this question. Another indication of scale is
found in the size of the trellis laths, which were "as thick
as a lance", that is about 5 cm compared to the 3.5 cm used
until recently in large tents.[34] They were evidently round
in section, or the simile would not have occurred to the
ambassador.

After his description of a second enclosure, belonging
to Timur's second wife, Kiçik Xanım, Clavijo goes on:

> "And in the middle of this enclosure there stood
> another very tall tent made like the first, of
> another such red material, and with other such
> silver plates, and these tents could be as tall
> as three war lances or more ..." (fo.48 verso).

It can be shown by a rather protracted argument, which
I am not able to demonstrate here, that the usual length for
a war lance, *lança de armas*, at that time was eleven feet
from point to burre, that is the ridge where it was held,
and that this was a standard measure, though the full
length was about 12'10". If we take eleven feet as the

minimum, that is 3.35 m, Clavijo means to say that the height of these tents could be about 10 m. The structure must indeed have been exceptional, for even the largest tents in the recent past did not exceed some 4.30 m. It is hardly surprising that the timbers were thicker than usual. I should add in justification that where Clavijo gives similar measures that can be checked, he is remarkably accurate.[35]

Among most tribes the height of the roof is no more than the height of the trellis, but at the beginning of this century rich Qırğız still used guest tents in which the roof was up to twice the height of the trellis[36] (Pl. 2a), and drawings from Pallas's work at the end of the eighteenth century show that similar pitches were used by the Western Mongols[37] (Pl. 2b). Now although most book paintings show a dome which is no higher than the trellis, this may be a convention designed to set off the figure seated in front of the tent, by emphasising the lower half. It seems to have been normal practice in the fifteenth and sixteenth centuries to reduce and distort the scale of the tents depicted in miniatures, lest they dominate the composition. The taller the trellis in fact, the less stable the tent would be. It is probably correct to assume that the trellis did not exceed one lance length, or 3.35 m. This in itself would be difficult enough to erect, even if in two tiers. The wind resistance of such a tall tent must have been hazardous, and there can be no doubt that the purpose of the stakes was to stabilise the structure. They are still to be found, placed just inside the trellis joints, among the Türkmen in Iran and Anatolia,[38] especially in rough conditions.

Though Clavijo gives no diameter for these large tents, one can guess at it by comparison with recent examples. The tall Qırğız tents just mentioned had a ratio of diameter to height of about 4:3. The Fīrūzkūhī tent with its double trellis has a ratio of 9:8. A Timurid tent 10 m high might thus have been between 11 m and 13 m in diameter. This is not at all unlikely, for tents of 120 struts existed last century, with diameters of from 10 m to 12 m.[39] It is claimed in fact that the largest of all had 360 struts,[40] but unless internal support were provided, the span would effectively be limited by the strength of the struts themselves. Clavijo does not mention a centre pole.

It can be seen, then, that the structure of these trellis tents was in no way foreign to the usual range of nomadic variants, except in height. This continued to be the case until the mid-seventeenth century, when new ideas were introduced, such as the silver-framed *khargāh* of Shāh Jahān. The tents at Kan-i Gil were still nomadic for all

practical purposes. A further passage of Clavijo's makes
this clear:

> "And of these enclosures which they call
> Çalaparda there stood eleven, one next to the
> other, each of a particular colour and workman-
> ship, and in each was one of the great tents which
> are not supported by guys, all covered in red
> velvet made in the same way, and there were many
> tents and awnings in each of them; and between
> one of these enclosures and another there was no
> more than the width of a street, and they were
> pitched next to one another, which appeared very
> beautiful, and these enclosures were those of
> His Majesty's wives, and his grandsons' wives,
> and these princes and princesses use them as
> their dwellings in summer and winter." (fo. 48 verso.)

He twice mentions the insulating properties of the tent
covering. The arrangements continue the Central Asian nomadic
practice of allotting a separate tent to each wife when
circumstances allow it, and it is very probable that the
trellis tent in each of these enclosures was symbolic of
her place in the household. If the princes and their wives
lived all year round in their tents, however, practical
considerations could not be ignored, and the trellis tent
must have been retained amongst the large variety of non-
nomadic tents as the best means of withstanding bad weather.
It is in fact remarkably well adapted to climatic control.[41]

We can now turn our attention to the soft parts of the
tent, and other points of detail. Gonçalez correctly identifies
the girths as the means by which the entire structure is held
erect, but the exact nature of the arrangement is obscure: I
have the impression that several different pieces of cordage
are described as one. The roof struts could hardly be fastened
to the trellis heads with bands 10 cm wide, for these would
be too clumsy to secure an adquate joint (Pl. 1a). Nor is
it likely that these strut ties would be fastened to stakes,
for there would be no advantage in it. But if the passage
is read as meaning "and this dome and the walls of the tent
were fastened amongst themselves (uno con otro) with belts as
broad as a hand", this would be no worse than many modern
descriptions of the arrangement of the trellis girths and
the wrapping girths on the struts, which hold them correctly
spaced. These girths are then said to "come down below, and
they were fastened to some stakes set next to the walls of
the tent". This is likely to refer to the lashings at the
vertical joints between trellis sections: these play an
important part in two-tiered trellises, and a tall trellis

of the kind suggested would be greatly strengthened in this
fashion. When stakes are placed at the trellis joints, it
is natural to incorporate them in these lashings. The width
of a hand given for the bands is in fact the average in
Central Asia, though the girths passing around the trellis
should be broader in such large tents as these, up to about
30 cm.

Another possibility remains. The girths are described
as coming downwards, *e venían fasta ayuso*. Now there is a
characteristic arrangement of girths in certain felt tents,
in which they descend from one side to the other at the rear
of the dome inside, those from one side crossing over those
from the other. These are the ties for the front roof felt,
and the play no structural role, but they are prominent, and
if as I surmise Clavijo has confused a number of functions
in one description, he may have had these in mind. They
are prominent in Qaraqalpaq, Özbek, and Fīrūzkūhī tents,
and rather less so among the Southern Qırğız and the Şahsevän.
In Anatolia too the Türkmen tent has a system of girths of
this width which traverse the dome in great circles, which is
part structural, part decorative, and may be a vestige of an
earlier arrangement with a clearer structural role. In either
case one sees some resemblance to the Spaniards's description.
Perhaps for such large tents there was a special arrangement
which has since disappeared: one which might strengthen the
dome against the wind.

Before discussing the outside of the tent, I should
like to digress on the terms used for fabrics. These are
clear on the whole, but the word *tapete* is problematic. It
is used for the fabric of enclosures, guyed tents, trellis
tents, and the lining of the great pavilion. The usual
sense of "rug" is clearly inapplicable. Nor does it simply
mean "material", for Clavijo uses the word *paño* in that
sense, and on one occasion actually writes of *un paño de
tapete clemesin,* "a crimson something cloth". Corominas
recognises that in the fourteenth century it sometimes
referred to a kind of material for clothing.[42] It seems
to have been obscure even in Clavijo's own time, for in the
British Library manuscript the copyist, Anthonius de Leon,
left a blank every time he encountered it, as if he did not
know the equivalent in his own dialect. However one of the
guyed tents is described as being made of *un tapete colorado
de velludo,* "a red velvet something";[43] this is the only time
the word is qualified in any way except for colour. From
this it seems that *tapete* was either a synonym for velvet,
or that it was a related material in which the pile was
sometimes raised, perhaps a heavy brocade. More evidence
for this interpretation can be found in the fact that when

Clavijo mentions gold embroidery, as in Timur's red enclosure, it is usually worked on *tapete:* in the Turkic tradition, gold embroidery is most frequently worked on velvet, and this is usually red.[44] I have translated it as velvet throughout.[45]

Entretallamientos should mean cut or slashed work. I have taken it as appliqué work, as this was certainly a common technique in princely tentage from the sixteenth century onwards. One should not overlook the nomadic mosaic technique used in counter-set designs by the Qazaq and others. It is also used to describe the work on a pair of silver doors (fo. 54 recto, see below), apparently in the sense of *intaglio,* or insets. *Lazos* should refer to strap-work or loops: I have translated it loosely as arabesques.

The adjective *colorado* can mean either "coloured" or "red". From the regularity with which Clavijo uses it, he seems to have meant something specific, and in one copy there is the phrase *colorado clemesyn,*[46] so I have taken it in general as "red". This was in any case the traditional colour for royal tentage in the Middle East.

The description of the covering is a little ambiguous. There can be no doubt that the top, that is the dome, was covered in a crimson material, probably velvet (*tapete*); but when Clavijo writes of a cotton sheathing like a coverlet *debaxo,* it is unclear whether he means that it was below the other on the tent, that is on the wall, or that it was underneath the velvet, that is inside. For "below" he generally uses the word *ayuso* (*dius* in the B.L. MS.), but if he meant a lining, he could have said *de dentro,* as he does elsewhere.[47] At all events he explains that the object was to exclude the sun. One would expect felt to be used. Gonçalez does not mention it, I suppose, because he could not see it: it was covered outside with the velvet, and inside, to judge from present techniques, a lining might have been sewn on with parallel lines of stitching. This practice was to be found among the Western Mongols,[48] the Noǧay[49] and the Şahsevän[50] in important tents, and it is still used by the Fīrūzkūhī. The comparison to a coverlet might well apply to this. On the other hand several miniatures of the fifteenth century show what is evidently a flimsier wall covering than felt, which may have kept out the dust instead of the usual cane screen.[51] Perhaps this was meant, for *colcha* could mean either quilt or bedspread. It seems to me that the simile is more likely to refer to the quilt, as it had a distinct form, directly intelligible to the reader.

Clavijo was struck by the uniformity of the royal camp,

for in speaking of the trellis tents in each of the eleven enclosures, he states that they were "all covered with red velvet and made in the same way". Every trellis tent that he describes was indeed red, *colorado;* of these only two, in Timur's red enclosure, were decorated.[52] One had appliqué work of different colours, while inside it was lined from the middle downwards, that is over the trellis, with sable furs; a much commoner fur, gris, was used to line the upper half of the tent, and an awning that stood in front of it. All this, it is explained, was for insulation against heat in summer and cold in winter.[53] Until recently the Qazaq used fur among other materials for trellis linings, *tus kiyiz,* though only as a trim.

To repeat the description, the tent was undecorated except that "...it was girded around the middle by some white bands which went crosswise, which passed all around ...". This criss-cross arrangement is immediately recognisable as a distinctive feature that still survives among the Southern Özbek and the Southern Qırğız (Pl. 3). It appears that a particular pattern was used by each of the Özbek tribes.[54] The pattern mentioned is still used by the Qarluq and Türk, that is to say pre-Shaybanid tribes.[55] The white ties of the rear roof felt are led down to an outer girth rope passed around the middle of the trellis, then up to the lower edge of the roof felts, down again to the rope, and so on, so that the superimposed ties form a diagonal network all round the tent. The silver gilt mounts are no longer found, though they are perhaps represented in the forms of appliqué work sewn onto the roof felt ties in elaborate Qazaq tents.[56] Metallic mounts of some kind can be seen on the roof felt ties of the Imperial Manchu tents drawn by Alexander in 1793[57] (Pl. 2c): these and the Timurid form might both be derived from a common Mongol tradition. The white pleated valance has also vanished, but it is shown quite clearly in contemporary miniatures at the top of the trellis outside,[58] and it was still in use under the Moghuls. The arrangement on another tent belonging to Saräy Mulk Xatun was different;

> "This was covered with very beautiful red silken cloth, and about it were some bands of gilded silver[59] which came down from the top to the bottom ..." (fo.54 recto).

In this case, as no crossing is mentioned at all, it seems that the bands were the ties for the top felt covering the roof wheel, probably four in number, led down vertically at the front, rear, and sides of the roof.

The construction of the doors is also recognisable.

The *cañas menudillas* or very small canes are undoubtedly the
çiy[60] so widely used in Central Asia: this reed is no bigger
than the quill of a hen's feather. Door flaps are still made
of this material, with the stems laid horizontally. In well-
made specimens the reeds are individually wrapped in wool of
different colours to make patterns. It may be this that Clavijo
means when he says that they are covered with coloured, or red
velvet, though he might equally well be referring to the facing
of the flap with cloth outside. The canes must in that case
have been exposed at the back as usual for him to have seen
them.[61]

Another type of door is described for Saray Mulk Xatun's
great trellis tent in her second enclosure:

> "And this tent had two doorways one in front of
> the other, and the first doors were of slender
> red wands joined together like a fence, and they
> were covered on the outside with silken cloth
> of a pink colour, and it was woven thin, and these
> doors were made in this way so that when they were
> shut the air might enter through them, and so that
> those who were within might see those outside, and
> those outside might not see them; and in front of
> these doors stood others which were as high as a
> man might enter on horseback, and they were covered
> with gilded silver with much enamelled strapwork,
> and intaglios of many sorts, in which there were
> blue and gold" (fo. 54 recto).

Here the first set of doors, which seems to have been
outside, was made of *varillas delgadas,* thin little rods,
that is wands or laths. The distinction made between these
and the *cañas menudillas* is certainly not arbitrary, but it
might mean two things. A type of door flap used for
precisely the function described is still made from osiers
by the Southern Qırğız. These wands, which have a reddish
bark, are laid horizontally like the reeds, and bound with
leather thongs so as to leave a small space between pairs.
Their edges are framed in felt strips, and a separate flap
of felt hangs on the outside.[62] In this case the felt was
replaced by the thin rose-coloured silk, which may have been
stretched over the wands. The comparison to a fence seems
appropriate. If alternatively we take *varillas* to mean
laths, made up in a frame and covered with the silk, we have
something very like what the Russians have called the "ladder
door", to be found among the Qırğız, which again was covered
in felt. This would allow a better view than the other.

The inner set of doors with their elaborate images of

St Peter and St Paul were reported to have been plunder from the Ottoman treasury at Bursa: one can imagine the machinations that took place before the Queen obtained them for her own tent. They are useful to us in providing another indication of the trellis height. If a man could ride through them, they must have been at least 2.6 m in clear height. The height of the trellis might then be about 3.0 m, which is nearly a third of the full tent height of 10.0 m estimated earlier.

In the course of this analysis, I have interpreted the descriptions by comparison with existing types of trellis tent: some of the inferences I have drawn have been fairly sure, and some more speculative. It is now possible to see where these comparisons lead.

Firstly it is clear that these tents did not resemble Mongol tents of the present day, which are characteristically squat, with a low angle of roof slope, and a shallow, though often elaborate roof wheel. Nor, in general, have I been drawn to comparisons with tents of the Qıpçaq or Türkmen groups of Turks. The similarities I have noticed have largely been to the south of Mā-warā'-al-nahr, in the areas less affected by the Shaybanid invasions from the mid-fifteenth century onwards. The descriptions suggest that the trellis is likely to have been two-tiered, the roof wheel small, and the roof as a whole somewhat conical rather than hemispherical. The two-tiered trellis is found only in the northern half of Afghanistan, and the neighbouring parts of the Soviet Union; the small roof wheel is found there too. In combination with a pointed roof shape, these features occur only in the tents of the Chahār Aymāq group: the Fīrūzkūhī, the Hazāra-i Qalᶜa-i Nau, and the Northern Taimanī, with some small Tajik groups to the north of them.[63] Some of the other elements identified are also characteristic of this group, namely the trellis stakes, the trellis joint lashing, the vertical ties descending from the top felt and, if that is what is intended, the quilted cotton covering of the felts (Pl. 2d).

One must be wary, however, of drawing any immediate conclusions about the association of this type with a particular race or tribe. The ethnic composition of the Chahār Aymāq is notoriously complicated, and its history far from clear. The Taimanī, it seems, have adopted the tent, which is still called *khergāh*, under the influence of the Fīrūzkūhī to the north of them,[64] and the Fīrūzkūhī themselves are said to have learned its use from the Tajiks.[65] The fact that it is the Tajiks of Javān and Gharchistān who make this apparently Turkic type of tent frame is typical of these complications. There does however seem to be a clear impulse in the transmission of the type from north to south, as one

might expect. It has been suggested that this tent might have been brought into the area by the Özbek who became the Yār Fūlād clan of the Fīrūzkūhī, or by another group of Özbek or Turks.[66] The combination of features is quite uncharacteristic, though, of the Qıpçaq group as a whole, and of those Özbek who continue to live in a Qıpçaq context, such as the Quñrad of the Amu Darya delta.[67] If, in any case, I am correct in identifying the Chahār Aymāq type with the tents used by Timur, one should seek its origin in earlier ethnic strata than the Özbek. Unfortunately there is nothing left, nomadically speaking, of the Çağatay: according to Ḥaydar Mirza Duğlat, they had already broken up by 1547.[68] One cannot, then, look for a parallel survival for confirmation.

More significance can, I think, be attached to the regional than to the ethnic content of these forms. It is my experience that throughout the Middle East certain tent types, or combinations of tent types, tend to dominate a given tribal region irrespective of the origin of the smaller groupings, with only minor variations in detail.[69] This preponderance cannot, of course, be dissociated from the dominance at some time, past or present, of the group that established the type; but it suggests that once a type has been adopted by the majority, it may be retained in spite of external influences.

An example of this regional conservatism can be seen in the distribution of the two-tiered trellis. It occurs not only among the Chahār Aymāq, but among the Türkmen of North-west Afghanistan,[70] and the Qıpçaq Özbek of Qattaghan, such as the Burka,[71] with their neighbours in Soviet Tājikistān, the Laqay, Marqa, Quñrad[72] and Durmen;[73] yet the general form of all these tents is quite distinct from the Aymāq type, and the Burka and Durmen at least use round trellis laths, instead of the flat ones of the Aymāq. Furthermore we know that the Özbek of the Amu Darya,[74] and the Türkmen of Iran and Türkmenistan[75] do not use the two-tiered trellis. It appears therefore to be a local device which has been adopted by these immigrants.[76]

No one has yet offered a satisfactory explanation for this duplication of the trellis. It can hardly be for lack of timber: willow rods cannot be any shorter here than elsewhere. Nor does the double tier necessary entail a greater wall height: for example the single tier Türkmen trellis is an average of 1.55 m high, whereas the double tier trellis of the Fīrūzkūhī is 1.70 m, but that of the Burka is only 1.48 m.[77] What is true, is the converse. A tall trellis must be two tiered. The whole tradition is therefore likely to have been adopted from tents in which

the tall trellis was an essential feature. I suggest that
these were the giant tents of the Çağatay nobility. The
two tiered trellis must then have become a status symbol
which was imitated for prestige, and passed down the social
scale in the usual way,[78] until it came to be used quite
inappropriately in small tents.

Ferdinand has proposed that the Aymāqs of different
origins might have been organised into four tribes by one
of the Timurid rulers, and that the kudos of officially
approved khans might have drawn further agglomeration.[79]
If this was so, it is at least possible that a Timurid
type of tent introduced among the tribal élite might have
been taken up by the tribesmen in general. Perhaps one
should see this in the wider context of a Turco-Mongol
presence in the area. In Timur's time the region of Ghūr
was still dominated by the Nikūdarī, a Mongol group of
mixed origin which had been in that area since the
thirteenth century.[80] Their tents might well have resembled
Timur's, but the possibility of proving such connections
remains remote.

There are strong grounds for believing that one feature
of the Aymāq tents in particular is archaic: the tallness of
the roof wheel, whether pointed like the Hazāra (Pl. 4b), or
bell-shaped like the Fīrūzkūhī, looks very much like the top
of the most ancient tents we know to have survived, at the
shrine of Çiñgis Xan at Ecen Xoro (Pl. 6a), as Gafferberg
has pointed out;[81] though these tents are not comparable in
other respects, as they are a rounded square in plan, and
they appear to have no trellis.[82] The other small roof
wheel, that of the Şahsevän, is found in the Mughān, one
of the favourite winter quarters of the Mongols in Iran, so
it too could be a relic of their presence.

Considerable weight can be given to this general
argument by comparing the Aymāq tents with the royal tents
illustrated in the manuscript of the Jāmiᶜ al-Tavārīkh at
Paris.[83] These are generally accepted as being Timurid, though
the pictures are to some extent based on earlier models.[84]
The essential point here is the profile of the dome: all the
paintings show a reversed curvature, convex at the top of
the wall, or shoulder, and concave towards the middle of the
slope, below the roof wheel (Pls. 5a, 6b). The wheel itself
is strongly convex, though not as much so as the Aymāq wheel.
This reversed curve is typical of the Aymāq roof strut, and
so far as I know of no other (Pl. 4b). The shoulder is bent
down quite sharply where the thickness of the strut is pared
away, the curve then reverses gently, and the upper half of
the length is straight. Though the proportions in such

paintings cannot be taken as very reliable, there is a general similarity between the shapes shown in the Paris manuscript and the Fīrūzkūhī tent. There is no apparent reason why the modern tent should incorporate this reversed curve in the roof, the effect of which is to extend a little inwards the area of minimum headroom at the periphery, which measures about 1.80 m to the inside of the shoulder. This may not be of any great practical importance, but it is unusual in giving emphasis to the height in the middle of the tent, and it is quite uncharacteristic of tents in the Turkic area, where the convexity of the dome adds to the spaciousness throughout the interior. If, however, one imagines a tent that is large in diameter, with straight struts above the shoulder, and no central support, one can see that the struts would tend to deflect downwards under the load of the roof covering. In these conditions, it might well be that the concavity would be accepted as inevitable, and with time perhaps would even be exaggerated for effect. This reversed curvature, then, might also be a characteristic of the Timurid tents which came to be imitated at a smaller scale in the Fīrūzkūhī *khergāh*.

The detail in the Paris paintings is consistent. Among thirteen pictures of trellis tents, in only one, folio 239 recto,[85] is the reversed curvature unclear. This picture, of the great tent made for Ğazan Xan in 1302, is in any case exceptional, for it is the only one, too, to show wooden doors and an open roof wheel, though the latter appears to be of the wrong size - it is too wide for the top of the tent, and may perhaps have been added as an afterthought. Apart from this, all exhibit approximately the same profile, and all show trellis walls which are tall compared with those used today, for they are at least 2.0 m high, to judge from the figures standing nearby; twelve have close-fitting top covers over the roof-wheel. These top covers are defined by decorative bands, sewn it seems to their edges; the angle at which they are set, with another band leading downwards from the corner, presumably as a tie, is again reminiscent of the Fīrūzkūhī tent, whose top felt has four such corners and ties. Such close-fitting caps are unusual now: apart from the Aymāq tents, they are found only in the Şahsevän area, and elsewhere a loose flap is used, either four-cornered or round. Another, similar band is shown in each case around the shoulders of the tent, apparently as a trim to the lower edge of the roof felts, and others mask the edges of the wall felts where they meet the door frame. Ornament is still found in all these positions on the Fīrūzkūhī tent, though admittedly it is not in the form of bands, but of appliqué work, and in detail appears to be a degenerate version of the motifs shown on the Freer Gallery

manuscript mentioned earlier.[86]

Though the covers for each tent are shown uniform throughout, the treatment varies a little. Two examples appear to represent plain felt, one being a bluish grey, and the other a brownish white, like the *boz üy* and *aq üy* familiar in Central Asia. Four others have light line patterns which could have been worked either on felt, or on some textile covering. Another, the tent of Çaǧatay Xan, has a pronounced cloud-collar motif with matching medallions, which might be in appliqué work. The rest are most probably brocade, of gold on a greenish ground. One is left to wonder whether Clavijo, in using the word *colorado*, had these complicated and multicoloured finishes in mind. None of these trellis tents is shown red, though there is a red awning for Çiñgiz Xan (fo.65 ro.).

In seven examples a further set of bands is shown running over the wall diagonally on either side of the door. There are two different arrangments. In four cases the bands lead from the top and bottom of the door jamb to converge at the point where they disappear from view, and in three cases they diverge from the centre of each jamb towards the top and bottom on the wall. Their function is not clear from these paintings, but a comparison with the Freer drawing shows that they are very likely to be ties for the rear wall felts, led forward. These might be taken as the equivalent of the bands "which went crosswise" mentioned by Clavijo, though if so, the points at which they cross are out of view, and it must be admitted that they are not white as he has them. One of the pictures shows a pleated flounce around the top of the wall, of a green material worked in gold. A double flounce can also be seen on the foremost of the Freer tents.

We do not of course know how far these paintings represent Chingisid tents, and how far contemporary Timurid ones, though it is thought that they were made between 1415 and 1430.[87] Nevertheless they do seem to correspond quite conveniently to the form I have deduced from Clavijo's description, and to the Fīrūzkūhī tents. If this were the only type of trellis tent shown in miniatures of that period, the conclusion might be simple; unfortunately, it is not. The type seems to be rare. So far I have found only one other manuscript which shows a tent with the same reversed curvature. This is the *Shāh-Nāma* in the British Library dated 850/1446, and classified in Miss Titley's most useful new catalogue (127:34) as north provincial Timurid, from Māzandarān.[88] Here, on folio 119 is an example with much the same profile, and a close fitting top cover

with the same bands trimming it at an angle, only wider, and
meeting at the shoulder, where there is another wide band
below the roof. Some caution is needed, for guys are shown
leading from the top edge of this band, and it is detailed
with diagonal stripes like the eaves trim of bell tents at
that time. I am inclined to think that this may be a half-
understood copy of an earlier painting in which the model
was a trellis tent. Here no trellis is shown inside the
tent, and the entrance has no door frame,[89] though there is
no pole either, as there should be in a bell tent. The bell
tents elsewhere in this book (fos. 36a and 34b) are quite
diffferent, and unmistakable. There is another manuscript
of the Jāmi^c al-Tavārīkh belonging to the Asiatic Society
of Bengal[90] which, although on the grounds of calligraphy
it cannot be dated much earlier than 1430, is believed to
be far nearer in the details of its paintings to the lost
originals than is the Paris manuscript.[91] Unfortunately
the only trellis tent shown (fo. 89 ro.) is cut off at the
top by a guyed tent pitched in front of it, so that the
profile of the dome cannot be seen (Pl. 6b). It is clear
that the struts rise directly from the trellis, but the
shoulder is a much gentler curve than those we have examined,
and though the roof could have a reversed curvature it might
equally well be in a hemisphere. A cane door flap is shown
rolled up above the entrance, and the ties for the wall
felts come in to the jambs on either side, like those in
the Freer drawing, in a knotted crowsfoot, or as the
Türkmen say, a goose-foot.

A rather different dome shape can be seen in a group
of manuscripts roughly contemporary with Timur. The earliest
of these, the book of four epics at the British Library
dated 800/1397-8,[92] shows three trellis tents, though only
one is fully visible, on folio 44b. The domes are tall,
but clearly convex throughout, like obtuse eggs. The complete
tent is crudely drawn, and appears to have been worn away,
but one can just make out the lower edge of the top cover,
with creases on either side, and a flounce around the top
of the trellis, all in the same light red material. Another
two trellis tents with much the same dome shape are on folio
362b of the Miscellany of Iskandar Sulṭān, dated 813/1410-11.[93]
In this case the fabrics are very like the "brocades" in the
Paris manuscript, and the flounce is shown in a different
colour. In the *Khamsa* of Niẓāmī that was formerly in the
Cartier collection, and which has been dated between 1410 and
1420, the scene of Khusrau killing the lion[94] includes half
of a trellis tent with its top cut off by the margin. Here
again there is a tall trellis, and what seems to be a steep
dome, with a rolled door flap, flounce, and goose-foot felt-
ties on the wall and roof, but the dome begins with a bulbous

shoulder where it leaves the trellis, behind the flounce.
The same shape can be seen in a picture of the same
subject in the Gulbenkian Anthology at Lisbon.[95] The
tent is complete this time, and apart from the bulbous
shoulder, the dome has an egg-shape, with a closely-fitting
top cover reminiscent of the Miscellany tents. The arrange-
ment of the bands along the bottom of the top cover and the
roof felts, though, is close to that in the Paris manuscript.
This is dated 813/1410-11. All four of these manuscripts are
of the Shīrāz School. I have not until now referred to copies
of the *Żafar-Nāma* itself, since there are only two surviving
manuscripts which can with confidence be assigned to the
fifteenth century, and neither of these is early.[96] The first
of these is the now dispersed manuscript of 839/1436. A page
from it illustrating a trellis tent, now in the Berenson
collection,[97] (Pl. 6d) shows another egg-shaped dome, bulbous
at the shoulder, with a loose flounce and top cover, and a
goose-foot tie on the dome: it has a general resemblance to
the Cartier picture, and again is in the Shīrāzī style. The
second copy, the Garret manuscript from Herat, of 872/1467-8,[98]
contains a well known painting of Timur in front of his trellis
tent (fo.82 b): there are some familiar elements, such as the
tall trellis, the double flounce, and the shouldered dome,
but the flattened profile of the dome, and the salient roof
wheel are typical of the second half of the fifteenth century
rather than the period which concerns us. In passing, one
can notice the resemblance of the lambrequin over the door
to that on the Fīrūzkūhī tent. A last example of this general
type can be seen in an *Iskandar-Nāma* of Niżāmī dated 907/1501:[99]
the smoke hole is surrounded by an angled trim, though there
is no tie leading downward from it, and the dome is traversed
by goose-foot ties, this time with a double, instead of a
treble bridle, leading as they should to the corners of the
door frame. A flounce surrounds the top of the wall, and the
wall covers are pulled up to reveal a cane screen around the
trellis. The profile of the dome is at first convex, with
very high shoulders rising straight from the trellis, but
higher up the curve is reversed up to the smoke hole. It is
unclear to what extent this reversal is due to the presence
of a salient, but partially covered roof wheel, and to what
extent to the struts as they meet it, for the top cover is
arranged in a close-fitting neck around the aperture at the
summit; one it tempted to see this as an archaic feature to
be compared with Rubruck's description of the Mongol tents
in 1253,[100] and with the low neck on Nog̊ay tents. Though the
roof wheel is not shown in this picture - there is simply a
green hole - its profile can be inferred from folio 55a in
the same volume, which shows a very similar tent with the
smoke hole covered: it then forms a continuous convex curve,
roughly one third of a sphere, above the neck. The shape is

much like the top of the tents in the Paris manuscript. The pattern of the bands in both these pictures is typical of the beginning of the fifteenth century rather than its end, but it should not cause too much surprise here, as the style is attributed to the Türkmen School, which was somewhat retarded.

Besides these two types of tent dome, the plain-shouldered reversed-curve shape, and the bulbous egg shape, yet a third must be taken into account, the plain hemisphere. The earliest picture of a trellis tent that I have found in Middle Eastern manuscripts is in the *Maqāmāt of al-Ḥarīrī* at Leningrad, dated between 1225 and 1235, and of the Baghdad School.[101] As this was before Hülegü's capture of the city in 1258, it is likely to represent a Turkish rather than a Mongol tent. The walls are tall, and the dome rises more or less tangentially from them, forming about a third of a sphere, with an apparently solid gilt disc where the roof-wheel should be, surmounted by a crescent. The covers are evidently brocade. The structure is completely hidden, but the profile is quite distinct from that of the guyed bell tents and ridge tents in the same painting. It may be significant that a somewhat similar tent in the Paris manuscript, an exception to the general type, is shown at the siege of Irbil after the victory at Baghdad: it has a dome of the same shape, with a slightly salient roof wheel, but its walls flare outwards below an eaves band in a way that suggests it may have been guyed at the eaves, with no trellis. A dome of this kind, again with a slightly salient wheel, is directly associated with Timur in a painting from an album at Istanbul.[102] It is partly obscured by a bell canopy pitched in the foreground, but a blue cloud collar can be seen, like that in the Paris manuscript, surmounted by a band with an inscription around the roof wheel, reading "al-sulṭān ... amīr tīmūr gūragān".[103] Al-Sulṭān is not, however, the usual title by which Timur was known in his lifetime, and one should probably not take it too seriously as an accurate record of his tent. The picture is likely to be from Shīrāz, about 1440. I should add that I have paid no attention before to the subject of these paintings, for the simple reason that accuracy in terms of historical place and period had little or no importance for the painters, whose work can therefore be taken only as representative of their own life-time and milieu, unless they were copying an earlier work; even then they were likely to adapt it. It is noticeable, though, that the trellis tents are generally associated with princely or heroic protagonists.

A particularly fine tent scene from about 1390 to 1400, in Timur's own lifetime, is to be found in another Istanbul album, though it is probably Jalairid, that is to say from

Baghdad or Tabriz (Pl. 5b). A richly decorated guyed tent is being pitched behind a trellis tent which stands ready; the hemispherical dome is closed, with a flounce below, and it is traversed by a series of white bands with decorative cross-stripes that inevitably recall Clavijo's description. Two of these apparently run down the edges of the top cover, and three on each side must be goose-feet, but the purpose of one which encircles the dome half way up, with two running down to the corners of the doorway is uncertain, and apparently unique. Further bands run round the trellis at the middle, and at the top; slightly different ones trim the doorway. In general the picture gives the impression of being an accurate record of a real tent. Surprisingly a dark streak seems to represent a centre pole within the doorway, but close inspection shows that the trellis pattern on the rear wall can be seen through it, and it seems to be a later addition. The whole cover is in a light red brocade.

We thus have evidence for the existence of trellis tents with at least three different dome shapes in the first half of the fifteenth century. There are perhaps grounds for associating the hemispherical type with Baghdad, and the egg-domed type with Shīrāz. Since the origin of the Paris manuscript has not yet been identified, we are left in doubt about the reversed curve type, though the *Shāh-Nāma* painting from Māzandarān, if it is accepted as showing the same type, might suggest a location further to the east, where from the parallel with the Fīrūzkūhī tent we should expect it. Such types were not necessarily exclusive to a given area. An example from a rather later period, 1540, the *Khamsa* for Shāh Ṭahmāsp from Tabriz,[106] contains a painting with several tents, among which there is a tall trellis tent with plain shoulders and a rounded dome, covered in red brocade with a cloud collar, and not far behind it another with the flattened type of bulbous dome, covered in a green and pink material. Both have the salient roof wheel common at that time. It is possible that the red tent, likely from its colour to be the royal one,[107] retained an older form as a sign of status, though the bulbous form was fashionable. Similar tall red trellis tents were retained by the Ottoman rulers.[108] The bulbous shoulders of the other type could be obtained simply by erecting the usual curved struts on a trellis set up rather smaller than the usual diameter. The struts will then tilt outward, and assume a steeper angle for the roof: this is precisely the form that can be seen in the egg-shaped dome, so far as I know the earliest variant of the bulbous type. The later, flatter variant requires much greater curvature in the strut, which must be specially made. Bulbous domes are found today only among the Özbek of

Afghanistan.[109] One is tempted to associate their appearance
in the Middle East with the emergence of the Özbeks under Abū'l
Khair from 1428 onwards, but it seems unlikely that the appear-
ance of their tents, if they were of this kind, in Khwarazm
could have been imitated so immediately in Shīrāz.

Though none of these tent types resembles the trellis
tents found in Mongolia today, there is evidence that something
very like them existed at the end of the fifteenth century if
not earlier. In a manuscript of the *Gulistān* of Sacadī dated
891/1486, formerly in the Rothschild collection,[110] folio 91b
shows a black tent with a low trellis wall, with the straight,
even slightly concave struts set at a distinct angle to it,
and a small roof wheel. The profile is relatively low. It
has only simple cordage, a rope girding the wall, and ties
for the top cover. The door has a single leaf, opening out-
wards, consisting of a frame with eleven rungs set across it
horizontally, like the ladder-door of the Qırğız today, and
as though to prove it, a child is shown climbing up them.
The door is hung so that one can enter from the right, as a
Mongol does. Yet the puzzling aspect of this picture is that
it is assigned to the Türkmen school.

Far from narrowing the range of types, this rather
cursory review of the miniatures has shown that there were
as many kinds of trellis tent in the Middle East then as
there are now, if not more. The introduction of new variants
must have been gradual. I have shown how the bulbous dome
appears to have been a product of the Timurid period itself,
first in the egg-shaped, and later in the flattened form.
One cannot help but be struck with the parallel emergence
of the bulbous dome in the architecture of the time; and
since the change from the plain shoulder to the bulbous
one can be made in the tent by a simple adjustment of the
same elements, one is left to surmise that the tent form
may have suggested the solid one. The salient roof wheel
seems already to have been present in the trellis-less tent
by 1402, as it is shown in the Freer drawing, though it
became characteristic of the court trellis tents only in
the second half of the century, as the dome became flatter.
A really clear definition of the dates and localities for
these forms can only emerge from the examination of many
more manuscripts: I am now busy with this.

After such a speculative discussion, I should like to
end with a return to hard facts, by mentioning two reports.
The first is the manual on royal book-keeping called the
Risāla-yi Falakiyya[111], the dates of which refer to 1362-63,
though it appears to refer to the splendour of the last
Ilkhāns. It lists the expenditure on a variety of tents.

Among these are trellis tents, *khargāhāt*, under the headings
ṣad-sarī, *hashtād-sarī*, and *shaṣt-sarī*[112]: these are clearly
the Persian equivalents of Turki *yüz başlı*, a hundred heads,
seksān başlı, eighty heads, and *altmış başlı*, sixty heads.
This refers to the number of heads, or crossings, at the top
of the trellis, which is the same as the number of struts,
and it is still the usual way of defining the size of a
trellis tent.[113] There was only one of a hundred heads, at
5000 dinars, two of eighty, at 2,500 each, and seven of
sixty, at 1,428.6 each. The disproportionate cost of the
hundred-head tent, when the area of its covering should
diminish relatively, shows that it was made to a higher level
of finish than the others. It approaches the size of 120
heads that I suggested for Timur's great tents. Sixty heads
is an ordinary size, and among the Türkmen today sixty-two
and sixty-four are the most common numbers;[4] even eighty is
not exceptional, and I have myself seen an eighty-two strut
tent.[115] It is plain that the range of size then was much
the same then as it is now.

The second document is the ᶜ*arża-dāsht* stuck onto one
of the leaves of the "Yaᶜqub Album"[116] in the Topkapı Sarayı.[117]
According to a paper read recently by Professor Soucek, this
is likely to refer to the court at Samarqand after the death
of Baysunqur (1433).[118] One of its headings is *khargāh*, and
it describes the work in progress on what appears to be a
single large tent.[119] As the text is full of technical terms,
it is particularly regrettable that some of them are corrupt
in this copy, so that one is forced to play guessing games,
but the original must have run something like this:-

> The top cover of fourteen pieces, and the (?) wall
> cover of seven pieces, in all twenty-one pieces,
> of these six pieces have been finished; the
> sewing of the velvet ornaments has been
> completed, and of the medallions in the middle
> of the pieces with writing, which are of
> figured work, numbering twenty-one in all, six
> have been completed. Of the top, and the
> embroidered cover, and the borders, about one
> quarter of the work has been sewn. The work on
> the outside of the trellis tent, which is basically
> of linen, and its decoration in silken material,
> and its inscription in gold embroidery, is about
> one quarter sewn, and they are busy completing it.

From this one can infer that the outside and the inside
were made up separately, and that the decoration was principally
of appliqué work and embroidery, as I suggested. The terms
used for this decoration, *shamsa*, *naᶜl*, *sharaf*, *ḥāshiya*, *taḥrīr*,

ṣūrat-karī, are the same as those used earlier in the same
report for the work on books,[120] thus tending to confirm
that the common currency of Islamic design was applied as
much to tentage as to other work, and that the miniatures are
not fanciful in showing it. In contrast, the first term for
the cover, *tepä turlug,* is Turki,[121] although its use is
odd, for *turlug* normally meant, and means, a wall felt, and
it is only in the Qaraqalpaq tent, which has no wall felts,
that it has shifted in meaning to designate the top felt.[122]
Since it was made in so many pieces, it can hardly mean the
top cover there, for that was small, but it is more likely
to mean the roof cover cut in gores. The second term, which
now reads *baūza,* hardly makes sense, though as it is likely
to mean the wall covers, it might just be a corruption of
Mongol *tūrğa,* a wall felt.[123]

The framework of a trellis tent, one supposes the same
one, is mentioned briefly in the first section of the report:

> All of the painters are busy mixing paint and
> (?) pounding it for the seventy-five timbers
> of the trellis tent.[124]

The word given here for timbers, *chūb,* must be a
substitute for the usual Turki *uq – uğ,* meaning roof strut:
a parallel for this can be found in the Aymāq today, where
the struts, if not of the trellis tent, at least of the
trellis-less hut, are called *sar-chūy*[125] or *chapar-chūb*[126]
by the Jamshīdī and the Hazāra respectively. Seventy-five
would of course be a reasonable figure for a moderately
large tent, the odd number being arrived at by five being
set on the lintel over the door. It is still usual to
paint the frame red, among both the Mongols and the Turks
of the Qıpçaq group: it is now done with red ochre, and
explained as a precaution against death-watch beetle,
though I suspect that it was associated with the Chinese
choice of poppy-red for luck, and perhaps with royalty too.
It can be seen in several of the Paris pictures, especially
one which shows the erection of a tier of trellis. The
mention of the struts alone is consistent with the rest of
the report, which is concerned with details of piece-work,
not the whole, perhaps at the end of a week. It is
interesting that the painters referred to seem to be those
mentioned previously in the same document, who were employed
in decorative work of various kinds on a small scale, for
this shows that the standards of finish must have been very
high. They were busy too with other things, and the mixing
and pounding does sound rather like an excuse for lack of
progress. Timur's reign of terror over his craftsmen was

over, after all.

However unsatisfactory my understanding of this passage
may be (for it requires further work), it is unique in allowing
us a glimpse of a vanished art form, which, I submit, may well
have been as fully developed as any other in the Timurid world.

P. A. Andrews

Transliteration. For Persian words and names I have used the system in the *Cambridge History of Islam.* For Turkic and Mongol words and names I have used a modified Turkish alphabet, including the letters X and Q.

1. Fażl Allah Rashīd al-Dīn Tabīb, *Jāmic al-Tavārīkh: Tārīkh-i Mubārak-i Ghāzānī,* ed. E. Blochet (London 1911), ii,49; tr. J.A. Boyle as *The Successors of Genghis Khan* (London 1971) p.63.

2. Ruy Gonçalez de Clavijo, *Historia del Gran Tamorlan* (Sevilla 1582); tr. G.Le Strange as *Clavijo: Embassy to Tamerlane* (London 1928).

3. Clavijo/Le Strange pp. 149 & 263.

4. F. Lopez Estrada, ed. *Embajada a Tamorlan* (Madrid 1943), based on MSS Biblioteca Nacional de Madrid Bb 72-9218 (XVth century) & 18050 (XVIth century).

5. B.L.MS. Add. 16613, *Vida y Hazañas del Gran Tamorlan* (XVth century).

6. Sharaf al-Dīn cAlī Yazdī, ed.A. Urunbaev, *Zafarnāma* (Tashkent 1972).

7. Aḥmad ibn Muḥammad ibn cArabshāh, cAjā'ib al-Maqdūr fi Akhbār Tīmūr, (Calcutta 1840); translated by J. H. Sanders as *Tamerlane, or Timur the Great* (London 1936).

8. P.A.A. fieldwork 1970 & 1974.

9. cAlā al-Dīn cAṭa-Malik Juvainī, *Tārīkh-i Jahān-Gushā,* ed. Mīrzā Muḥammad Qazvīnī (Leiden 1937), iii, 98; transl. J.A. Boyle as *The History of the World Conqueror* (Manchester 1958), ii, 618.

10. Literally paces, *passos,* but this measure in other contexts which can be checked, such as the dimensions of Haghia Sophia, clearly corresponds to a foot.

11. Or, "and they opened and closed", in the Madrid MS, quoted Estrada.

12. Cf. F. Wolff, *Glossar zu Firdosis Schahname* (Berlin 1935), pp. 515-6.

13. E.g. the late Herat painting of Sulṭān Ḥusain Mīrzā in a garden, ca. 1485, ascribed to Bihzād.

14. Ibn ^cArabshāh, *op.cit.* text pp. 320-21; transl. p. 216, adapted.

15. *Yurt* properly means "home territory" in all nomadic dialects, or by extension sometimes, "tent site". See P.A.A. "The White House of Khurasan: the Felt Tents of the Iranian Yomut & Goklen", in *Iran* XI (British Institute of Persian Studies, Teheran 1973), p. 93 n.4.

16. A.Róna-Tas, "Preliminary Report on a Study of the Dwellings of the Altaic Peoples", in *Aspects of Altaic Civilization* (Indiana 1963) ed. D. Sinor, p.50.

17. R.A. Rorex & Wen Fong, *Eighteen Songs of a Nomad Flute, the Story of Lady Wen-chi* (New York 1974), scenes 3,4,8 & 13 (no. pag.), etc.

18. *The Mongol Mission*, ed. C.Dawson (London 1955), pp. 8 & 94.

19. Faẓl Allah ibn Rūzbihān, *Mihmān-nāma-yi Bukhārā* ed. M.Sutūda (Tehrān 1962), pp. 222-223.

20. P.S. Pallas, *Travels through the Southern Provinces of the Russian Empire in the Years 1793 and 1794* (London 1802-3), i, pl.6.

21. F.R. Martin, *Miniatures of the Period of Timur in a Manuscript of the Poems of Sultan Aḥmad Jalair* (Vienna 1926), plates v & vi.

22. Letter from Mr. Basil Gray, 14.8.75: "I see no reason to attribute to Samarkand, but would believe in Tabriz as location".

23. P.A.A. fieldwork 1970: my article on these tents is due to appear shortly in *Mardum Shināsī va Farhang-i ^cĀmma-yi Īrān* (Teheran).

24. Sharaf al-Dīn Yazdī, *op.cit.* fos. 397a & 446a.

25. CAlā al-Dīn CAtā-Malik Juvainī, *op.cit.* text i, 206; trans. i, 250; any doubt that felt tents are intended here is removed by comparison with Rashīd al-Dīn, *op.cit.* text ii,253; trans. p. 187: white felt is of special significance for the installation of princes, at weddings, etc. Dr. Gandjei has kindly given me a reference from Maulānā Jalāl al-Dīn Rūmī which strengthens this interpretation; in the poet's *Kullīyāt-i Shams yā Dīvān-i Kabīr,* ed. BadīC al-Zamān Furūzānfar (Tihrān 2535), iv, no. 1728, p.61, line 8, is the hemistich *"ba-Cishq u ṣabr kamar basta hamchū khargāh-am"*. This shows the connection of the idea of a girth, *kamar*, with the *khargāh* in the mid-thirteenth century. It can hardly refer to anything but a trellis-tent, particularly when the context is Turkic, as it is here.

26. E.g. a contemporary Scots use: "Sum lugit without the townys in tentis and in palzeownys" (1375 A.D.) Barbour, *Bruce,* xi, 139.

27. Sharaf al-Dīn CAlī Yazdī, *op.cit.* for. 459 a, line 16.

28. Ibid. fo. 459 a, lines 4-5.

29. Gonçalez de Clavijo /Estrada, *op.cit.* pp. 35-36 & 45.

30. *E el cielo del era redondo como boveda* ... (fo.47 verso).

31. Sharaf al-Dīn CAlī Yazdī, *op.cit.* fo. 459 a etc.

32. If the word *chapitel* is taken as meaning "spire", it is noteworthy that there were Spanish spires of this period which did in fact consist of groins running together into a roundel at the apex, with open work between, such as the western spires of Burgos Cathedral. The ambassador may have had these in mind.

33. In Mongolian tents the doorway is characteristically low, rarely exceeding 1.4 m to the top of the lintel.

34. Cf. The 92 strut Qazaq tent in the Museum für Völkerkunde, Hamburg.

35. Gonçalez de Clavijo/Estrada *op.cit.* p.42 gives a description of the Obelisk of Theodosius at Constantinople, which stands on a base. He estimates these as six lances, and two lances and more, respectively. In fact they measure 20 m and 6 m. The rise in ground level may render the second

dimension inaccurate, but the obelisk itself thus
yields a lance length of 3.33 m, which is close
enough to the 3.35 m standard.

36. Cf. Stephen Graham, *Through Russian Central Asia*
 (London 1916) pl. fa. pp. 206 & 214.

37. P.S. Pallas, *Samlungen Historischer Nachrichten über
 die Mongolischen Volkerschaften* (St Petersburg 1776),
 especially i, pl. 4; cf. i, pl. 7, which shows a
 much lower Buryat tent of the usual proportions.

38. P.A.A. fieldwork. See P.A.A. *op.cit.* (1973) p. 103.

39. *Ibid.* p. 98 & f.n. 28.

40. A.Kh. Margoulan, "The Kazakh Yourta and its Furniture"
 in *VII Mezhdunarodnui Kongress Antropologicheskikh
 i Etnograficheskikh Nauk,* t.vii (Moscow 1970), p.103.

41. See P.A.A. *op.cit.* (1973), p. 102.

42. J.Corominas, *Diccionario Crítico Etimológico de la Lengua
 Castellana* (Madrid 1954): otras veces claramente una
 clase de paño de vestir (see *tapiz*). Mr. King of
 the Victoria & Albert Museum confirms that this is
 unresolved, 5.10.77.

43. Gonçalez de Clavijo (1582), *op.cit.* fo. 48 verso, as
 develludo in a misprint. The Madrid MS has *de vellud,*
 and the B.L. MS *de velluto.*

44. Cf. E.M. Pescherova, "Gold Embroidery of Bukhara" in
 Sbornik Muzeya Antropologii i Etnografii XVI (Moscow
 1955).

45. *Velludo* does not occur again in these excerpts, so no
 confusion arises.

46. Gonçalez de Clavijo/Estrada, *op.cit.* p.173; cf. B.L.
 MS fo. 87 vo. *colorado carmesin.*

47. Cf. The description of the fur linings, fo. 55 recto.

48. Cf. The Torgud temple tent from Qara Şahr in Stockholm's
 Etnografiska Museet.

49. A.P. Arkhipov, report in *Geographicheskiya Izvestiya*
 (St. Petersburg 1850), Jan., Feb. & Mar., p. 72,
 footnote.

50. P.A.A. fieldwork 1970.

51. Cf. F.R. Martin, *op.cit.* loc. cit.

52. The trellis tent in Saray Mulk Xatun's second enclosure, covered in red silk, is described as having beautiful appliqué work in the first edition (fo. 54 recto) but this phrase is omitted in the Madrid and B.L. MSs.

53. The phrase *el frio* "the cold" is omitted in the first edition (fo. 55 recto).

54. N.G. Borozna in "Materialnaya Kultura Uzbekov Babataga", in *Materialnaya Kultura Nardov Sredney Azii i Kazakhstana* (Moscow 1966), p. 96 & p. 98.

55. Cf. K. Shaniyazov, *Uzbeki-Karluki* (Tashkent 1964), plate on p. 93, and P. Centlivres, "Les Uzbeks du Qattaghan", in *Afghanistan Journal* 2,i (Graz 1975), p. 31 fig. 10.

56. Cf. The Hamburg specimen.

57. William Alexander, water colour No. 19 in the Prints & Drawings Collection, B.M.

58. Cf. Sir T. Arnold, *Bihzad and his Contemporaries in the Zafar Nāmah Manuscript* (London 1930), plates I & II.

59. The word *chapas,* plates, is added in the first edition.

60. *Lasiagrostis splendens.*

61. Cf. The door of the Qazaq specimen at Hamburg.

62. Cf. The Pamir Qırğız tent from the Alay Steppe, No. Q 174 at Copenhagen Nationalmuseet, collected 1896. It has been drawn to my attention that *gızıl tal* (= purple osier, *Salix purpurea* ?) has a talismanic importance.

63. A.Janata. "On the Origin of the Firzkuhis in Western Afghanistan", in *Archiv für Völkerkunde* 25 (Wien 1971), p.61. Cf. Klaus Ferdinand, "Ethnographical Notes on Chahār Aimāq, Hazāra and Moghōl", review article in *Acta Orientalia* 28 (Copenhagen 1964), p. 191.

64. Ferdinand, *op. cit.* p.191.

65. Ibid.

66. Janata, *op.cit.* pp. 61-62.

67. K.L. Zaduikhina, "Uzbeki Deltui Amu-Dari" in *Trudui
 Khorezmskoy Ekspeditsii I* (Moscow 1952), pp. 355-59.

68. Mīrzā Muḥammad Haidar Dughlāt, *Tārīkh-i Rashīdī*, trans.
 E.Elias & E. Denison Ross, (London 1895), p. 148.

69. There are of course exceptions to this, such as the
 black Kurdish tents pitched side by side with felt
 tents on the southern shores of Lake Režāiya, or at
 Marāva Tepe.

70. Ferdinand, *op.cit.* p.200.

71. P. Centlivres, "Les Uzbeks due Qattaghan", *loc.cit.*
 fig.11.

72. B.Kh.Karmuisheva, "Uzbeki-Lokaytsi Yuzhnogo Tadzhikistana",
 in *Trudui A.N. Tadzh. S.S.R.* t.XXVIII (Stalinabad/
 Dushanba 1954), p. 133.

73. Borozna, *op.cit.* p. 95.

74. Zaduikhina, *op.cit.* p. 356.

75. P.A.A. (1973) pp. 96-7.

76. A confirmation of this can be seen in the characteristic
 reverse outward curve of the top of the Qıpçaq trellis,
 which is retained in the Burka trellis, despite its
 division into two tiers, in the top sections. It is
 absent in the Aymāq tents.

77. From my own measurements relating to tents with 62, 42,
 & 54 struts respectively.

78. Cf. Lord Raglan, *The Temple and the House* (London 1964)
 pp. 6-7.

79. Ferdinand, *op.cit.* p.182.

80. Janata; *op.cit.* p.59. Cf. J.Aubin, "L'Ethnogénèse
 des Qaraunas", in *Turcica* I (Paris 1969), pp. 69-70
 and 74.

81. E.G. Gafferberg,"Khazereyskaya Yurta Khanai Khuirga",
 in *Sbornik Muzeya Antropologii i Etnografii* XIV
 (Moscow 1953) pp. 90-93.

82. Ferdinand, *op.cit.* p. 199, quoting O.Lattimore. For shape see Rintschen, "Zum Kult Tschinggis-Khans bei den Mongolen" in *Opuscula Ethnologica Ludovici Biró Sacra* (Budapest 1959), p. 15, figs. 3 & 4.

83. Bibliothèque Nationale, Supplément Persane 1113, fos. 44vo, 66vo, 132vo, 153ro, 159ro & vo, etc.

84. B. Gray, "An Unknown Fragment of the Jāmic al-Tavārīkh in the Asiatic Society of Bengal", in *Ars Orientalis* I (Michigan 1954) p. 67.

85. See E.Blochet, *Les Peintures des Manuscripts Orientaux de la Bibliothèque Nationale* (Paris 1914-20), pl. xviii.

86. The *Dīvān* of Sulṭān Aḥmad Jalair, Freer Gallery of Art, Washington D.C. 32.34.

87. I am most grateful to Dr. Eleanor Sims for much patient guidance on the subject of miniatures.

88. Firdausi, *Shāh-Nāma*, B.L. Or. 12688.

89. There was of course another type of tent, the bell tent with a roof wheel at the top covered by a top cover, but it seems to me that in this instance the profile is so close to those in the Paris MS that there can be little doubt of its being a trellis tent, at least in origin.

90. Mīrzā Ashraf cAlī's catalogue of the Society's MSS (1890), p. 19 no. D 31.

91. Basil Gray, "An Unknown Fragment of the Jāmic al-Tawarīkh ..." in *Ars Orientalis* I (1954), p. 67. The picture is shown in pl. 4b.

92. B.L. Or. 2780, (Titley 99:4).

93. B.L. Add.27261, (Titley 98:19). This is illustrated in B.Gray, *Treasures of Persian Painting* (London, Skira, 1977) p. 73.

94. See L. Binyon, J.V.S. Wilkinson, & B. Gray, *Persian Miniature Painting* (New York 1971) p. 65 no. 42b, and pl.xxxii c.

95. Gulbenkian Foundation Museum, Lisbon, L.A. 161. See

A.U. Pope, *A Survey of Persian Art* (2nd edn. Oxford 1964-65), ix, 861b.

96. See E.G. Sims, *The Garret Manuscript of the Żafar-Nāma, a Study in Fifteenth Century Timurid Patronage*, Ph.D. Thesis in Fine Arts, New York University 1973, p. 147 ff.

97. See R.Ettinghausen, *Persian Miniatures in the Bernard Berenson Collection* (Milan 1961), pl. 7.

98. See Sir.T. Arnold, *Bihzād and his Paintings in the Zafar-Nāmah Manuscript* (London 1930), pl. I & II.

99. Bodleian Library, Oxford, Elliot 192 (Ethé 587), fo. 333a, and fo.55a. in the *Khamsa* of Niżāmī. Cf. Sir T.W. Arnold, *Painting in Islam* (Oxford 1928), pl. XXXVIIb.

100. Willem van Rubruck, "Itinerarium", in P.A.van den Wyngaert, *Sinica Franciscana*, I (Florence 1929), p. 172, cap.ii,2: "*et conveniunt in unam parvulam rotam superius, de qua ascendit collum sursum tamquam fumigatorium*".

101. Oriental Institute, Academy of Sciences, Leningrad, MS.S.23, p. 22. See R. Ettinghausen, *Arab Painting* (London, Skira, 1977) p. 112.

102. Topkapı Sarayı H 2138, fo.67b. I am indebted to Dr. Sims for the slide, as for several others used in the lecture.

103. It is possible that *al-sulṭān* applies to the nominal king, with his name obscured.

104. There is no text, date, or attribution by which the painting can be identified.

105. Topkapı Sarayı H 2152, the Baysungur Album, fo. 66a. This again has no identification.

106. At the Fogg Art Museum, Harvard. No folio numbers.

107. The red colour in tents was associated with royalty at least as early as the Salcuqs. Professor Faruk Sümer has told me of an instance, which I have not yet traced, in which a Salcuq prince was prohibited from using red tents to which he was not entitled.

108. Cf. Topkapı Sarayı, Istanbul, *Nusretname* 699 H 1365, fos. 29b, 43b etc., dated 1584. These very tall tents were guyed, and it is not certain that they had trellises, though they certainly reproduced the expected shape.

109. P.Centlivres, "Les Uzbeks du Qattaghan", *loc.cit.* fig.11: this shows precisely the flattened dome, and to a lesser extent the salient roof wheel of the late fifteenth century type. Only the trellis is too low.

110. Now in a private collection; I owe the slide again to Dr. Sims. It is illustrated by E. de Lorey, "Behzād: Le Gulistān Rothschild" in *Ars Islamica* IV (1937), pp.122-143, esp. 125 & 133-136, & fig. 3. It is attributed to ᶜAbd al-Ḥayy, and is in a different hand to the other miniatures in the book.

111. ᶜAbd Allah ibn Muḥammad ibn Kiyā, al-Māzandaranī, *Die Resalǟ ye Falakiyyǟ* ed.W.Hinz (Wiesbaden 1952). My thanks to Dr. A. Morton for this reference.

112. *Ibid.* fo.58b, p.93. Cf.fo.71a, p.119.

113. P.A.A. *op.cit.* (1973) p.98.

114. *Ibid.*

115. *Ibid.* This was a Gökleñ tent frame bought by a rich Yomut for his son's wedding in 1970.

116. İstanbul, Topkapı Sarayı H.2153, fo.98a. My thanks to Pr. Soucek for mentioning this.

117. Published by M. K. Özergin, with facsimile, as "Tebrizli Ca ᶜferin bir Arzı", in *Sanat Tarihi Yıllığı* VI, 1974-75 (1976), pp.471-518.

118. At the conference on Imperial Images in Persian Painting, Edinburgh 1977.

119. Özergin, *op. cit.* printed text p.493, C, and last section in facsimile.

120. *Ibid.* p.490, A, 4-5.

121. The word *tepǟ* has lost the lower dot, but it seems clear.

122. *Narod i Sredney Azii* I, ed. S.P.Tolstov (Moscow 1962),
 p.467, and N.A. Baskakov, ed. *Qaraqalpaqşa-Russa
 Sözlik* (Moscow 1958), p. 658, *tuwırlıq*.

123. ^cAlī Shīr Navāī noted that parts of the *khargāh*
 retained Turki names, see *Muḥākamat al-Lughatain*,
 ed. R. Devereux (Leiden 1966), text p.15, (1499 AD)
 though the terms he gives are the usual ones.

124. Özergin, *op.cit.* p.492, A,19.

125. E.G.Gafferberg, "Zhilishche Djemshidov Kushkinskogo
 Rayona", in *Sovetskaya Etnografiya* 1948 no. 4,
 pp. 127-28.

126. K.Ferdinand,"Preliminary Notes on Hazara Culture", in
 Historisk-filosofiske Meddelelser, bd.37, nr. 5
 (Copenhagen 1959) p.13, fig.3.

PLATES

1a. *Türkmen tent in Iran: frame, showing girths.*
 Photo from *Honar va Mardom,* Tehran.

1b. *Wen-chi Scroll, Metropolitan Museum of Art, New York.*
 Fourteenth century copy of twelfth century original.
 Trellis tent with curved struts, and domed roof
 wheel.
 Photo from R.A. Rorex, Eighteen Songs of a Nomad
 Flute, M.M.A., N.Y.1974.

1c. *Wen-chi Scroll. Trellis tent with straight struts.*
 Photo ibid.

1d. *Double-tier trellis of Hazāra tent, khāna-i khergāh,*
 from N. Afghanistan. Photo by E.G. Gafferberg in
 Sbornik Muzeya Antropologii i Etnografii XIV, 1953.

2a. *Festival Tent. Northern Qırğız in the 1920s.*
 Photo by F.A. Fjelstrup, State Ethnographical
 Museum, coll.4417-2.

2b. *Small Kalmuck Temple Tent, late eighteenth century.*
 Photo P.A.A. from P.S.Pallas, Samlungen
 Historischer Nachrichten (St Pbg.1776).

2c. *Imperial Manchu Tent, Jehol 1793:* Emperor Ch'ien Lung
 and Lord Macartney. Photo from water colour by
 William Alexander, no. 19 in P & D, B.M.

2d. *Fīrūzkūhī Trellis-Tent.* Tropenmuseum, Amsterdam.
 Photo P.A.A.

3. *Types of Trellis Tent in Central Asia*
 1,2. Durmen Özbek; 3. Quñrad Özbek; 4. Qarluq Özbek;
 5. Laqay Özbek; 6,7. Southern Qırğız; 8,9. Northern
 Qırğız.
 Photo from Materialnaya Kultura Narodov Sredney Azii
 i Kazakhstana, ed. N.A. Kislyakov (Moscow 1966),
 article by N.G. Borozna.

4a. *Dīvān of Sulṭān Aḥmad Jalāīr, Freer Gallery of Art,*
 Washington, (1403 A.D.). Nomad camp with trellis-
 less tents.
 Photo from F.R. Martin, Miniatures of the Period of
 Timur (Vienna 1926) pl.vi.

180

4b. *Frame Elements of Hazāra Trellis Tent.*
 1. Trellis section from lower tier, folded; 2. Trellis
 section from lower tier, open; 3. Trellis section from
 lower tier, seen from end; 4. Trellis section from
 upper tier, seen from end; 5. Roof struts; 6. Door
 frame, taken apart; 7. Roof wheel.
 Photo from E.G. Gafferberg, op. cit. (1d above).

5a. *Çiñgis Xan among the Tents of his own Ordu. Ibid.fo.66b.*
 Photo from ibid.

5b. *Unidentified Scene: Trellis Tent and Awning in the Course*
 of Erection. Jalairid ca 1390-1400. Istanbul,
 Topkapı Sarayı H.2152 fo.66a.
 Photo Topkapı Sarayı.

6a. *Tent Claimed to be that of the Wife of Tolui, Youngest*
 Son of Çiñgis Xan.
 Photo from Rintschen, Zum Kult Tschinggis-Khans bei
 den Mongolen, in Opuscula Ethnologica Memoriae
 Ludovici Biró Sacra, ed.Bodrogi (Budapest 1959).

6b. *Çiñgis Xan Feasting. Jāmic al-Tavārīkh of Rashīd al-Dīn,*
 Asiatic Society of Bengal, D 31, fo.89a.
 Photo from Warburg Institute.

6c. *Temücin Proclaimed Çiñgis Xan at the Great Qurıltay of*
 1206. Jāmīc al-Tavārīkh of Rashīd al-Dīn, Paris,
 Bibliothèque Nationale Supp.Pers.1113 fo.44b.
 (ca. 1415-1430)
 Photo from E.Blochet, Les Enluminures des Manuscrits
 Orientaux (Paris 1926).

6d. *Mīrzā Jahāngīr's wedding to Sevin Beg Khānzāda,*
 Samarqand 1373-74. Żafar-Nāma of Sharaf al-Dīn cAlī
 Yazdī, Berenson Collection, I Tatti, Florence.
 Shiraz, 1436.
 Photo from R.Ettinghausen, Persian Miniatures in
 the Bernard Berenson Collection (Milan 1961).

Plate 1

a

b

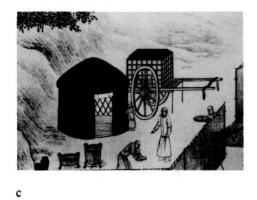

c

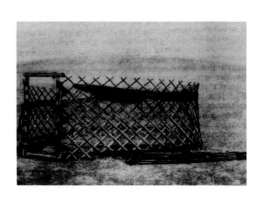

d

Plate 2

a

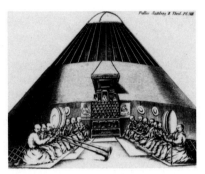

b

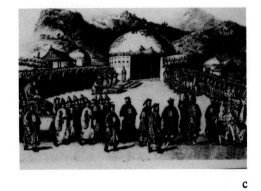

c

d

Plate 3

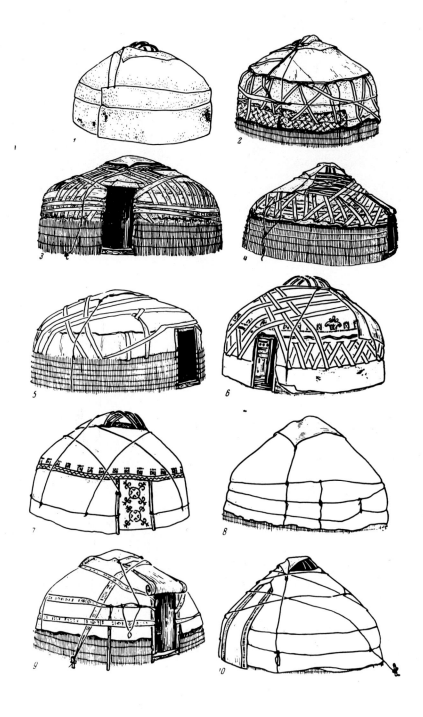

Plate 4

a

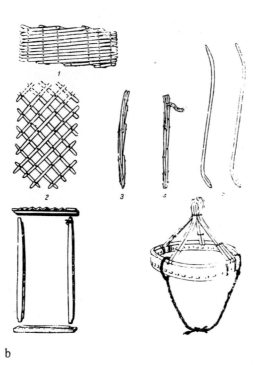

b

Plate 5

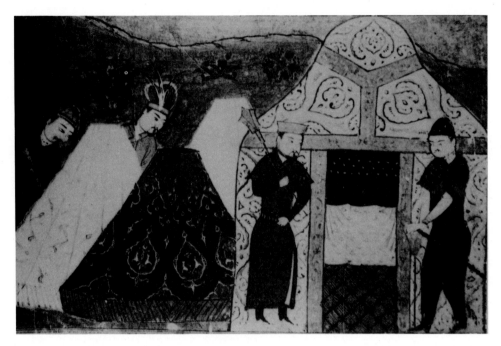

a

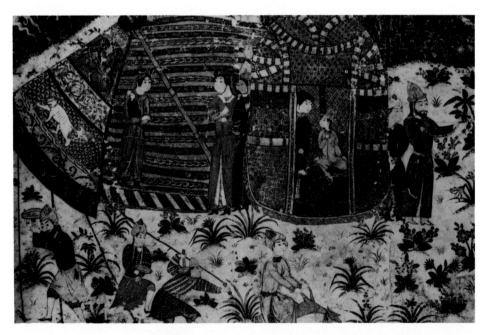

b

Plate 6

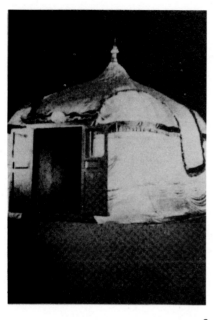

a

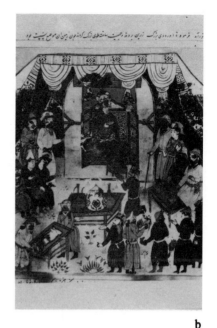

b

c

d

NOMADIC ARCHERY: SOME OBSERVATIONS ON COMPOSITE BOW
DESIGN AND CONSTRUCTION

The horse-riding nomads of Central Asia showed themselves
throughout history to be capable of welding together their
scattered tribes and, despite their lack of numbers, of
over-running the empires of settled peoples.

 To the Chinese they were a constant source of worry
and danger. Many Chinese dynasties were founded by nomadic
conquerors who in their turn, having become Sinicised and
having lost the basis for their organisation as horse archers,
succumbed to a fresh wave of nomadic horsemen or were
engulfed by a resurgence of native Chinese.

 In Western Asia and India the same pattern of events
was repeated and kingdoms rose and fell as the nomads found
leaders who for the periods of their lifetimes were able to
hold together the turbulent tribesmen of the steppes.

 The period of their dominion stretches from around
707 B.C. when the Cimmerians crushed the kingdom of Urartu
in the Middle East to the establishment of the Ch'ing dynasty
in China. It was only with the perfection of firearms that
the nomadic power was finally broken.

 My purpose here is not to trace the history of the
nomads of Central Asia and the empires they founded during
the course of many centuries - such a task would be beyond
my competence and would fill many volumes. Rather it is to
examine the weapon on which these peoples were able to base
their ability to dominate. I refer of course to the composite
bow.

 The composite bow was not the sole prerogative of nomadic
horsemen from the vast steppe lands of Central Asia, but the
various peoples who adopted this way of life modified the
weapon to make it perfectly adapted to use from the back of
a horse. In carrying out these modifications, over the course
of centuries, they produced a bow superior to all other types.

 As has been ably demonstrated by English archers at such
battles as Crécy and Agincourt, the simple bow of wood, if
well made from the finest materials, is capable of tremendous
execution. However, such a bow has its limitations. A wooden
bow has to be made of great length - six feet or more - to
withstand the strains imposed by a long draw. This factor
meant that the archer could only be at his best when on foot,

with an inevitable lack of tactical manoeuvrability. If the
foot archer failed to stop a charging enemy with the first
one or two shots he became obsolete as an effective missile
agent. No such problems existed for the horse archer, who
could keep his enemy within range of his arrows while ensuring
that an adequate distance was maintained to avoid hand-to-
hand combat. Of course, if both sides were similarly equipped
this advantage was cancelled out, and strenuous efforts were
made by the peoples of the littoral to equip and train their
troops in the nomadic fashion.

The composite bow, made of horn, wood and sinew was
usually extremely short, some forty to fifty inches (1015-
1275 mm.) measured around the curves in the best specimens.
Its effective length was even less by reason of the compound
curvature of the weapon. The bow would, despite its lack
of inches, encompass a draw fully as long as that of the
long-bow. Because of its shortness, and certain other
features of its design, it was far more effective than a
wooden bow. In simple terms it would propel an arrow to
approximately twice the distance that a wooden bow of
equal weight would do.

Present-day archers often assume that the specimens of
Chinese composite bows which can be seen in museums and
private collections today are identical to the weapons used
by Mongolian horse-archers of the armies of Genghis Khan and
his successors, but as I shall seek to show, this is far from
being the case.

The composite bow of Asia has a long history. It must
surely have been invented in those areas of the world where
a scarcity of suitable materials to make a self wood bow of
reasonable efficiency prompted the bowmaker to look for a
means of improving the structure.[1] Some doubts have been
expressed as to the veracity of this theory, for it is an
undisputed fact that some of the areas where the best bows
were made had a plentiful supply of good bow woods.[2] What-
ever the truth of the matter may be, it was invented and
came to be the major weapon of all the Central Asian nomads.

Its appearance changed over the centuries due to its
continuing development and since this development was not a
uniform one, certain styles of bow can now be ascribed to
different areas and peoples. Nevertheless, they all had the
same basic construction, i.e. they were all laminated from
wood, horn and sinew with a covering of tree bark, skin or
leather. There was also usually a coating of paint or
lacquer to protect the highly hygroscopic materials from the
effects of climatic changes and especially humidity.

189

The nomadic bowmakers did not record their methods of bowyery themselves but the peoples of the kingdoms they founded or usurped did. It is from the writings of these peoples that the information which can be obtained by examination of extant specimens can be explained and supplemented, but for a more complete picture an additional examination in the light of empirical research into the art of composite bowmaking is called for. Such research over the course of some seventeen years has convinced the present contributor that the old methods with their almost ritual observance of a certain season for each stage of manufacture are essential. Any attempts to speed up the processes invariably lead to failure.

It may be as well here to describe briefly the construction of a composite bow and to give the technical nomenclature used to describe the bow and its various parts.

The composite bow was invariably a reflexed bow, i.e. when unstrung it was curved in the reverse direction to that which it would assume when braced. This degree of reflex varied and depended upon the type. Chinese bows of the Ch'ing period, for example, had perhaps the least reflex while the Korean bow had the greatest. It was only possible to build this amount of reflex into a bow because of the flexibility of the materials used in its construction. The advantage it gave to the bow was that the string was under a much greater tension at brace height than a simple bow would be, i.e. when it was in the strung position but before the archer had commenced his draw of the bow. In fact the limbs of the bow would have moved as much or more before the arrow was drawn as they would at extreme tension of the bow-string, therefore for a given limb length and thickness more power was stored within the bow when it was used.

The first stage in the construction of a composite bow was to assemble the core which established the final form of the weapon. Using the Ch'ing dynasty bow (Pl. 1) as an example, it can be seen that the flexible parts of the bow core were composed of bamboo with a plug of wood - usually mulberry - glued to the centre of the back of the limbs (Pl. 2). The 'back' of the bow is the side which faces away from the archer when he holds the bow in shooting. One piece of bamboo formed both limbs in the case of both the Chinese and the Korean bows, but bows from some parts of the Islamic world in which wood rather than bamboo was used for the core had a variation in construction where as many as seven pieces of wood were joined together to form the whole core, and the handle section was spliced into the two separate limb pieces.[3]

Into each end of the bamboo was spliced an 'ear' or tip of mulberry wood. The joint was held by glue made from fish bladders, that is, isinglass. This was the glue used throughout the bow except for non-essential parts such as the decoration of patterns cut from coloured birch bark which might be applied to the best quality bows. Where stress was present in the bow isinglass was the only glue used. The 'ears' in addition often had strips of horn inserted into them as re-inforcement for the nocks which held the bowstring loops. The 'brain' which was the curved ridge just below the 'ear', could also be re-inforced with a horn strip especially when the 'ear' and the 'brain' were formed as a single unit from one piece of wood and there was as a consequence some cutting across the grain of the wood.

In the Chinese bows the bamboo of the core was positioned so that the outer skin of the bamboo formed the belly side of the bow and had the horn strips glued to it. The 'belly' of the bow is the side which faces the archer when he holds the bow for shooting.

The horn for the 'belly' of the bow was in two strips which butted together in the centre of the handle and extended to the base of the 'ear' at each end of the bow. The horn was usually that of the water buffalo in China but when these were not available, other horns were used. As Sung Ying-Hsing noted in the 17th century, 'This type of long ox horn is not available to the northern barbarians, who have to use four pieces of sheephorn joined together to form a horn plate. In Kwangtung province, the horns of both water buffalo and yellow cattle are used by the bowmaker'.[4]

The final layers to be applied to the bow, apart from the water-proofing bark and lacquer, were of sinew soaked in glue. There could be one, two, or three layers of sinew in the normal bow depending on the strength required. It was this section which played the major part in giving the speed of cast to the bow. In the Chinese bow the sinew was taken from the spine of an ox. The Islamic bowmakers on the other hand, preferred to use the sinew from the Achilles tendon. Spine sinew is somewhat coarser in texture than the Achilles tendon but is just as strong and is much longer, which is probably the reason why the Chinese bowmakers with their large bows used it. In my experiments in the making of composite bows I have found that it does not break down into such fine fibres as Achilles tendon does, which perhaps explains why the Chinese bowmakers found it necessary to soak their sinew in water overnight to soften it before saturating it in glue prior to applying it to the back of the bow.[5] With the finer fibres from the Achilles tendon

the sinew can be soaked in a fluid glue mixture at once and
soaking in water is unnecessary.[6] It should be noted that
Sir Ralph Payne-Galwey was entirely wrong when he stated that
the sinew used was from the '...great neck tendon of an ox
or stag'.[7] This material is far too ductile in its natural
state for use in a bow and when dried and hammered, both
essential stages in the preparation of sinew, it will break
down into short brittle pieces which have no cohesive
strength. Even if some way could be found to form a back
from the neck sinew, it could not function, but would shatter
at the first flexing of the limbs of the bow.

The dried sinew was first pounded with a hammer to
break it down into fibres and it was then dragged through
an iron comb to straighten and separate the fibres. At this
stage the sinew looked like bundles of flax. The sinew was
carefully weighed so that the correct quantities of the
material could be applied to the various parts of the bow.

After the bow, which at this stage had only a slight
reflex, had been heated and drawn into a reverse curve by
means of a cord tied between the two 'ears', the bowmaker
applied a coat of glue and then laid the bundles of glue-
soaked sinew onto the back of the bow, starting with the
'brain' and finishing with the handle section. The sinew
was combed out straight with a wooden or metal comb and
each bundle was then tapered off at its ends so that the
adjoining bundle could overlap without increasing the
thickness of the layer at this point. Sinew laying had to
be done in a warm atmosphere but winter was the time chosen
by Ch'ing bowmakers because winter nights were 'quiet and
solemn'.[8]

When the sinew layer had been completed, the bow was
left to dry for many months before a further layer was
applied. Before a second or third layer was applied the
reflex was increased, after heating the bow, by tightening
the cord holding the two ears together.

After the final layer of sinew had dried thoroughly,
the bow was carefully smoothed and polished and the bark
cover applied.

The finishing of the bow was not just a matter of
polishing. The bowmaker had to ensure that the bow bent
evenly in both limbs with the correct curvature throughout
the draw. This was done by a combination of heating and
pressing with the aid of a wooden mould shaped to the
curvature of a braced bow. Such adjustments of the bow
took much time and a bow could easily be ruined if the

process was not carried out with due care and attention.

The making of a batch of bows would take the bowmaker three years according to the practice of the bowmakers of Chengtu, but a batch could consist of as many as six hundred bows and it was not necessary to wait for one batch to be completed before another was started so that although it was three years before any particular bow was completed, bows were produced by an established bowmaker at a reasonable rate. The reason for the great length of time taken was the drying time required by the sinew layers and there is no doubt that if sufficient time was not allowed between layers then the resulting bow would rapidly lose its cast and would not last very long.[9]

The Ch'ing type of bow which can be seen in many museums, as I have noted earlier, is often taken to be the old Mongolian bow (Pl. 3b). It is true that the bows used in Mongolia today at the annual games at Ulan Bator are of very much the same appearance as the Ch'ing bows, indeed Chinese bowmakers are said to have exported bows to Mongolia[10] but this type of bow is strictly a Manchu one or at least was developed during the Ch'ing period.

If we examine the evidence available from Chinese paintings and the illustrations in the great encyclopedias we find that before the Ch'ing dynasty shorter, double curved bows were in use (Pl. 5). These bows resembled the bows of the Koreans (Pl. 3a) and at the other end of the steppes, those of the Crimean Tatars, in that they had a reflex built into their handles. This was rigid and did not flex when the bow was pulled. This reflex seems to have been a feature of the earliest bows such as the Scythian, which lacked the stiff 'ears'. It is probably because of this lack that the arrows used with Scythian bows were fitted with small light arrowheads. I deduce from this that the Scythian bows lacked the armour-penetrating qualities of later types of bows which could propel much heavier arrows.

The next stage of development of the composite bow appears to co-incide with the advent of the Huns, although this development may have taken place long before their clash with Rome. At any rate, the graves of Hunnic princes were furnished with bows fitted with bone plates which formed long 'ears'.[11]

This bow did not greatly resemble the bows of later times (Pl. 4). The ears tended to be long like those of the Ch'ing bows but instead of being formed of wood alone the core of the bow was extended to the ends where it was re-inforced by

a bone plate on either side. When the bow was braced, instead of the bowstring resting at the base of the ear, it cleared the bow for its entire length. This meant that although the ears acted as levers to bend the flexible parts of the limbs, they did not have quite the ability of the later bows to spread the power band of the draw to avoid 'stacking' (which is a term used by archers today to describe an intensive build-up of weight in the last few inches of draw).

Bows of this type were carried unbraced in a case covering the entire length of the bow. We can see from the form of this case that the bow within did not have a greater reflex than the Ch'ing bows. The arrows for this type of bow tended to be carried in a long box-like quiver with a lid to keep out moisture. They were carried point uppermost, and must have been somewhat difficult to remove in a hurry.

The Mongolian bows of the Yüan dynasty were intermediate between these Hunnic bows and the later types. The 'ears' were angled more sharply forward but still the bowstring only touched them for part of their length. The bows continued to have a set-back handle but not to the extent of the Scythian bows.

The Ming dynasty bows reached the ultimate development except for the retention of the set-back handle section. The 'ears' were now distinctly separated from the 'brain' or ridge section. These two areas formed a unit which described a compound path of travel which spread the power band of the draw so that the bow picked up weight rapidly during the first half of the draw and then during the second half increased its build-up much more gradually. This made the bow easier to hold at full draw and the aiming of it less affected by minor variations in draw length, which might occur during the heat of battle.

Such a bow would be only some fifty inches (1275 mm) in length measured around the curves and was easier to use on horseback than a longer bow would be. Moreover, the shortness of the limbs made for a sharper-casting bow than the relatively long Ch'ing weapon. The range of the Ch'ing bow was only some two hundred yards maximum with an ordinary arrow, but the Ming type would have been capable of sending an arrow to twice this distance. We are therefore faced with a problem. Why did the Ch'ing bow develop as it did and why did it take over from the earlier type in China and those other areas affected by Chinese culture? In Korea the earlier type has survived down to this day,

although with some minor detail modification. In Western and Central Asia bows tended to become shorter and to lose the set-back in the handle. The set-back handle accentuated the tendency all composite bows had to twist and the same effect could be obtained by reflexing the 'ears' more acutely thus making the feature unnecessary. Even the largest of the Ch'ing bows were made with only a slightly set-back handle.

The most likely explanation of the problem is that we are faced with two divergent streams of development from the Hunnic bows. In Manchuria the type gradually became modified to give a bow that was easy to shoot and was very accurate at short range. It could propel a very heavy arrow with great force and because of its length was very durable in the field although less easily managed on horse back, although this is not to say that it wasn't used perfectly adequately by Ch'ing horse archers for there are plenty of illustrations available which prove the point. With the conquest of China by the Manchus China's bowmakers were naturally instructed to make the weapon of the new rulers. Expert no doubt in the use of their national weapon, the Manchu Bannermen would not be inclined to adopt the weapon of a conquered people.

In Central and Western Asia the bow developed along separate lines with the emphasis being placed on speed of cast and distance of shot with relatively light arrows. Perhaps the Manchus preferred to emphasise penetration above all else. The words of the Ch'ing emperor K'ang-Hsi when writing about his hunting exploits are perhaps illuminating:-

'Hunting with the Khorcin, I shot clean through two mountain sheep with one arrow, and my officers were astounded; but I explained that it is all a question of using the force of the sheep's own leap to get extra penetrating power for the arrow. The crossbow may have the distance, but it lacks the penetration and the precision of the reflex bow; it makes a good plaything, but is not reliable for regular use'.[12]

E. Mc Ewen

NOTES

1. H. Balfour, 'On the Structure and Affinities of the Composite Bow', *Journal of the Anthropological Institute,* Vol. XIX, (London, 1890).

2. G. Rausing, 'The Bow: Some Notes on its Origin and Development', *Acta Archaeologica Lundensia* Series in 8. No. 6, (Lund, 1967), 145-146.

3. J. D. Latham and W. F. Paterson, *Saracen Archery,* (London, 1970), 11.

4. E-Tu Zen Sun and Shiou-Chuan Su (trans.) *T'ien-Kung K'ai-Wu: Chinese Technology in the Seventeenth Century,* (Pennsylvania State University Press, 1966), Chapter 15.

5. P. E. Klopsteg, *Turkish Archery and the Composite Bow,* second edition, (Evanston, Ill., 1947), 173.

6. Klopsteg, op. cit., 47.

7. Sir R. Payne-Gallwey, *The Crossbow. With a Treatise on The Balista and Catapult of the Ancients and an Appendix on the Catapult, Balista and the Turkish Bow,* (London, 1903. Reprinted London, 1958), Appendix 4.

8. C. B. Swinford (unpublished trans.) T'an Tan-Chien, *Investigative Report on Bow and Arrow Manufacturing in Chengtu, China,* (T'aipei, 1956).

9. Swinford, op. cit.

10. W.F. Paterson, personal contact with Mongolian archers at the World Archery Championships, York 1971.

11. K. Jettmar, *Art of the Steppes,* (London, 1967), 145.

12. J. D. Spence, *Emperor of China: Self-portrait of K'ang-hsi,* (London, 1974), 10.

PLATES

1. Typical Ch'ing dynasty bow, braced and unbraced.
 Length (unbraced) around curve from nock to nock,
 63" (1600 mm). Author's collection.

2. Sections taken through two Ch'ing dynasty bows.

3a. The author shooting a Korean bow. Courtesy Society
 Archer-Antiquaries.

3b. Ch'ing horse archer. Ma Chang Chasing the Enemy, by
 Lang Shih-ning, (Giùseppe Castiglione), National
 Palace Museum, Taipei, Taiwan.

4. Hunnic type bow. Archer and Horse by Li Tsan-hua, 10th
 century, National Palace Museum, Taipei, Taiwan.

5. Ming dynasty bow. Emperor Shih-tsung, Ming dynasty.
 Detail from a scroll, National Palace Museum, Taipei,
 Taiwan.

Plate 1

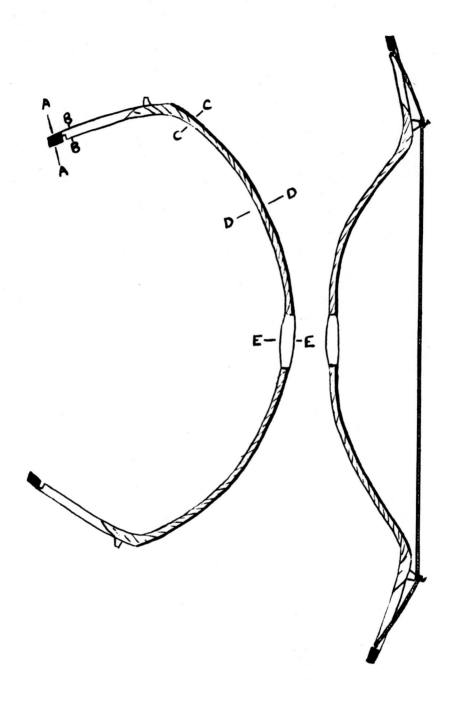

Plate 2

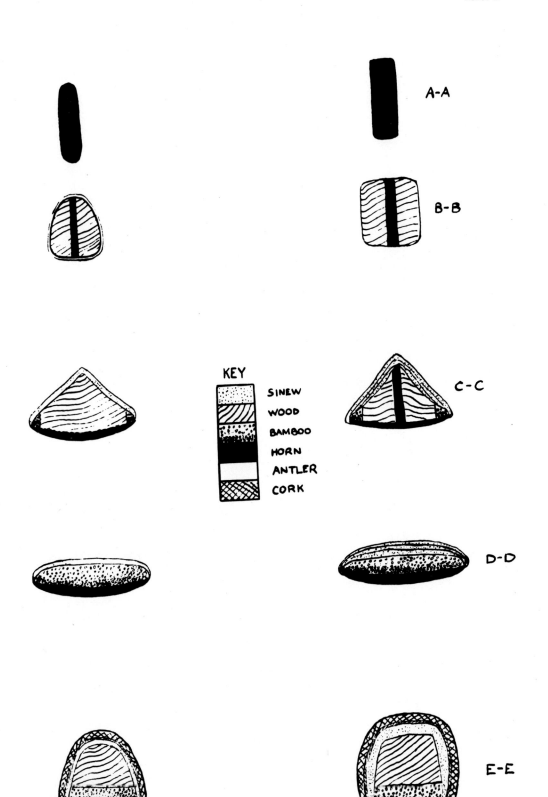

KEY

SINEW
WOOD
BAMBOO
HORN
ANTLER
CORK

A-A

B-B

C-C

D-D

E-E

Plate 3

a

b

Plate 4

Plate 5

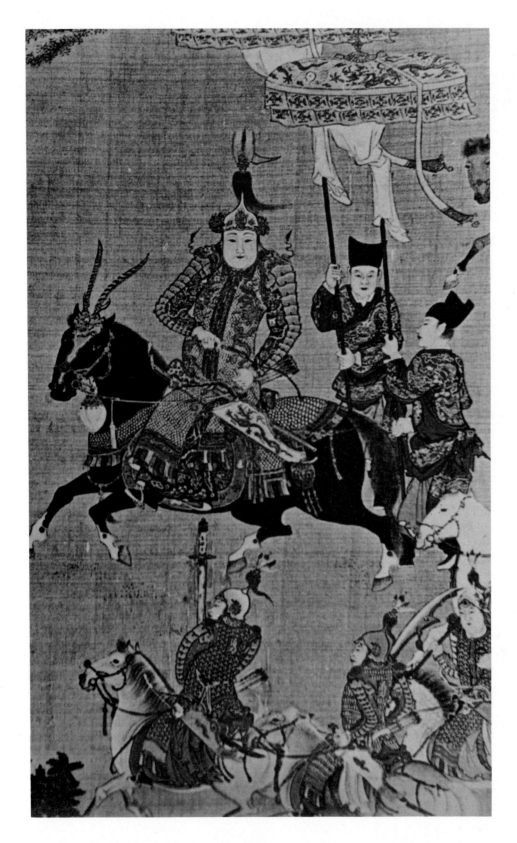

RECENTLY FOUND RELICS OF TURKIC STONE SCULPTURE FROM
THE TERRITORY OF THE MONGOLIAN PEOPLE'S REPUBLIC

The latest Mongol-Hungarian archaeological expeditions, in addition to exploring prehistoric and Asian Hun (Hsiung-nu) relics, have made it possible since 1963 to scrutinise also archaeological remains from the Turkic period.

I should like to present a group of relics which have not yet become known to science; nor have they been treated in our preliminary report.

We had the opportunity to examine such relics in the territory of Kenti-aymak, East Mongolia, in 1971, and in the territory of Arkhangay-aymak, Central Mongolia, in 1974. We give below brief descriptions of these; then we venture to interpret them.

We came across one - as yet unpublished - stone statue near the airport of Öndörkhaan district centre in 1971 (Pls. 1a, 1b). Its full height is 180 cm. It is weathered by rain and wind quite a bit and the details are very blurred; still We can discern - chiefly from the side-view - that the male figure sits in an armchair with his legs held closely side by side. In his right hand he holds a small stoop; his left hand rests on his knee. On his head a round hat is to be seen. At his waist, to the right, there hangs a square bag. Behind his ear a pendant of spiral end can be made out.

In front of the statue two sizable sacrificial stones, one flat and one cube-shaped, are standing; they are frequented by Mongols with food offerings to this day. We did not discover any traces pointing to the presence of graves nearby.

This must have been the statue which was mentioned by L. A. Amsterdamskaya in her manuscript report in 1927. I have gleaned this information from the small monograph of N. Ser-Odjav, a Mongolian archaeologist, who did not publish any picture of this statue (1970). Statues similar to this are not too frequent in this aymak (county). In 1971, we spotted from afar a statue representing a standing figure, presumably of Turkic period, along the road between the district centre Yargaltkhaan and Mount Dulga, a short way from a nomadic shelter. Unfortunately we had no time to examine it then. Neither Gábor Molnár, a Hungarian writer and traveller, who was in this aymak in 1968, nor

Kh. Perlee and D. Navaan, Mongolian archaeologists who were
exploring this region in the same year could find any Turkic
statues. In the territory of Kenti-aymak, only one find-
spot is recorded in N. Ser-Odjav's above-mentioned monograph
(1970. pp. 60-61). In Batshireet district of the county in
question very simple, small-size sculptures (five pieces side
by side) representing merely human faces were discovered by
L. Jisl, a Czech archaeologist and N. Ser-Odjav, of Mongolia
in 1963 (1966. Figs. 41., 42.). These statues are standing
near Lake Egin, 9 km from the railway. They are, undoubtedly,
of Turkic period. They are placed in front of small square
sacrificial sites fenced off with stones. It is noteworthy
that we had found similar ones in the territory of Uktal-
Tsaidam state farm, on the bank of a brook called the Nuden,
in 1962. These too stood in front of small, square
sacrificial sites built of rough stones (I. Erdélyi - L.
Ferenczy, 1963, p. 123.). They seem likely to have been
erected to commemorate not-so-well-off people.

Now let us have a closer look at the other two
statues which we have studied, after which we shall sum up
and make our evaluations.

As has been mentioned, the other two stone sculptures
were found in the territory of Arkhangay-aymak. No mention
of them whatever has so far been made in the specialist
literature. Having found one stone statue - toppled over -
on the right bank of the Huni river (one of the Selenga's
tributaries), facing the valley called Tsorgin-am some 7
air kilometres away from one of our excavation-sites, in the
border area Naymaatolgoy, we put it in place again (Pl. 2a).
This statue had been carved from a prehistoric so-called
'stag-stone' (another stag-stone, uncarved, lay next to it
on the ground, broken in half). Here again, we did not find
any trace of graves nearby.

The originally flat stag-stone has been carved in a bas-
relief fashion. In the upper part the contours of a male
figure's head and shoulders can be seen. Its full height
is ca 170 cm (of which 140 cm rises above the ground). Its
average thickness is a mere 23 cm. The male figure on the
stone slab is seated with legs crossed. In his right hand
he holds a narrow-necked bottle; the left hand rests on his
sabre's hilt. He is bare-headed, and above his forehead
there is a thick wisp of hair. His belt is only schematically
represented.

The third stone statue was found in the vale of the
Bayan-tsagan streamlet (a tributary of the Tamir river) in
1974, broken (Pls. 2b, 3a). It lay toppled over. Its

severed head we came upon nearby and managed to fasten on
the trunk. Its full height is 190 cm. Originally this
statue had also been a stag-stone. This fact is corroborated
by the surviving representation of a sun-disk on the thin
foot, which used to figure once at the top of the stele.

Without doubt this stone sculpture is one of the
finest known relics of its kind in Mongolia. The standing
male figure holds a cup on the finger-tips of his right hand;
his left hand is placed on his dagger. At his waist we can
easily distinguish the belt decorated with laid heart-shaped
studs and a round leather bag hanging from its right side.
His face - unlike the other known statues - is framed by a
wavy, triangle-shaped beard. His headgear is rather sketchy
and battered.

* * * * * * * * * * *

As we have seen, the three stone sculptures represent
three wholly different styles. Nevertheless, we shall
attempt to show that they possess features in common as
well.

The sitting and standing stone statues in the tomb-
groups of the Turkic khagans Kül-tegin (died in 731) and Bilgä
(died in 734), like the similar statues of "Minister" Tonyukuk's
tomb, are actually to be studied as parts of planned and
elaborated memorials and this itself, plus their diverging
stylistic features, excludes them from being considered as
solitary tomb-sculptures. These are quite well-known from
various publications, although none of them has so far been
dealt with in a specific monograph. Still we deem it beyond
the scope of our present survey to discuss them at length.

Among the pre-Turkic nomadic peoples of Mongolia, such
as the Asian Huns (or Hsiung-nus), it was not customary to
set up stone statues at the tomb. As to later periods, it
is to be remembered that not from the territory of Mongolia
but from the valley of the Angren river (near the town-let
Toy Tübe) in Özbegistan, Central Asia, and from the shore
of Lake Sari in Kazakstan we do know of pre-Turkic-period,
rough stone statues dated from the 5th century, A.D. (Masson
M.E. 1951.).

In connection with the stone statues we have studied,
some comprehensive problems must be recalled. Therefore we
note here that the purpose of setting up statues in the
Turkic era was the subject of a protracted and recurring
scientific debate in the Russian and Soviet specialist

literature. We refrain from reviewing this debate but should
like to indicate our standpoint in brief: it tends to agree
with the now widely held opinion, viz. that the statue
standing by, or perhaps on, the tomb was intended to represent
the deceased, who thus was figuratively drinking together with
those present at his funeral feast (see Larichov V. 1968. p.
235). True, in many cases we fail to detect any individual
features, but to portray these was above the sculptor's
abilities, or else he simply wanted to render a type.
Moreover, individual features of attire were ignored because
of a uniform style of dress. Of course we do find portraits
among the statues of the Turkic era, for instance the one
representing Kül-tegin khagan himself which was discovered
by a Czechoslovak-Mongolian archaeological expedition
fifteen years ago.

Before the statues, at the foci of the tombs or
sacrificial places there regularly stood the so-called
balbal row, i.e. an array of rough stone columns, which
indicated the number of enemies killed in battle by the
deceased (incidentally this custom is mentioned in the Sui-
shu). From amongst the stone statues we have examined, it
was only by the statue last-mentioned in our above description -
standing on the shore of the Bayan-tsagan streamlet - that we
found such a row of stone stelae. The grave itself had
already been destroyed.

For a further analysis of the three sculptures we can
have recourse to such excellent monographs as the one by
L. Ievtyuchova, of Moscow (1952), or the one by I. Sher, of
Leningrad (1966), although the latter treats primarily of the
stone sculptures of the Semirechie (Seven Streams' country).
At that time I. Ievtyuchova had had the opportunity to study
only 22 Mongolian stone statues, and the major part of those
only from photographs or drawings. Their distribution is
mainly the western and southern parts of the country. The
stone statues of the region called Dariganga lying in the
southeastern part of the Mongolian People's Republic, were
collected by V. Kasakevich already in the late '20's
(his work was published in 1930). Apart from N. Ser-Odjav's
previously mentioned later work (1970), the studies above
are the most important sources. Already this Mongolian
author sought to classify the Turkic age statues according
to costume details. Thus he ascertained that, e.g. there
are no stone statues with studded belts in the eastern
regions of Mongolia (1965. p.11.). In our opinion, for an
up-to-date treatment of the Mongolian sculptures there is
need for a work like I. Sher's book, a work utilizing the
same kind of method. We shall return to this question
later.

For a comprehensive study, there is the problem that in Mongolia very few presentations, that is, photographs and drawings, have thus far been published about the stone statues. Our pictures to be published mark a crucial contribution in this respect as well.

Additionally I should like to present a stone statue - found in 1928 - currently on display in the Central State Museum of Ulaanbaatar, the place of origin of which is one of the Choyren kurgans southeast of Ulaanbaatar (Pl. 3b). Of this no picture has been published either, although the runic inscription upon it was deciphered by S. Malov on the basis of a photograph, which cannot have allowed a perfect translation. This statue is important since it can be dated exactly between 687-691 by virtue of the inscription ascribed to the above-mentioned Tonyukuk, one of the chief figures of the second Turkic khaganate (S. Kliashtorny, 1973. p. 411). Beside the inscription, left, the tamga representing a mountain goat of the Khagan's family can be seen. This statue should be regarded as a peculiar, or even "popular" Turkic relic which fits well into the category of simpler Turkic-age stone relics. It has good analogies both from the region of the Semirechie and from the Tien-Shan as well as from Mongolia itself, e.g. from the aymak of Bayan-ölgy.

Our aim in the foregoing has been to give a sketchy outline of the features of stone statues which we have discovered and examined. Now let us turn to the finer details, first of all the elements of attire on them.

The outer garments, that is, the cloak (del in Mongolian) is most distinguishable on the sculpture found by the Bayan-tsagan streamlet. It is an important article of attire. The predominant majority of the Turkic-age statues wear a cloak with a central fastening both in Mongolia and west of it. On a large part of the representations this is quite visible. So the members of the sculptural group detected close to the remains of the Kül-tegin memorial hall almost all wear cloaks with central fastening, or perhaps (twice) left fastening. This is highly suitable for nomadic warfare, as it does not hinder the right-hand drawing of the bow. Among the stone statues by Bilgä khagan's tomb we have found only one seated figure with a cloak fastened on the right. Presumably this - already headless - stone statue represents the khagan himself. The cloak of another seated statue here, however, fastens to the left. We should bear in mind that the Turkic khaganates were never homogeneous ethnically, hence they were not uniform regarding their attire either. This may partly account for the observable divergencies of attire. Referring to the

problems outlined above we remark here that it was chiefly
the perceivable differences of attire which led astray those
researchers who took the statues to be not the representations
of the deceased but those of the arch-enemies killed by them.
This mistaken notion is further refuted by the very fact
that some of the Turkic tomb statues represent women.

Statue-figures wearing cloaks with right fastening,
as far as I know, occur only in Mongolia (L. Ievtyukhova,
1952. p. 98), in the territory of the Gobi and elsewhere,
but are exceptionally rare. This again makes us aware of the
significance of the analysis of the statue found beside the
Bayan-tsagan streamlet. In the cases of the two khagan
memorials mentioned above we might trace it back to Chinese
influence. As for the *belt,* it is again this standing
statue which provides the clearest visibility from amongst
the statues involved. The characteristic of the Turkic-age
belts is that the entire strap is all but covered with studs.
This applies to our statue as well. However, the heart-
shaped studs which differ from the general semicircular and
square belt-studs have few analogies on Turkic-age statues
(e.g. on the shore of the Issigköl in Kirgizia: I. Sher
1966. Table 7, 33. a.). We do know stone statues wearing
heart-studded belts from a territory nearer to Mongolia,
from Tuva in particular (L. Ievtyukhova 1952. p. 84., 24.a.
and p. 86, 23.a.), still these three are overwhelmingly
insignificant in number compared to Turkic-age statues with
belts decorated with other kinds of stud. (There are two
more Tuvan stone statues where the belts are decorated with
heart-shaped studs of normal position - i.e. with tip down -
op. cit. p. 87., 24.a. and p. 88. 26.a.). These heart-
shaped studs L. Ievtyukhova regarded as later than the
squared or pierced belt-studs rounded off on top (op. cit.
p. 109.), that is, she dated them to the 9th century with
reference to similar findings at the Srotsky cemetery (the
Altai Mountains).

The *bags* generally hung from the right side of the
belts to keep them easily at hand. On our standing statue,
by the Bayan-tsagan streamlet, we see a round bag, on the
sitting statue at Öndörkhaan a square one. The round-
shaped small bags are quite frequent on Turkic-age statues
both in Kazakhstan and in the region of the Semirechie
(see I. Sher 1966. Table 2, 8.a., Table 3, 16.a. and Table
5, 20.a.) as well as in the Altai Mountains (L. Ievtyukhova
1952. p. 74. 3.a., p. 76. 5.a.) and in the territory of
Tuva (op.cit. p. 79., 12.a., p. 83., 19.a. and p. 90., 31.a.).
It is so in Mongolia also (ibid. p. 97., 45.a., p. 98., 47.a.).
We can see such bags at the waists of one standing and one
sitting figure of the Kül-tegin memorial, and at the waist

of a sitting statue of Bilgä khagan's memorial (B. Rinchen 1968. pp. 123-125.). Such a square, broad bag as on the statue at Öndörchaan is nowhere to be found from the Turkic period. This fact also corroborates the statue's later origin.

On the statue which stood in the valley of the Bayan-tsagan streamlet we can clearly see the *sabre* worn on the left side with the male figure's left hand resting on it. The hand is lying calmly and restfully above the hilt. The sabre worn always on the left side had to be pulled out of the sheath with the right hand. The position of the left hand like this is very common, though not exclusive, on Turkic-age stone sculptures. Here it denotes one of the iconographic aspects which link this relic to the Turkic age. On other statues the left hand is often on the belt or is tucked into it.

Now let us look at the *vessel* held usually in the right hand, and let us examine its position on all three statues. On the seated statue at Öndörkhaan it is only the crooked fingers which indicate that the figure holds a tiny stoop in his right hand. The statue carved from flat stone located on the right bank of the Huni river shows a cross-legged seated figure who grasps a vessel with his right hand, while the statue which stood in the valley of the Bayan-tsagan streamlet holds delicately on his finger-tips a hemispherical wooden cup with metal-studded rim. That it is wooden we know from the (silver?) band of triangle-motifs represented on the rim of the cup carved in stone. It is of crucial significance in all three of them that they hold the stoop, the vessel, or the cup in their right hands; that is, the drink is symbolically in the vessels already and the figures may even be imagined as having had a draught of it. For were it a gesture of offering they should hold the vessels in both hands, as can be perceived on some statues, mainly in Tuva and in one case in Khakassia. We are unaware of such statues in Mongolia. The graceful gesture with slightly outward-bending finger-tips on the statue found by the Bayan-tsagan streamlet is almost redolent of the refined hand-positions of Buddhist art.

We judge it acutely important to discuss the *beard* represented on the stone statue found beside the Bayan-tsagan streamlet. This is extremely rare on Turkic-age stone statues. Sometimes we do find it, but then it is wholly different in character from this one - shorter and merely under the lower lip, sticking closely to the chin: a small-size Mongol-type beard. From the territory of Tuva not more than four or five bearded statues are recorded besides scores of smooth-chinned

statues. We are aware of one or two bearded statues from the
Tien-Shan, but this number again is meagre as compared to the
other smooth-faced statues. A bulky, long beard was represented
with gusto on Uiguric frescoes, on the pictures of notables,
although not in the stylized manner as on our statue. In
spite of this, considering the above-mentioned details which
are seemingly later than the Turkic era, I think this statue
should be regarded as an Uigur-age relic.

An ample, detailed analysis of the sitting statue near
the Öndörkhaan airport is still to come. Its Mongolian
analogies provide the opportunity, though the statue is
thoroughly worn away by wind, rain and frost. Still, we
can discern the shape of the armchair-like throne, the
quasi-Chinese sitting posture (not cross-legged as with the
nomads), the thick felt boots on the feet. The exact shape
of the headgear, which is rather worn away, can be visualized
only on the basis of familiar parallels. Analogies to the
statue have emerged only from Mongolia, but from more than
one location, discovered one after another early in the 60's
and published mainly by N. Ser-Odjav. It was Kasakevich
who first gave news of such pieces from Dariganga where he
had found two similar statues. One of the two seated statues
holds the vessel in his right hand, the other in his left.
Both stand in front of devastated tumuli. A third was
discovered by N. Ser-Odjav in the Sukhbaatar-aymak; here, too,
the vessel is in the left hand (1964. p. 98 - without picture).
Outside the Dariganga region of southeastern Mongolia there
have been found two similar statues (seated) in the region
of the Khalkhin river, the eastern-northeastern part of the
country, at the excavation site called Shonkh Tavan Tolgoy.
Their heights are 170 cm and 140 cm. Although the head of
the second statue was knocked down (it lay beside the statue),
both are in good enough condition for the details to be
perfectly discerned. Thus the characteristic square bags
and, on one of them, the armchair's elbow-rest follow the
shapes of the statue at Öndörkhaan. From them we can
ascertain that the spiral-ended pendant moulded behind
the ear seen on this statue is an accessory to the hat,
hanging from it. There is no armament (dagger or sabre)
represented on them. N. Ser-Odjav makes the exact dating
dependant on the results of the excavations of the tumuli
beside the statues found in Mongolia's eastern-southeastern
parts, but, regretfully, such work has yet to be carried out.
The sphere atop the hat recalls the insignia of high-ranking
Chinese officials. It is certain that these statues are not
of Turkic age, and we cannot dismiss their late Mongol-age
origin either (17th century). Concerning them V. Kasakevich's
opinion proves incorrect at all events, which is to say that
we do not regard them as Turkic stone sculptures.

This brings us to the end of the lengthy description of our statues and the presentation of their analogies. Here I should like to spare some thought for a few methodological issues which have relevance to further elaboration.

With respect to Mongolia's stone statues this is still a task ahead of us. N. Ser-Odjav's pioneering short catalogue (1970), which is part of a small monograph on the Turks and enumerates sixty stone statues, is no longer sufficient. In the territory of Mongolia the work is still at the stage of collecting primary material, grouping and mapping. The Soviet studies have been mentioned. Relics of the Turkic stone sculpture are to be found ranging from the eastern part of the Lower Volga as far as Central Asia. Concerning a major area of Soviet Central Asia we do have at our disposal an excellent book, cited several times in our study, whose author, Iakov Sher of Leningrad, has given us a modern, comprehensive elaboration (1966). In the decade since then there has not been published any work which follows his method on this topic. I give a short outline of his process of elaboration; first he classified the statues of the Semirechie, the Tien-Shan Mountains, into six groups: 1. Armed male figures with vessels in their right hands; 2. Unarmed male statues (and statues of unspecified sex) with vessels in their right hands; 3. Statues featuring a human head or face only: 4. Statues holding a bird figure in their hands; 5. Male statues holding a vessel in both hands; 6. Female statues holding a vessel in both hands. Then he tabulated the details of the statues and contrasted them with the enumerated groups. Analysing the correspondence, he stated and confirmed the existence of two types: Type 1 includes the statues of the 1st, 2nd and 3rd groups, Type 2 those of the 5th and the 6th groups. Naturally these groups are not entirely independent of one another. His method, as I. Sher himself remarks, ignores the dynamic elements, i.e. disregards the statue's origin, its ancient prototypes and development; yet at the present phase of research it is employable and can be instrumental in obtaining results. As regards Mongolia, the first step ought to be the compilation of as full a catalogue as possible. This needs expert drawings and exact measurements of the statues. Only then could a data system as required for mechanical processing be worked out in relation to sites and individual features of the statues. We hope this will be performed in the coming years. Up to now, however, even the photographs or exact drawings of the discovered statues have not always been published and the brief descriptions cannot make up for

them. Often even the measurements are missing.

Concluding remarks and inferences

It has become evident through our analyses of stone relics
that, apart from the numerous relics of Turkic-age stone
sculpture in Mongolia, we shall have to reckon with such
relics from other periods as well. It is possible that the
custom of erecting tomb statues continued into the Uigur
era. The four or five known seated stone statues from the
eastern regions of Mongolia refer to an even later period.
Any further inferences are to be expected only in the wake
of more field-work - expeditions and excavations - which
should be followed by a full cataloguing and analysis of
the statues. The scientific world can reasonably ask as
much from Mongolian archaeology.

I. Erdélyi

Erdélyi, I. & Ferenczy, L. 'Az 1962. évi mongóliao expedició eredményei', *Archaeologiai Ertesito* 1963, pp. 120-126.

Ist, P.F. 'O Kamennykh izvayaniyakh v Sin'tszyane', *Sov. Etnogr.* 1958, Vyp. 2, pp. 101-103.

Eftyukhova, L.A. 'Kamennye izvayaniya Yuzhnoi Sibiri i Mongolii', *MIA* 24, 1952, pp. 72-120.

Jisl, L. & Ser-Odjav, N. 'Recentes decouvertes de gravures et peintures rupestres', *Arch. Rozhledy*, Prague 1966, pp. 21-53.

Kazakevich, V.A. *Namogil'nye statui v Darigange*, Leningrad 1930.

Klyashtornyi, S.G. 'Drevneishii pis'mennyi pamyatnik', *Tyurkologicheskii svornik* 1973 p. 411.

Larichev, B.E. *Aziya dalekaya i tainstvennaya*, Novosibirsk 1968.

Masson, M.E. 'Unikal'nyi namogil'nyi litseboi pamyatnik iz doliny Angrena', *Izv. AN Kaz. SSR. Ser. arkheol.* vyp. 3 1951, pp. 111-116.

Rintchen, B. 'Les dessins pictographiques et les inscriptions sur les roches et sur les stèles en Mongolie', *Corpus Scriptorum Mongolorum* tomus XVI fasc. 1, Oulaanbaatar 1968.

Ser-Odjav, N. *1969 ony kheeriin shinzhigeenii kheregledgdekhüün,* Ulaanbaatar 1962.
'Arkheologicheskie razvedki v Vostochnom aimake MNR v 1962 g'. *Studia Archaeologica* tom. III fasc. 10, 1964, pp. 95-100.
'Mongolyn töv, umart khesgiig arkheologiin talaar sudlan shinzhilsen n'. ' In *Mongolyn Khürliin üe*, Ulaanbaater 1965, pp. 47-66.
BNMAU dakh' ertnii türegiin arkheologiin dursgaluud, Ulaanbaatar 1965.
'Ertnii türegüüd', *Studia Arch.* vol. 2, 1970.

Sher, Ya.A. *Kamennye izvayaniya Semirech'ya,* Moscow & Leningrad 1966.

1a. Stone statue representing a seated figure near the
 Ondörkhaan airport (taken by L. Sugár, 1971).
 Kenti-aymak, East Mongolia.

1b. Ibid., from side-view (taken by L. Sugár, 1971).

2a. Stone statue representing a seated figure on the
 right bank of the Huni river. (Taken by L.
 Sugár, 1974). Arkhangay-aymak, West-central
 Mongolia.

2b. Stone statue representing a standing figure near
 the Bayan-tsagan streamlet (taken by L. Sugár,
 1974). Detail. Arkhangay-aymak, Middle-West
 Mongolia.

3a. Ibid., the complete statue (taken by L. Sugár. 1974).

3b. Stone statue representing a standing figure from the
 Choiren kurgan, near Ulaanbaatar. (Taken by
 L. Sugár, 1971). At the exhibition of the Central
 Museum, Ulaanbaatar.

Plate 1

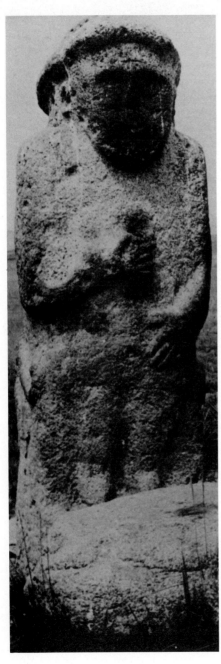

a

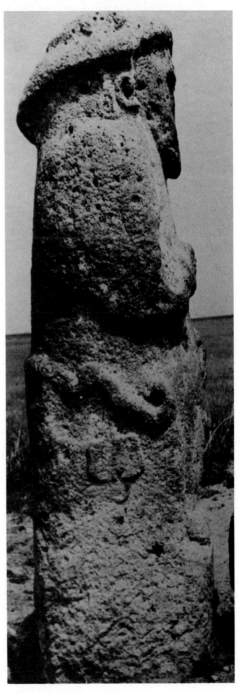

b

Plate 2

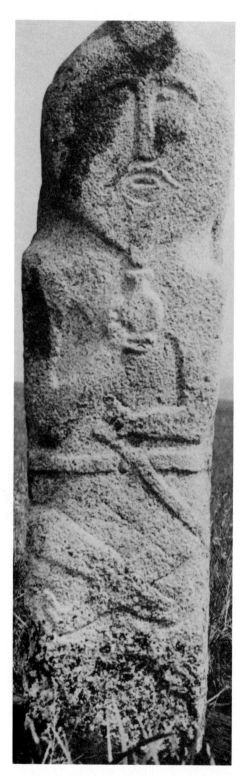

a

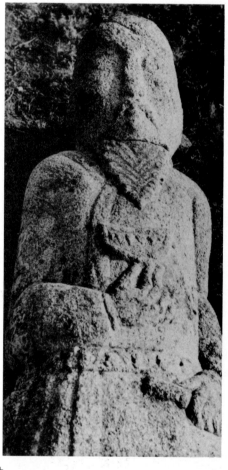

b

Plate 3

a

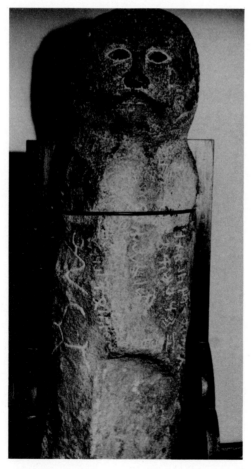

b

NOMAD ARTS AND TIBET

History and prehistory in Tibet

Both Tibetan and Chinese historical sources seem to reach firm
ground in the 7th century AD, namely in the reign of Songtsen
Gampo (c.609-649). From that time on we seem to be dealing
with a basically settled agricultural civilisation which fell
progressively under the spell of India in all its higher art
forms (and many of its lower ones). There are hints of
influence from Sasanian Iran at first, while influence from
China, probably never absent, is marked from the Ming and
quite strong in the Ch'ing.

Two considerations have prompted the writing of this
paper: the oft-held assumption that the Tibetans were of
nomadic origin and have somehow always been nomads at heart;
and the existence of pieces of evidence, partly of an artistic
character, which have been held to support that view. It is
admitted that Tibetans are fond of long-distance travel; also
that they number among them groups who can truly be called
nomads. But does this make them the descendants of a
fabulous 'royal horde' like that of the Scythians, Huns or
Mongols?

Nomadism and Tibetan origins

'(Tafel) states that all the Koko-nor (nomad) Tibetans are
called *Banag*, probably by reason of their 'black tents'; and
in fact the black tents *(sbra-nag)* of the Tibetans were
proverbial even in the eighth century A.D.'

In voicing such an opinion, F.W.Thomas[1] was far from
alone, even among eminent Tibetologists. Perhaps the boldest
assertion of a nomadic origin for the Tibetans was made by
Roerich, who writes:

> 'The forefathers of the modern Tibetans invaded
> the country from the North-East. The high table-
> lands of the Koko-nor and the surrounding mountain
> country afforded sufficient grazing for the moving
> hordes and their cattle. It is from this gigantic
> region that the hordes of ancient Tibetans,
> displaced by some other tribal movement had been
> forced to seek new pasture grounds descending
> the river valleys of South-eastern Tibet. The
> character of the country forced the raw nomads

to take up agriculture. In these valleys a
population of sedentary tribes created the
theocratic culture of Tibet But the south
was not the only direction of Tibetan migratory
movement, another body of Tibetan tribes moving
from the Koko-nor region across the northern
uplands, struck the mighty Nyen-chen Thang La
and was forced to turn westwards along the
northern slopes of the Trans-Himalayas, searching
for an easy passage across the mountain range
into the basin of the Tsang-po or Brahmaputra...
These nomad tribes brought with themselves that
highly conventionalized art of nomad Central
Asia which is distinguished by the so-called
'animal' style'.

In support of this thesis, Roerich[2] mentions the
Chinese historical sources, though without any specific
references, and then discusses three categories of artifacts -
graves, megaliths and 'animal-style' objects discovered by
his Central Asiatic Expedition of 1925-8.

Thomas's statement is easily disposed of. The only
evidence he cites for it is the passage from the *rGyal-po
bka'i thang-ying*:

> gru-gu yul-gyi 'ong-ngu yang-chod-la
> bod-kyi dmag-dpung sbra-nag phab-nas-ni.

Now the text in question is certainly not older than
the 14th century in the form we now have it. Doubtless many
parts of it are versions of much older material, indeed,
this very passage echoes the inscription at the tomb of king
Khri-lde srong-btsan, but significantly, there is no mention
of black tents in the latter.

Thomas translates the passage 'As far as 'Ong-ngu in
the Gru-gu kingdom the army forces of Tibet, set up the
black tents (and escorted the people, their land overthrown,
into the Mon territory)'. This cannot be right. *Phab* means
'throw down', exactly the opposite of 'set up'. The meaning
may be that the Tibetans dismantled the tents of the Dru-gu
(perhaps some kind of Turk) before taking over their country
and transporting them elsewhere. Such an interpretation is
supported by Desgodins' dictionary entry, *gur phab -
tentorium colligere.* Or Richardson's translation: 'The
Tibetan army fell upon the black tents...' may be nearer the
mark.[3] In any event the assertion that Tibetan black tents
were proverbial, or even that they existed in the 8th century
is unwarrantable.

I have recently combed the early literature in Tibetan (7th-10th centuries) relating to the first historical period, that of the Kingdom. There are plenty of references in it to fields, crops, houses, fortresses and farmers, but although the word *'brog* 'steppe' occurs sporadically, sometimes in contexts suggesting that it has economic value, I have found not a single mention of *'brog-pa* 'steppe-people', the usual modern and historical word for 'nomad'. Nor are there any other words which could be interpreted as 'nomad', or any words for 'tent'. There is no evidence that the Tibetan armies were mounted nomad hordes; rather the contrary. The Chinese sources which speak of the Tibetans as partly nomadic should be treated with reserve on this point and are sometimes contradictory; even they attest the existence of substantial houses and regular agriculture. On the whole one gets the distinct impression of a society like that of modern times - a basically settled, sometimes partly transhumant farming population with a small minority of true nomads inhabiting areas unfitted for agriculture.

Turning now to the passage quoted from Roerich, one notes its general vagueness, especially concerning time. No evidence is offered that the Tibetans moved in hordes, or that their chief animals were cattle. Tibetan nomads of historical times have generally moved around in small groups, their animals being sheep, yaks and horses. And why should the character of southeast Tibet 'force' anyone to take up agriculture? Historically, we know that agriculture preceded true pastoral nomadism by some millennia: no evidence is adduced for the reverse procedure in Tibet. The shortage of information about neolithic farming communities on the Tibetan plateau must be due principally to the lack of archaeological exploration, and the chance discovery of neolithic-type tools reported by Tai[4] is a hint of what might await systematic investigation. Megalithic remains, common in many parts of Tibet, would fill in part of the gap and correspond perhaps to a bronze age. There are certainly indications of a movement of certain aristocratic lineages from the north-east in the period of the early kings, and at other times, but the actual process of peopling and cultural unification of the Tibetan plateau must have been much more complicated than Roerich suggests. There seem to have been many diverse ethnic groupings, from the T'u-yü-hun, Yang-t'ung, Sum-pa and others of the early period to the Mons, Bhutanese, Lobas and others of more recent times, who have progressively become 'Tibetanised'. The decisive event in this process was the formation of the Tibetan empire under Songtsen Gampo, but it had probably begun before then and it has continued down to the present day - is indeed still operating in parts of the Himalayas. Unfortunately the

historical part of the operation, in which mounted nomadism
plays but an insignificant part, begins centuries later than
the heyday of the 'animal style'.

Megaliths

Roerich states that 'the region where have been found stone
graves and megalithic monuments corresponds to the region
where are found objects ornamented in "animal" style'.
R.A. Stein, probably following Roerich, makes the point that
the areas associated with the ethnic name 'Hor' - parts of
north-central and of eastern Tibet - are characterised by
'deux traits a première vue peu "tibétains". Ce sont les
ensembles de menhirs et de tombes formés par des cercles
de pierres ... et le style animalier des objets de métal...'.[5]
A glance at Roerich's own map, however, will show that the
two phenomena, megaliths and animal-style objects, are any-
thing but coincident. Megaliths are shown to be predominantly
western and south-western, the animal style predominantly
central and north-eastern, with only a slight overlap. A
study of Tucci's and Macdonald's observations[6] reveals that
firstly megalithic monuments are much more widespread than
suggested by Roerich, and secondly that the correspondence
with the animal style area cannot be maintained.

In any case, there is no particular reason to associate
megalithic monuments of the types found in Tibet - alignments
of standing stones - with mounted nomads of the classic type,
among whom such artifacts were elsewhere conspicuous by their
absence.

Graves

In the case of graves, Roerich may be on surer ground. The
small enclosures of boulders he illustrates to show similar-
ities with some Siberian, Mongolian and Altai graves, though
without excavation it is impossible to say how far these
similarities extend. Some of them may not even be graves at
all - they could for instance be the remains of enclosures
for sheltering tents, a device mentioned in early Chinese
accounts of Tibet and still used by some Tibetan nomads,
and by the Gujar nomads on the fringes of western Tibet.
Nor is the distribution of the graves particularly convincing
in relation to the 'animal style' area. One is inclined,
with Tucci, to reserve judgement.

Small objects

A collection of apparently pre-Buddhist objects, obtained in

Tibet (mostly the west and south) from local inhabitants, has been described by Tucci and by Bussagli,[7] who have attempted tentatively to connect some of them with objects from other cultures. The clearest case has been pursued by Goldman.[8] It concerns a class of flat bronze circular objects (Pl. la,lb) consisting of one, two, or three concentric rings, linked by radiating bridges, the inner ring or rings often being incomplete at the top. Here is placed a central projecting part, sometimes anthropomorphic or zoomorphic, which is flanked by projecting animals or birds. Goldman analyses several such objects in some detail and makes out a convincing case for linking them to a well-known class of Luristan bronze. The similarities are of both general features and of quite small details, and some surprising parallels occur between the Tibetan bronzes and another Luristan-related group – from Etruria.

The Tibetan pieces are quite undatable, although the simplified, rigidified and seemingly distorted shapes would seem to put them later than their Luristan counterparts. Since the precise dating and cultural attribution of the latter is far from settled, any question of transmission to Tibet must remain speculative. Conceivably, some early 1st millennium BC Cimmerian/Median/Scythian cultural continuum stretching as far as the Pamirs, such as has been postulated by Ghirshmann,[9] might be called upon, but there is still no way of knowing whether population movements or trade would have been involved. A few Luristan-like objects have come to light from the intervening territory, such as a bronze jar from Chanhu Dharo in Sind and a dirk from Fort Munro. Evidence of migration from Iran into the Indian north-west in the 1st millennium BC is not lacking, and such sites extend at least into Swat on the edge of the Tibetan area.[10] At any rate the link must be made somehow, and a nomadic connection is not to be ruled out.

Rock bruisings

While in the general area of western Tibet it is worth mentioning a class of scratchings and bruisings made on rock. These have been mentioned by Tucci, Francke[11] and others; I was able to photograph a set of them near Alchi in Ladakh (Pl. lc,ld). I have seen them elsewhere in Ladakh, and Tucci mentions them as existing in western Tibet as well as on the eastern borders. They have been produced by scratching or bruising the dark weathered surface of granitic boulders to reveal the lighter rock beneath. The chief subjects depicted are the ibex and other cervids, with a few birds and human archers. Some of the bows appear to be compound, others not. One drawing shows a centaur-like

creature. Such depictions are found in many parts of Central
Asia and seem to have been made at all times from the neolithic
to modern times. The interest of the present group is that
they occur on the same boulders as Tibetan graffiti datable
by orthography to not later than the tenth century AD, while
the slight discoloration of the underlying rock shows that
they are somewhat earlier in date than the graffiti. This
makes them prehistoric. I would advance them as evidence of
an early peopling of the Tibetan plateau by groups with some
affinities to outside cultures. The connection with nomadism,
if any, remains unclear, though in Afghanistan and Mongolia
similar carvings are found in areas nomadic in historical
times.

Animal-style objects

The finds of the Roerich expedition which lend the most
support to the nomadic thesis are small objects in animal
style found in regular use by groups of nomads in northern
and north-eastern Tibet, or otherwise discovered in those
regions. The quasi-ethnic designation 'Hor' is assumed to
be crucial in that the 'Nub-Hor' or 'Western Hor' nomads to
the north-north-east of Lhasa and the 'Hor' principalities
of the Derge area in Kham are the centres of the style.

Unfortunately Roerich's definition of the animal style
areas turns out to be quite confused. Thus his map includes
the Changpa and Namru nomads to the north-west of Lhasa, and
the Panag and Amdo regions in the north-east, but not the
Derge area. (It is worth noting in passing that the Derge
and Amdo areas have historically been settled zones). It is
not clear whether the objects are manufactured in the Nub-
Hor region or just in Derge, a well-known metal-working
centre. Thus the animal style is shown to be current among
many others besides the Hor nomads, while being absent from
the Hor areas of Kham.

What does the word 'Hor' really signify in this context?
An article by Ligeti is the latest discussion of its use in
the early period.[12] Many ethnic names used by the Tibetans
are notoriously vague, which is perhaps not surprising in
view of the unstable nature of the populations to the north
of them. 'Hor', when not occurring in essentially mythical
contexts, seems to have been used for several Turco-Mongol
peoples at various times, before being applied to the
Genghiside Mongols and the Yuan, who were eventually to be
known as Sog-po. In modern times Hor seems to be little more
than a label, and the only meaning common to the various Hor
groups might be 'having had Turco-Mongol connections'. It
can be compared with 'Mon' which can be applied to almost any

group living between Tibet and India or between Tibet and China, even such Tibetan-like peoples as the Bhutanese or Monpas of Tawang. The Derge area probably retains the name Hor, along with some Mongol dialect words, because of the old Genghiside administration there; its application to the Hor nomads, whose territory is far from being contiguous with the Derge Hor area, may be a hangover from some Turco-Mongol nomadic tribe which entered into their composition at some early date. There need be no direct connection between the two areas - indeed Tibetans seem to recognise none.

The objects collected by the Roerich Expedition are of three types. That associated with the Hor nomads comprises thin plaques designed to be attached by rivets to leather. Four tinder pouches with brass plaques have been illustrated, three from the Nub-Hor region and one from 'West Tibet' (Pl. 2a-d). All depict two addorsed standing animals - perhaps female deer - facing outwards towards vertical elements which are probably intended for trees, but in three or perhaps all four cases with heads turned to look over the shoulder. On two of the plaques, curious appendages on the animals' haunches are seen by comparison with a third to represent smaller animals, probably fawns. Three have a wheel motif in the centre, all of different design, and the fourth an odd triangular piece which might show two human figures flanking a central tree. One has fish leaping from the deers' mouths. One is made of a single piece of metal, while in the others each animal forms part of a separate triangular or rho-shaped plaque.

One notes a rigid symmetry around the central vertical axis, and a general simplicity and crudity of technique, which nevertheless allow the expression of a certain liveliness. The pieces are evidently late in a long tradition of copies, in which parts of the design, such as the fawns and trees, and doubtless others, have lost their outlines and become meaningless shapes.

In seeking parallels from elsewhere I would not reject out of hand the circular 'Luristan'-type bronzes discussed above. The plaque form, the symmetry, the two animals and some of the decoration are present in both. Another object found by Roerich, a circular plaque containing an alleged double eagle, might be considered related. These resemblances are however general rather than particular. Much closer correspondences can be found between the Tibetan objects and certain well-known types of Ordos plaque.[13] We have the overall shape, the symmetry (considering that the relevant Ordos plaques seem usually to have been made in mirror-image pairs), and the composition - animal and tree. Details in

common are the turned head, and the ring-punched hooves of the Tibetan examples which recall the inlay-sockets (real or pseudomorphic) and knee- and hoof-dots well known from the Ordos group. Central wheels are also represented on those Ordos examples which give the whole composition of a doubled animal on a single piece. The tendency towards a rather static feeling, flattening of the surface, and the disintegration of design elements are to be seen on some Ordos plaques, which have been dated late, probably on that account.[14]

Now the region of the Ordos bronzes is adjacent, or nearly so, to the Koko-nor area of Tibet, which is where the present Tibetan animal style begins. Can we find a connecting link? The Ordos bronzes concerned are generally attributed to the Hsiung-nu. That tribe was eventually succeeded in the Koko-nor and adjacent areas by the T'u-yu-hun (4th century AD), a Turco-Mongol people. Maenchen-Helfen has written, 'It is unlikely that we will ever know what the art of the T'u-yu-hun was'.[15] Could it not have included developments of the Hsiung-nu bronze plaques?

An early aim of the Tibetan king and empire-builder, Songtsen Gampo, was the subjugation of the A-zha, as the T'u-yu-hun were known to the Tibetans. This was achieved in 634 AD and the following years, after which the T'u-yu-hun seem to have continued as a quasi-separate entity strictly under Tibetan control. Many of their troops were used by the Tibetans in their campaigns. It seems that they were largely or partly nomadic - they certainly had numerous tents. What more likely than that the T'u-yu-hun horde should be moved back by the Tibetans from the front against China, into precisely the areas where the animal style now flourishes? Here they would form a strategic reserve, gradually becoming Tibetanised but retaining their nomadic ways. Some of their peculiar cultural traits, such as items of dress and the presence among them of 'europoid' physical types may hark back to their origins. There would be no difficulty in applying the name 'Hor' to members of such a group, since it would be Turco-Mongol. Others have hinted at the 'Little Yueh-chih' as a possible source for the Tibetan animal style. Of course they cannot be ruled out, but I would suggest that the T'u-yu-hun have at least as good a case.

In a Tibetan context, the similar layout of the Buddhist wheel of the dharma with flanking deer springs to mind. Assimilation of one design to the other is possible; the presence of Buddhist-derived elements even in Hsiung-nu times is not to be dismissed.

The second type of animal style object is represented
by a round, silvered iron plaque said to be from Derge, and
depicting a lion in near-profile, with turned head (Pl. 3a).
Roerich rightly compares it with a round silver plaque from
Noin Ula depicting a yak (Pl.3b) [16]. The two pieces are
obviously related. The general elements of the composition
are the same, as are the static pose and heavy treatment of
the animal. The lion plaque, however, may have been influenced
by the Buddhist metalwork tradition, betrayed perhaps by the
very choice of a lion and by the treatment of the foliage.
Here again we seem to have a connection leading back to the
Hsiung-nu. The attribution of Derge is vague, and Roerich
himself admits that it is only the 'older' objects that
show traces of the animal style. There is no proof that the
plaque was made in Derge, which was a centre of trade and
exchange.

The third type is exemplified by Roerich's silver pen-
case. Amid florid traceries of foliage of well-known type
and what seems to be the sinuous body of a dragon are a small
crouching horse or deer and two swan-like birds whose pose
is reminiscent of an embroidered bird from Noin Ula. Roerich
claims that the piece was made in a Chinese workshop but it
is not clear whether this is a guess or an authoritative
statement. Certainly such figures are not typical of Tibetan
metalwork and a connection with steppe art would seem to be
indisputable.

Weapons

In a discussion of Tibetan swords and lances, Roerich traces
one of them - the 'long-hilted' sword - to a 'Sarmatian' type
current in the Han epoch and known in Chinese Turkestan in
the 6th-7th centuries. Since the Tibetans were in control
of large parts of Chinese Turkestan in the 7th century they
could easily have borrowed this type of sword then, as they
have obviously borrowed many of their weapons since.
Incidentally, the Tibetans seem to have no strong tradition
of mounted archery, as admitted by Roerich. This would be
surprising if they were originally of nomad stock.

Conclusions

The brass tinder-puch plaques of Roerich's expedition were a
significant discovery. Interesting in themselves, they are
remarkable as survivals into modern times, in semi-fossilised
form, of ancient works of nomad art; a testament to the
conservative aspect of Tibetan civilisation. Together with
the lion plaque and pencase from the Derge region they seem

to point unmistakably to the art of the Hsiung-nu. The
intermediaries can only be guessed at - I have suggested
the T'u-yu-hun as one of them. Some of the pieces described
by Tucci and Bussagli may be links in an earlier chain of
the first millennium BC, leading across to Luristan and
conceivably representing an infiltration of nomadic elements
from the Iranian area into western Tibet.

 This said, it cannot be maintained that Roerich's
findings prove that the Tibetan nation or any large part of
it is of nomadic origin. The animal style, as represented
by the objects I have discussed, is but an odd accident in
Tibetan art - fascinating, but minor.

Philip Denwood

NOTES

1. Thomas, F.W., *Nam. An ancient language of the Sino-
 Tibetan borderland*, London 1948, p.21; and *Tibetan
 literary texts and documents concerning Chinese
 Turkestan* part I, p.273; part II, p.289.

2. Roerich, J.N., *The animal style among the nomad tribes
 of northern Tibet*, Prague 1930, p.29ff.

3. Richardson,H.E., 'The inscription at the tomb of Khri
 lDe Srong brTsan', *Journal of the Royal Asiatic
 Society* 1969, 29-38; p.33f.

4. Tai Erh-chien, 'Stone objects found at Nyalam in Tibet'
 (in Chinese), *K'ao-ku* 1972 no.1, 43-4.

5. Stein, R.A., *La civilisation tibétaine*, Paris 1962,
 p.13.

6. Tucci,G., *Transhimalaya*, London 1973, p.50ff; and
 Macdonald, A.W., 'Une note sur les megalithes
 tibétains', *Journal Asiatique* 1953.

7. Bussagli,M., 'Bronze objects collected by Prof. G.
 Tucci in Tibet. A short survey of religious and
 magic symbolism', *Artibus Asiae* 12, 1949, 331-47.

8. Goldman,B., 'Some aspects of the animal deity: Luristan,
 Tibet and Italy', *Ars Orientalis* 4, 1961, 171ff.

9. Ghirshman, R., *Persia from the origins to Alexander
 the Great*, London 1964, pp.76, 124.

10. Allchin,B. & Allchin,R., *The birth of Indian
 civilization*, Harmondsworth 1968, p.149ff.

11. Francke,A.H., *Antiquities of Indian Tibet*, Calcutta
 1914 & 1926, vol. I pl. XLIV.

12. Ligeti, L., 'A propos du "Rapport sur les rois
 demeurant dans le nord"', in Macdonald,A.W.(ed),
 Etudes tibetaines, Paris 1971, 166-189.

13. See, e.g. Bunker,E.C., Chatwin,C.B. & Farkas, A.R.
 "Animal style" art from east to west, New York
 1970, p. 136f; and Salmony, A., *Sino-Siberian*

art in the collection of C.T. Loo, Paris 1933.

14. See Salmony,*op. cit.*, pl. XXVIII.

15. Maenchen-Helfen, O.J., 'The ethnic name Hun', in
 Egerod,S. & Glahn, E. (eds.), *Studia Serica Bernhard
 Karlgren dedicata*, Copenhagen 1959, 223-238; p. 234.

PLATES

1a. Bronze object from Tholing, Tibet.

1b. Bronze object from Western Tibet.

1c-d. Rock scratchings from Alchi, Ladakh.

2a-d. Tinder pouches from North-Central Tibet.

3a. Silvered iron buckle from Derge.

3b. Silver plaque from Noin Ula.

Plate 1

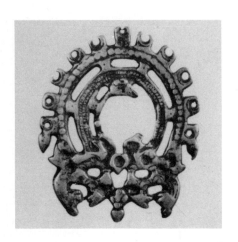

a

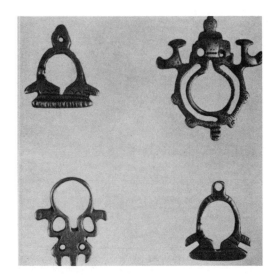

b

c

d

Plate 2

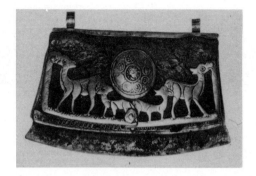

a

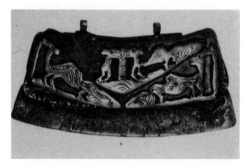

b

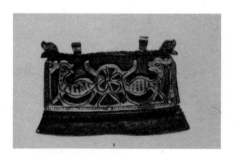

c

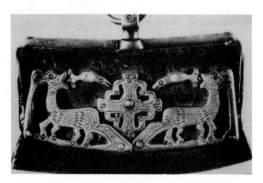

d

Plate 3

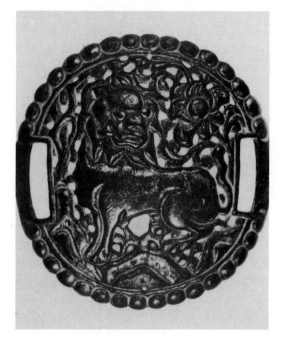

a

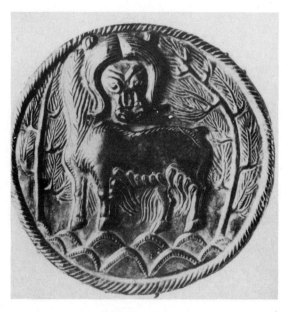

b